T0339708

Patterns of Bias

in

Hollywood Movies

PATTERNS OF BIAS

IN

HOLLYWOOD MOVIES

JOHN W. CONES

Algora Publishing
New York

Library of Congress Cataloging-in-Publication Data —

Cones, John W.
 Patterns of bias in Hollywood movies / by John W. Cones.
 p. cm.
 Includes bibliographical references and index.
 ISBN 978-0-87586-957-5 (soft cover : alk. paper) — ISBN 978-0-87586-958-
2 (hard cover: alk. paper) — ISBN 978-0-87586-959-9 (ebook) 1. Discrimination
in motion pictures. 2. Stereotypes (Social psychology) in motion pictures. 3.
Motion pictures—Social aspects—United States. I. Title.
 PN1995.9.D555C66 2012
 791.43'6552—dc23
 2012032061

Printed in the United States

This book is dedicated to all of the women, African Americans, Latinos, Native Americans, Asian Americans, German Americans, Italian Americans, Christians, Muslims, Arabs, white Anglo-Saxons, Southerners and others who have been victims of Hollywood patterns of bias for some 80 years.

TABLE OF CONTENTS

INTRODUCTION

This work grew out of the frustration observed among film industry critics who have chosen to criticize specific Hollywood movies over the years only to be rebuffed by overly simplistic studio arguments. They maintain that such films reflect the real world and that moviegoers vote with their pocketbooks. But, if it can be shown that there is a consistent pattern to the choices Hollywood studio executives make with respect to the movies produced and released and the specific content of those movies, it becomes obvious that Hollywood is portraying reality selectively and that movie goers only have limited options among all of the possibilities that could be portrayed on the silver screen.

This book differs from other studies touching on the same topic. Whereas most books on the subject of bias in motion pictures focus on the treatment of a single ethnic, religious, cultural, racial or other readily identifiable interest group in our diverse society, this study attempts to provide an overview of such biases. The underlying assumption is that once the patterns of bias in motion picture content are demonstrated, it then becomes easier to identify the source of the bias and to explain why such bias exists. The patterns-of-bias approach is also more useful when remedies are considered, since

no single interest group offended by Hollywood with its movie portrayals has yet been able to effectively persuade Hollywood to substantially alter such portrayals over a long period of time. To the extent that some slight change has been brought about, due to the pressure of a particular group or the gradual evolution of cultural sensibilities, Hollywood has merely substituted another equally offensive pattern of bias for the previous one.

This study also attempts to avoid redundancy by providing only summary coverage in the areas that have been fairly adequately studied, (e.g., treatment of African-Americans, Hispanics, women, etc.), while placing a greater emphasis on subjects that have not been adequately covered (e.g., treatment of people, places and things of the American South). In addition, in order to avoid the creation of a book that is too lengthy to digest, the entire text of the section on anti-Nazi movies has been omitted, since there appears to be no question that Hollywood's all-time favorite villain is the Nazi.

This study of Hollywood patterns of bias in motion picture content also serves as a companion volume to several other books in a series about Hollywood. One of those books, *Who Really Controls Hollywood* demonstrates quite clearly that the Hollywood-based U.S. motion picture industry is controlled by a single very narrowly defined interest group. It further concludes that it is inappropriate for any such group to control a significant medium for the communication of ideas in a society that is as diverse as that in the U.S.

Another book in the series, *Hollywood Wars—How Insiders Gained and Maintain Illegitimate Control Over the Film Industry* ("*Hollywood Wars*") catalogs and discusses a variety of business practices and other techniques used by the Hollywood control group to gain and maintain its dominance over the U.S. film industry for the past 100 years. The book concludes that many of such business practices are unfair, unethical, anti-competitive, predatory, and in some cases, illegal. A closely related volume entitled *The Feature Film Distribution Deal* critically analyzes the single most important film industry agreement, and shows how the Hollywood major studio/distributors have abused their excessive power in the film industry market-

place to contractually exploit producers, directors, writers, actors, actresses, investors and others through documents that can only be characterized as contracts of adhesion, filled with unconscionable provisions.

Another of the books in this series, *Motion Picture Industry Reform*, takes a serious look at various approaches to instigating significant and long-term reform in the way the motion picture industry operates. It specifically promotes a policy designed to insure equal and fair opportunities for persons of all races, religions, ethnicity, cultures, nations or regions of origin, sexual preferences and so forth to tell their cultural stories through this important communications medium, the feature-length motion picture.

CHAPTER 1

Movies Mirror Their Makers

One of the underlying theses of this work is that to a large extent, movies mirror the values, interests, cultural perspectives and prejudices of their makers—not to an absolute degree, but as a general rule. As George Custen pointed out in connection with his study of biopics, "[a]lthough the cinematic lives of the famous take place in locations the world over, and are set in time periods covering more than two thousand years, they inevitably reflect the values of the world of the Hollywood studio and their personnel."

Hortense Powdermaker agreed, saying that the "taste, good or bad, of the men (and women) who make the movies will be inevitably stamped on them and will break through all rules and taboos."

Powdermaker went on to say that "[m]uch of the producer's power is similar to that of the front-office executive. Both tend to project onto the movies their own personalities, their ideas of love and sex, their attitude to mankind, and their 'solutions' to social problems." In addition, Powdermaker says that the producer also "usually picks able, skilled authors who share his (or her) interests."

> The personalities of the men who sit in the front office are of interest . . . because their own natures influence the content of the movies . . . it is the executives (and producers) who have the greatest power to stamp the movies with their personal day-dreams and fantasies . . . the tendency of executives to see the movie audience in their own image results in a rather high correlation between the executives' personalty and their opinions of the audience . . . power concentrated in the hands of one man or a few becomes personalized . . . In Hollywood . . . the man (or woman) who sits in the front office sets the tone of the whole studio, influencing and shaping attitudes and behavior of everyone in it; even more important, he leaves his stamp on the movie.

In other words, regardless of whether the "executive reads or listens, acts singly or with others, he usually projects his own taste onto the public." The "important decisions on scripts are conditioned by the taste, judgment and personality of executives. Decisions about casting and cutting or on shooting a picture on location or in the studio, on the production's budget, and the settlement of disputes which may arise between any of the important people involved in the movie is likewise the responsibility of the production executive." Of course, all of the above decisions made by a film's producer and/or its supervising studio executive will inevitably have creative effects on the ultimate film.

Thus, one of the less than desirable direct results of a film industry dominated by a small group of men who share similar backgrounds is a likely bias in the content of the movies. For example, as Pristin points out, the practice of nepotism "is at least partly responsible for Hollywood's insularity, narrow perspective and largely homogeneous work force. The industry has long been criticized for employing relatively few women, blacks and other minorities, especially in its upper ranks. More diversity among management personnel would likely lead to a more interesting mix of movies." Again, the economic control of Hollywood cannot be separated from creative control.

As noted earlier, Powdermaker also states that "'Hollywood is no mirrorlike reflection of our society, which is characterized by a large number of conflicting patterns of behavior and values.'

Instead, Hollywood had emphasized some of those values to the exclusion of others." Also, as noted earlier, in talking about Hollywood's politically liberal slant, David Prindle says "it is not Hollywood's willingness to embrace national problems in movies and on television that is disturbing. It is the relentless one-dimensional viewpoint that dominates the films and television that come out of the industry."

The present studio dominated system also allows certain insider filmmakers or filmmakers with insider backing to pursue their own hidden agendas (i.e., plans of things to be done or intentions that are not apparent or divulged). Filmmakers make movies for many reasons. Making money, becoming famous, earning the respect of professional peers, providing entertainment and communicating important ideas would seem to be high on anyone's list of the typical reasons why movies are made, although the order of importance certainly may differ amongst individuals. The feature film, as a communications medium, with its large screen, color technology, special effects, lighting techniques, exquisite photography, incredible sound, excellent talent on and off the screen, is also, without question, one of the most effective forms of communicating ideas that the world has yet devised. It would indeed be naive for anyone to assume that the communication of ideas is not an important motive for any serious filmmaker or filmmaking concern. A feature film also affords a unique opportunity for those who control or dominate the process of decision-making as to which movies or ideas are included in motion pictures, to insert such ideas or select and actively promote the movies which best express the views held by those same decision-makers.

This book serves to collect and furnish some of the available evidence which points toward the answers to two fundamental questions about the American motion picture industry: (1) Is the control exercised by the Hollywood control group reflected in the kinds and content of the motion pictures produced and released? and (2) Do American movies adequately reflect the nation's multicultural diversity or do they reflect a consistent pattern of bias in favor of those who control Hollywood and against those who do

not control Hollywood? Because of the inherent difficulties in assembling an objective panel and reviewing enough movies that have been produced and released over a sufficient period of time to constitute an adequate sampling of negative and positive portrayals of various ethnic, religious, racial, gender, sexual preference and cultural groups in American motion pictures this report is based on a different approach and a less formal study of the above questions. Hopefully this effort will stimulate interest in this overall approach to the study of patterns of bias in motion picture content and lead to further studies using more formal methodologies.

As stated earlier, there appears to be substantial evidence that the Hollywood control group does in fact consistently portray itself in a positive manner while consistently portraying other populations in a negative manner (see discussion in *Movies and Propaganda*). The various ethnic, cultural, religious and racial groups that have publicly complained about the portrayal of their members in movies are listed below. A significant number and variety of ethnic, cultural, religious, gender, sexual preference and racial groups within the American multi-cultural society have bitterly complained over the years about how Hollywood's mainstream movies have consistently portrayed them in a negative manner and about unequal employment opportunities in the film industry. A sampling of these complaints is set forth below in a mostly chronological order within each subject category.

Hollywood movies have consistently exhibited certain specific patterns of bias with respect to the people and places portrayed. Some of the patterns of bias have been consistently negative and others, consistently positive. Michael Medved's book *Hollywood vs. America* vigorously, and I believe, in most instances, correctly, criticized Hollywood for attacking religion, assaulting the family, using excessive foul language, being addicted to violence, being hostile to heroes and for bashing America and its government agencies.

In fact, it was quite instructive to see President Clinton in April of 1995, following the Oklahoma City bombing, attacking the conservative talk show hosts for bashing America and its government, when Hollywood motion pictures have been doing the same thing

for years, through, what I believe is an even more effective communications medium (i.e., the feature-length motion picture). As an example, we have to look long and hard to find a movie portrayal of a CIA or FBI agent that is sympathetic. We also have to look long and hard to find a movie portrayal of a politician or government official that is not negative. But, in a rather transparent attempt to use one of our nation's greatest tragedies for political gain, Clinton did not choose to criticize the Hollywood establishment for its America-bashing but instead chose to criticize the political right and their talk show cronies.

In other words, if anyone, including the President, is going to make the argument that ideas espoused on talk shows contribute to an environment in which domestic terrorist attacks actually occur, no one could possibly assume that the communication of similar ideas or others through film is any less responsible for contributing to the creation of that same environment. Instead of pointing the finger of blame toward one side or the other of the political spectrum, both should be held responsible. In any case, the forms of Hollywood bias in motion pictures criticized by Medved are not reiterated here. The focus in this book is on other Hollywood patterns of bias, patterns that are equally damaging to society, patterns of bias that were either overlooked or simply not addressed by Medved.

The material that follows relating to the resulting patterns of bias serves to demonstrate two additional results of the situation in which the control of Hollywood resides in the hands of a narrowly defined interest group: (1) it demonstrates how such control affects the kind of movies we see and (2) having seen these results (and moving in the opposite direction with respect to cause and effect), it provides additional support for the contention made in another of the books in this series on Hollywood: *Who Really Controls Hollywood*, that Hollywood is, in fact, controlled by a small group of Jewish males of European heritage, who are politically liberal and not very religious; a narrowly-defined group that is either making the kinds of movies its members want to see or making such movies it

is being pressured into making by various segments of the broader so-called "Jewish community."[1]

As reported in that book, the history of the upper level management of the major studio/distributors which have dominated the American motion picture industry during that century reveals relatively few examples of such positions being held by African-Americans, Latinos, women and others besides the previously identified Hollywood insider group. Gays, of course, present a special problem for analysis in that during most of that century, gay men were not likely to be openly gay. Thus, it is extremely difficult to determine whether there were some so-called "closet gays" in upper level management film industry positions who simply chose not to fight for positive portrayals of gays in movies for fear of revealing their own sexual orientation. Other than that possibility, the nearly 100-year history of Hollywood management suggests a positive correlation between who does not control Hollywood and who is consistently portrayed in a negative or stereotypical manner in American motion pictures.

If movies, to a great extent, mirror the values, interests and cultural perspectives of their makers, then it is possible to learn a great deal about movie makers by observing who and what things or places are consistently negatively portrayed in their movies. For purposes of this book, the term negative portrayals refers to the unfavorable or stereotypical depiction of someone or something in a motion picture. The underlying assumption is that it is absolutely wrong for the motion picture industry to consistently portray any

1 The book *Who Really Controls Hollywood* is by the same author. It analyzes and compares the various segments of the film industry to reveal where the real power resides (i.e., the power to determine which movies are made, who gets to work on those movies and the actual content of such films). The study concludes that such power, by and large, still rests in the hands of the top three studio executives of the so-called major studio/distributors. It then proceeds to analyze the backgrounds of the 226 such individuals who have held those positions throughout the history of the Hollywood-based U.S. film industry, ultimately determining that somewhere between 60 to 80 percent have been, and continue to be, Jewish males of European heritage, who are politically liberal and not very religious.

particular group of persons in a negative manner in its feature films, and in fact, such consistent portrayals actually rise to the level of private propaganda, since the Hollywood-based U.S. film industry is, after all, in private hands. Be that as it may, my studies and the work of others in this regard indicate that there are clear biases expressed in movies released by U.S. filmmakers.

One of those studies was conducted during the eight years prior to the publication of this book while lecturing on topics relating to "Film Finance," "The Business and Legal Aspects of Film Distribution," "The Relationship Between Economic and Creative Control in the American Motion Picture Industry" and "Motion Picture Industry Reform" under the sponsorship of the USC School of Cinema-TV, the American Film Institute, the USC Cinema-TV Alumni Association, the UCLA (graduate level) Independent Producer's Program, the UCLA Anderson Graduate School of Management Entertainment Section, UCLA Extension, IFP/West (now FIND), Cinewomen and other film industry groups. The people attending such lectures represented an international cross-section of film industry professionals and other persons interested in careers in the film industry, who were also avid moviegoers. Informal surveys of such classes were undertaken from time to time, asking the question: "Based on the movies you have seen during the past ten-year period, what racial, ethnic, cultural, religious, sexual preference and/or gender groups have been consistently portrayed in MPAA movies[2] in a negative manner? These informal survey results consistently included the following groups:

America	American Indians	American Institutions
Arabs	Asian Americans	Bi-Cultural Couples
Business	Capitalism	Gay/Lesbians
Establishment	Government	Hispanics
Japanese	Middle Class	Nazis

2 The survey question was limited to MPAA movies because their releases have for years consistently generated approximately 92% of the box revenues for theatrical releases in the U.S. Thus, the independent releases as a whole are not that statistically significant.

Police	Professionals	Rednecks
Religion	Texans	White Southerners
White Supremacists		

Such informal surveys again suggest that there is a positive correlation between the groups who publicly complain from time to time (see discussion below) about being portrayed in American movies in a negative manner and those groups perceived by a cross-section of moviegoers to be consistently negatively portrayed in American movies.

The literature of the industry also provides additional evidence of these same patterns of bias in our movies. Where applicable, references from industry literature are included in the study below. Further, this study is based on reviews of motion pictures covering the entire period of the existence of the Hollywood-based U.S. film industry, as those reviews appear in several publications[3] including Steven Scheuer's *Movies on TV and Videocassette Halliwell's Film Guide* and *Roger Ebert's Video Companion* (1994 Edition). In other words, the movies used as the basis of this study were not specifically selected for that purpose. Rather, the study primarily relies on the selections of several others who are not in any way related to this study.

3 Included among this group of described movies are some that are ostensibly British productions. They are included because it is extremely difficult to separate British movies from U.S. movies since the two industries have traded actors and directors back and forth for years, both are English-speaking countries, of course, some of the U.S. majors have owned British-based studios, production units and distribution facilities for years, funds from the U.S. have often been utilized to finance what might otherwise be considered a British production and a U.S. domestic distribution commitment may have been the critical financial element which allowed the film to be produced. In any case, the British productions that are included were released in the U.S.

Chapter 2

Race-Based Portrayals

Several of Hollywood's most blatant patterns of bias fall within the categories of race, ethnicity and/or national origin. Included in this group are negative and/or stereotypical portrayals of Arabs and Arab-Americans, Asians and Asian-Americans, Hispanics and Latinos, African-Americans, along with Native Americans.

Arabs and Arab-Americans—Arabs and Arab-Americans have often complained about being negatively portrayed in American movies, an obvious pattern of bias ignored by Medved in his important work *Hollywood vs. America*. In one of the most recent incidents of Arab-bashing, Walt Disney Studios actually changed two "lines of lyrics [sung by the movie's evil Jafar character] for the opening number 'Arabian Nights' in the animated smash *Aladdin*, following protests from the American-Arab Anti-Discrimination Committee." The lyrics referred to Aladdin's hometown, (i.e., a place "Where they cut off your ear/If they don't like your face/It's barbaric, but hey, it's home"). "But even toned down, Jafar instantly joins the ranks of the studio's most sinister villains."

The negative portrayal of Arabs in Hollywood movies, however, has been a consistent feature of American films for many years.[4] As early as 1921, *The Sheik* starred Rudolph Valentino in a film about "an oversexed desert royal who carries an English girl off to his tent." George Melford directed. Two years later (1923), Theda Bara was featured in *Salome* the original movie version of the "events leading up to (the) . . . famous dance of the seven veils." The Hollywood film "colony knew that the fatal vamp, being sold to the rubes as a French-Arab demon of depravity born beneath the Sphinx, was in truth Theodosia Goodman, a Jewish tailor's daughter from Chillicothe, Ohio, a meek little goody-two-shoes." A remake of the film starring Rita Hayworth was released in 1953.

In the 1924 release of *The Thief of Baghdad*, a thief "uses magic to outwit the evil Caliph." Raoul Walsh directed this early version. The film was remade in 1940 as a British production (produced by Alexander Korda; Ludwig Berger-Director); again in 1961 as a French/Italian production (Arthur Lubin-Director) and for television in 1978 (Clive Donner-Director). The 1924 version "includes a performance by Brandon Hurst "as the villainous caliph."

Two years later, (1926) *Son of the Sheik*, starred Rudolph Valentino and Vilma Banky in a "sequel to *The Sheik*. The film was "full of sandy fights, romance, chases, and escapes." George Fitzmaurice who emigrated to the U.S. from France in the early '20s directed . Karl Dane "played a shifty Arab."

The Mummy (1933) starred Boris Karloff and Zita Johann as "a reawakened Egyptian high priest . . . (who) reappears in the guise of Ardath Bey, an Egyptologist intent on slaying a young Englishwoman possessed by the soul of his dead princess lover." Karl Freund who emigrated to the U.S. in 1929 directed . The following year, in *Lost Patrol* (1934) a "British patrol is ambushed by hostile Arabs and picked off one by one." John Ford directed.

More stereotypical Arabs appeared in Universal's *The Mummy's Hand* (1940) with Dick Foran and Peggy Moran. The film is about "[t]wo archaeologists excavating Egyptian tombs" and they "inadver-

4 Note also how few of these films have been directed by Arabs or Arab-Americans.

tently trigger a mummy rampage." Jay Griffin directed.[1] Two years later, *The Mummy's Tomb* (1942) starred Lon Chaney and Dick Foran and Turhan Bey in a film about an "Egyptian fanatic (who) brings a mummy back to life, and sends it out to do his dirty work." Harold Young directed[1]. That same year, Walter Wanger (Feuchtwanger) produced the 1942 Universal release *Arabian Nights*. It continued the pattern of stereotypical portrayals of Arabs focusing on "the days of dancing slave girls, tent cities, and the Caliph of Baghdad."[1]

In 1943, the J. Walter Ruben production, distributed by MGM (*Assignment in Brittany*) was released. It contained gratuitous violence against an Arab, an "opening scene in which a Free French officer stabbed an Arab[1]." The following year, Everett Riskin produced the MGM release *Kismet* (1944). The film starred Marlene Dietrich in a "fable of poets and caliphs and poets' daughters." German born William Dieterle directed. Another version, directed by Vincente Minnelli, was made in 1955. It was "about the wise beggar and his beautiful daughter in old Baghdad."[2] Also, in 1944, *The Mummy's Ghost* (produced by Ben Pivar and released by Universal) starred Lon Chaney as the "gauze-wrapped mummy of Prince Kharis in America, searching for the reincarnation of his ancient love." Vienna-born Reginald Le Borg directed.[3]

The consistent stereotypical and negative portrayals of Arabs continued in 1947 (in the absence of positive portrayals) with *Sinbad the Sailor* starring Douglas Fairbanks, Jr., Maureen O'Hara, Walter Slezak, George Tobias and Anthony Quinn. In this film the "seafaring storyteller has adventurous experiences with a secret amulet and a beautiful princess." Steven Ames produced and Richard Wallace directed for release by RKO.[4] Halliwell's Film Guide refers to the film as an *Arabian Nights Swashbuckler*.[5]

Universal's *Casbah* (1948) is about a "criminal who hides from the law in the Casbah section of Algiers." The film was produced by German-born Erik Charell and directed by John Berry.[5] In *Bagdad* (1949) the "British-educated daughter of a tribal leader of the desert returns to her people after her father is murdered." The film was produced by Robert Arthur and directed by Charles Lamont.[6]

The stereotypical Arabian Nights adventures continue into the '50s with the Columbia release *The Desert Hawk*. This one features Jackie Gleason in "the supporting role of Aladdin." Mississippi-born B. Reeves Eason directed.[7] *The Magic Carpet* (1951) starred Lucille Ball and Raymond Burr "in the mystical time of Caliphs and Viziers" in what Steven Scheuer calls a "corny Arabian Nights farce." Lew Landers (Friedlander) directed.[8] Also, in 1951, *The Prince Who Was a Thief* stars Tony Curtis (Schwatz) and Piper Laurie in a "film about the plush pageantry of the Arabian Nights and the colorful Princes and Paupers who lived on opposite sides of the Masques." The film was produced by Leonard Goldstein and directed by Polish-born Rudolph Mate (Matheh).[8]

The 1952 Columbia release *Harem Girl* is described by Steven Scheuer as a "[t]ypically raucous and cheerful Joan Davis comedy set in an Arabian Nights locale."[8] Halliwell's says the story is about a "secretary to a princess (who) vanquishes her employer's Arab ill-wishers[8]." Edward Bernds directed. That same year, *Babes in Bagdad* (1952) starred Paulette Goddard in what Steven Scheuer calls a "[r]idiculous burlesque of Arabian Nights epics."[8] Halliwell's says the film was about a harem that "goes on strike." The film was directed by Vienna born Edgar G. Ulmer.

Also in 1952, in Universal's *Flame of Araby*, Jeff Chandler "dons the trappings of a desert sheikh who woos and wins the not-so-fiery princess Maureen O'Hara." Charles Lamont directed.[9] That same year, (1952) *Son of Ali Baba* starred Tony Curtis, Piper Laurie and Hugh O'Brian in what Steven Scheuer calls a "typical Arabian nights adventure with Curtis cast as the son of Ali Baba and Princess Azura." Kurt Neumann directed.[9]

The following year, *Saadia* (1953) starred Cornel Wilde, Mel Ferrer and Rita Gam in a film "set in Morocco where a young girl who believes she is a sorceress, a dashing leader of the Berber tribes, and a doctor engage in a war against plague and belief in black magic." Albert Lewin directed.[9] That same year, *Salome* (the remake) starred Rita Hayworth, Stewart Granger, Charles Laughton and Judith Anderson. It's the "story of Salome and the events leading up to her famous dance of the seven veils." William Dieterle directed.[9]

Also, in 1953, the film *Veils of Bagdad* starred Victor Mature, Mari Blanchard, Virginia Field and James Arness in what Steven Scheuer describes as another "typical Arabian Nights adventure." Stereotypes abound. New York born George Sherman directed.[9]

The 1954 release *The Adventures of Hajji Baba* is about "a barber longing for adventure." He "finds it when he rescues the daughter of the caliph." According to Steven Scheuer, the film is "played straight, which makes this Arabian Nights tale even funnier." The film was produced by Walter Wanger and directed by Don Weis[10]. Also, in 1954, MGM's *Valley of the Kings* starred Robert Taylor, Eleanor Parker and Carlos Thompson. It was an "adventure set in Egypt. Taylor plays an archeologist who accompanies Eleanor Parker and her villainous husband on an expedition to the tombs of Pharaoh Rahotep." Robert Pirosh directed[10]. That same year, (1954), RKO's *Son of Sinbad* was released, starring Dale Robertson, Sally Forrest and Vincent Price. In this film, "Sinbad is captured by a wicked caliph, (and) must perform arduous tasks to win his freedom." Ted Tetzlaff directed.[10] Warner's *Land of the Pharaohs* came out in 1955. It is an "account of the building of the pyramids," the story of "a visionary pharaoh saddled with an ambitious wife." Howard Hawks directed.[10] Also, that year, MGM's *The Prodigal* starred Lana Turner and Edmund Purdom in a "70 B.C." tale about "a wicked high priestess" who makes "it rough all over." The film was produced by Charles Schnee and directed by Richard Thorpe.[10]

In 1957, *Pharaoh Curse* starred Mark Dana and Ziva Rodann in the story of an "[a]rcheological expedition (that) encounters a monster from thousands of years ago in Egypt." Lee Sholem directed.[11] That same year, Paramount's *The Sad Sack* starred Jerry Lewis "in the army again, as inept as ever, getting mixed up with spies and Arabian intrigue." The film was produced by Paul Nathan and directed by Chicago-born George Marshall.[11]

In 1959, the British production of *The Mummy* starred Christopher Lee and Peter Cushing. The film was about "an archaeological dig where a mummy comes back to life to deal with the scientists disturbing its rest." The film was produced by Michael Carreras and directed by Terence Fisher, both born in London[11]. The

next year, (1960), *The Wizard of Baghdad* featured Dick Shawn and Diane Baker in the story of a "[g]enie without much talent (who) is ordered to settle down in his work (and), is assigned to Baghdad." George Sherman directed[12]. Also in 1960, *101 Arabian Nights* is "back in old Baghdad . . . (and) the nearsighted one is a lamp dealer whose nephew, Aladdin, gets the lamp with the genie." Jack Kinney directed.[12]

Paramount's *Escape from Xahrain* (1962) was about a "[r]ebel leader in an Arab oil state (who) escapes along with some fellow-convicts, and they make a dash for the border." London-born Ronald Neame produced and directed[12]. Also in 1962, Columbia's *Lawrence of Arabia* (actually a British production) was "about the legendary British officer and his exploits, military and nonmilitary, in Palestine circa WWI." Austrian-born Sam Spiegel produced and Britisher David Lean directed.[12]

In 1963 Detroit-born Richard Quine directed Columbia's *Siren of Bagdad*, an "Arabian Nights tale." The film starred Paul Henried, Patricia Medina and Hans Conreid.[13] That same year, *Blood Feast* (1963) featured "a crazed Egyptian caterer who carves up young girls to pay homage to his favorite goddess." New York-born Sam Katzman produced[13]. In 1964, The *Moon-Spinners* was a U.S./British production starring Hayley Mills, Joan Greenwood and Eli Wallach. It is a "Disney mystery about jewel thieves . . . (and) a young girl's misadventures in Crete." The film also features "silent-screen star Pola Negri . . . as Madame Habib, a shady buyer of stolen goods." The film was produced by Bill Anderson and directed by James Neilson.[13]

In 1965, 20th Century Fox's *John Goldfarb, Please Come Home* starred Shirley MacLaine, Peter Ustinov and Richard Crenna. Scheuer calls the film, produced by Steve Parker and directed by J. Lee Thompson, an "offbeat comedy set in a mythical Arabian principality."[13] The story is actually about an "American spy pilot (who) crash lands near the palace of a Middle Eastern potentate at the same time that a girl reporter arrives for an interview." That same year, in *Sword of Ali Baba* (Universal) "Ali Baba is forced from the royal court to become a king of thieves." Virgil Vogel directed.[14]

Also in 1965, Elvis Presley appeared in MGM's *Harum Scarum* as "a movie star who is kidnapped while he's on a personal appearance tour in the Middle East." New York-born Sam Katzman produced and Gene Nelson (born Gene Berg in Seattle) directed.[14]

UA's *Cast a Giant Shadow* (1966) was "about the Israeli-Arab conflict in the days when Israel first became a state. Kirk Douglas is . . . Col. Marcus, the legendary American soldier who helps shape up Israel's fighting force in 1948." New York-born Melville Shavelson, who in 1971 "published a book, *How to Make Jewish Movie*, about his misadventures while filming (this film) . . . in Israel . . . ,"[14] wrote, produced and directed[14]. Of course, the dreaded Arabs are the enemy. In 1967, the British production, *The Mummy's Shroud* was released. It was about "an archaeological exploring group (that) discovers a pharaoh's tomb and gets a curse put on them." Britisher John Gilling directed.[15] Two years later, 20th Century Fox's *Justine* (1969) tells the story of the "a mysterious wife of a well-to-do banker in 1930s Alexandria (who) becomes involved in Middle East politics." New York-born Pandro S. Berman produced and George Cukor directed with Joseph Strick.[15]

In 1974, Vienna-born Otto Preminger produced and directed UA's *Rosebud*, starring Peter O'Toole, Richard Attenborough, Cliff Gorman and John V. Lindsay. Scheuer says the film was "about politics, espionage, the C.I.A., the Israel-Arab war and dozens of other subjects[15]." In the film "[f]ive girls of wealthy families are kidnapped by the Palestine Liberation Army[15]." Producer/director Preminger is identified by the Katz Film Encyclopedia as being "Jewish."[16]

Twenty-One Hours at Munich (1976) starred William Holden, Shirley Knight and Franco Nero in a so-called made for TV movie about the "slaughter of the Israeli athletes by Arab terrorists during the 1972 Olympics." William A. Graham directed.[17] That same year, Marvin Chomsky directed *Victory at Entebbe* (1976), a made for TV movie starring Elizabeth Taylor, Kirk Douglas, Linda Blair, Burt Lancaster and Helen Hayes. The film was a "re-creation of the dramatic Israeli rescue of the hostages at Uganda's Entebbe Airport."[17]

Again, the point here does not relate to whether such movies should or should not have been made, but whether in the long run

they are balanced with movies portraying the Arab point of view. For example, from the Arab perspective, some would say that the only difference between Arab terrorism and Israeli terrorism is that the latter is state sponsored, which presumably provides more legitimacy in the eyes of many. On the other hand, if Israel and its powerful friends would allow the Palestinians to have a state, maybe their terrorism could also be more legitimate, at least in that same sense. Surely, the Arabs would love to have some of the deadly Israeli attacks on Arabs dramatized in a glossy American-made film with well-known American stars, but they simply do not have the opportunity, because the production and distribution apparatus in America is controlled by a small group of Jewish males of European heritage, who are politically liberal and not very religious, with loyalties quite naturally more aligned with Israel (see analysis in *Who Really Controls Hollywood*).

Also, in 1976, Richard Sarafian directed *The Next Man* (1976—produced by Martin Bergman) starring Sean Connery, Carnelia Sharpe and Albert Paulsen. The film is described by Scheuer as a "political thriller about Saudi Arabian diplomats, and the effort to kill *The Next Man*[17]." The plot actually involves the hiring of a "female assassin . . . to kill the Saudi Arabian Minister of State at the United Nations[18]." Surely this is an irresponsible film concept considering the ongoing conflict in the Middle East. The Katz Film Encyclopedia reports that Sarafian was New York-born of Armenian descent[19]. New York-born Martin Bregman produced and co-wrote the story.

In Paramount's 1977 release, *Black Sunday*, the "Arab guerrilla terrorist organization Black September plans to intimidate America by blowing up the Super Bowl (with a stolen Goodyear blimp) while the President is in attendance."[20] According to former Paramount studio chief Robert Evans (Shapera), the film's producer, the "Red Army of Japan threatened to blow up every theater around the world that exhibited *Black Sunday*. To them, it was sacrilegious to the plight of the Arab people." Notices were also "put up in Jewish-owned stores throughout the country calling for a boycott of the film."[20] The film was directed by John Frankenheimer[20] who was

born in New York "to a German-Jewish stockbroker father and an Irish Catholic mother."[20]

Also, in 1977, American producer Jerry Bruckheimer, co-produced *March or Die* (with the UK). The film starred Gene Hackman, Candice Bergen, Terence Hill, Max von Sydow and Catherine Deneuve "under the half-baked desert sun" in a story about "loyal Legionnaires fend(ing) off (an) attack by blood-thirsty, ubiquitous Arabs." Another American, Dick Richards, directed.[21] That same year, *Sinbad and the Eye of the Tiger* (1977) was a British film (distributed domestically by Columbia) starring Patrick Wayne, Taryn Power and Jane Seymour as "Sinbad searches for a prince who's been transformed into a tiger by a sorceress's evil spell." American Sam Wannamaker, directed.[22] The British produced another Arabian adventure released in the U.S. called *Arabian Adventure* in 1979. It was about a "wicked caliph [who] seeks ultimate power through a magical rose."[22]

As the '80s decade opened, Raymond Burr starred in *The Curse of King Tut's Tomb* (1980) "as the scheming villain . . . in dark makeup, wearing a towel on his head."[22] *Sphinx* (1981) starred Lesley-Anne Down, Frank Langella, Sir John Gielgud in a film about an Egyptologist who "finds herself in the thick of an intrigue involving stolen riches from ancient tombs." Tokyo-born Franklin Schaffner, "[t]he son of Protestant American missionaries" directed[23]. Also in 1981, Orion's *Rollover* starred Jane Fonda and Kris Kristofferson in a "thriller involving murder and intrigue in the world of high finance and exploring what might happen should Arab oil money be suddenly withdrawn from American banks instead of redeposited ('rolled over') as expected." Do people really believe that such powerful suggestions made through film do not influence the thinking of thousands in the audience? The film was produced by Bruce Gilbert. New York-born Alan J. Pakula, "of Polish-Jewish parents"[24] directed.

In the meantime, in 1981, the "April/May issue of *The Link*, a magazine published by an organization called 'Americans for Middle East Understanding', (was) . . . entirely devoted to attacking the media's negative portraits of Arabs, particularly in conjunction

with positive images of Israelis,"[25] exactly the kind of pattern of bias this film listing demonstrates.

One of the few films that provide a somewhat positive portrayal of Arabs was independently produced by Falcon International and directed by Moustapha Akkad. The 1981 release *Lion of the Desert* starred Anthony Quinn who (according to Steven Scheuer) "leads the local rebels against" Mussolini, who is "set to conquer Libya in the thirties."[28] The description found in Halliwell's Film Guide seems to favor the Italian fascists in the conflict, however, saying the film is about "an Italian general in Libya [who] withstands the attacks of rebel leader Omar Mukhtar. Halliwell's goes on to call the film a "[w]hitewashed account of the activities of a patriarchal partisan who was hanged in 1931" and that the film is "[o]f interest primarily to Arab zealots."[28] Would it then be equally fair and accurate to say that all of the rest of the films listed in this study (that portray Arabs in a negative or stereotypical manner) would primarily be of interest to "Jewish zealots"?

In the 1984 Warner release, *Cannonball Run II* a stereotypical Arab "sheik promises a million bucks to the winner of a cross-country car race."[28] The following year, Jeff Goldblum stars in *Into the Night* (1985) and gets "mixed up with Iranian bad guys after some stolen gems." Albert S. Ruddy produced and Chicago-born John Landis directed.[28]

Also in 1985, 20th Century Fox's *The Jewel of the Nile* starred Michael Douglas and Kathleen Turner in a "tale about a Holy War in the Middle East." Douglas, the son of Kirk Douglas (who was born in New York Issur Danielovitch to Russian Jewish peasant immigrants)[28] also produced and New York-born Lewis Teague directed.[28] In this film, a sequel to *Romancing the Stone*, the Turner character is invited "to travel with . . . (a) fabulously wealthy Arab (Spiros Focas) . . . to his homeland" for some very vague reasons. The Turner character "is quickly involved in danger as the Arab reveals plans to usurp the role of a legendary holy man (played by Avner Eisenberg), and (the) Douglas (character) becomes an ally of the great spiritual leader, who is known as the Jewel of the Nile."[28] That same year, Israeli Menahem Golan produced and directed (for Cannon) *The*

Delta Force (1985) The "chief terrorist" in the film is named Abdul. Ebert calls the film a thinly disguised dramatization of "the June 1985 hijacking of the TWA airplane and the hostage crisis after the passengers were held captive in Beirut."[28]

The 1986 Edward Pressman production, *Half Moon Street* starred Sigourney Weaver and Michael Caine in a movie that portrays stereotypical "rich Middle Easterners" and a plot having "to do with Middle Eastern intrigues, spy rings, terrorists, and plans to sabotage (a)... peace initiative[29]." The film was directed by Bob Swaim[30]. That same year, *The Sword of Gideon* (1986) was a so-called made for TV movie starring Steve Bauer, Michael York and Rod Steiger. The film tells a "story about a trained commando group hired to avenge the deaths of athletes massacred at the Munich Olympics in 1972." Michael Anderson directed.[31]

Also, in 1986, *The Tomb* starred Cameron Mitchell, John Carradine, Sybil Danning, Susan Stokey, Richard Alan Hench and Michelle Bauer in a story about "an Egyptian princess who reincarnates so she can acquire amulets needed to keep her revivable." Fred Olen Ray directed[32]. That same year, (1986), *On Wings of Eagles* presents a "businessman (who) decides to bypass diplomacy and the excuses of his government in order to set free two of his employees captured by the Iranians." Andrew McLaglen directed[33].

In the Harold Ramis directed *Club Paradise* (for Warner release—1986) "greedy Arabs" are thrown into the middle of a conflict between snobs and slobs on a tropical island.[34] The film was produced by Michael Shamberg.[35] Also, in 1986, *Popeye Doyle* tells the story of a man "involved... in a drug-homicide case that's linked to terrorism and the balance of power in the Middle East." Peter Levin directed[36]. The following year (1987), *Death Before Dishonor* (1987) features "a Marine gunnery sergeant (who) gets fighting mad after extremists hijack American weapons and kidnap his commanding officer in" [37] an Arab country."[39]

Columbia's 1987 release, *Ishtar* starred Warren Beatty and Dustin Hoffman as "a singing-songwriting duo who become involved in international intrigue when . . . ," according to Steven Scheuer, "they bring their rancid lounge act to the fictional Saudi

city of Ishtar[40]." On the other hand, Ebert says the plot of *Ishtar* involves "two . . . songwriters who dream of (making it big, but who actually) . . . perform bad songs badly before appalled audiences. Their agent gets them a gig in Morrocco, and once they're in Northern Africa, they become involved in the political intrigues of the mythical nation of Ishtar" exacerbated by the CIA[41]. Our film critics seem to disagree as to whether the film was set in Northern Africa or Saudi Arabia and as to whether Ishtar is a city or a country. In any case, the film was directed by Elaine May (born Elaine Berlin in Philadelphia) who as a "child . . . toured in several plays with her father, Yiddish stage actor Jack Berlin.[42]

In the meantime, Hollywood historian George MacDonald Frazer reported in 1989 that based on his studies, Hollywood movies about ancient Egypt "have helped to fix in the public mind the idea of old Egypt as a cult-ridden, curse-stricken land of mystery given over to embalming, necrolatry, interbreeding, and the worship of gods with animal heads[43]." Based on the above study, it would appear that Arabs in general are, in more modern times, most commonly portrayed in Hollywood films as terrorists.

Finally, as the '90s decade opened, and *Not Without My Daughter* hit the screens, film critic Roger Ebert, noted what he referred to as "moral and racial assertions (in the film) that are deeply troubling." The movie is about "a mother deprived of her child and her freedom by the rigid rules of an unbending religion (Islamic fundamentalism)." As Ebert reports, "[n]o Muslim character is painted in a favorable light." Instead they are portrayed as "harsh, cruel religious fanatics." Ebert states that the film "does not play fair with its Muslim characters." He says that if "a movie of such a vitriolic and spiteful nature were to be made in America about any other ethnic group, it would be denounced as racist and prejudiced." Ebert then suggests that "movies fueled by hate are not part of the solution[48]." Finally, after all the other anti-Arab movies included above, it took an extreme example of prejudice expressed through a movie released in 1990 for critic Roger Ebert to recognize how vicious Hollywood's prejudice and propaganda can be and has been (as di-

rected toward the Arabs) throughout the history of the Hollywood-based U.S. film industry.

Patrick Robertson reported that same year (1990), that "[w]hile the greasy, knife-toting Mexican, the shuffling, wide-eyed Negro and the perfidious American Indian have been discarded as offensive stereotypes, there is no such constraint on depicting Arabs as oily and oversexed or shifty-eyed and violent. Nicholas Kaldi is a US-based Iraqi who makes his living playing terrorists, but deplores the racial typecasting. 'There are other kinds of Arabs in the world', he said in a 1990 interview with the Washington Post. 'I would like to think that some day there will be an Arab role out there for me that would be an honest portrayal.'"[49]

Hollywood has not seemed to pay much heed to Robertson, Ebert or Kaldi, however. As reported above, in Disney's *Aladdin* (1992) "[m]ost of the Arab characters have exaggerated facial characteristics—hooked noses, glowering brows, thick lips—but Aladdin and the princess look like white American teen-agers[50]." Also, in 1992, Vidmark's *Beyond Justice* features "a former CIA hotshot (who is) hired by a wealthy woman (Carol Alt) to rescue her kidnapped son. The mission takes them to Morrocco, on the trail of an Arab warrior (Omar Sharif) who is keeping the little boy captive somewhere in the Sahara."[51]

In 1993's *Hot Shots! Part Deux*, Charley Sheen stars in another David Zucker, Jim Abrahams and Jerry Zucker sendup. This movie has the hero on "a mission to rescue hostages from a Hussain-like dictator[53]." Also, the 1993 Warner Bros release *The Pelican Brief* (starring Julia Roberts and Denzel Washington) "opens with two Supreme Court justices murdered on the same night by a contract killer named Khamel (Stanley Tucci)."[56]

Even more recently, the 1994 release *True Lies* starring Arnold Schwarzenegger and Jamie Lee Curtis, portrayed Arab terrorists as cardboard characters and idiots. Also, in the 1994 release *Little Odessa*, a Mafia hitman of Russian-Jewish heritage is contracted to erase an Iranian jeweler" and the "Iranian contract is carried out."[60] Hollywood must hope that all of the Arab viewers of these propagandistic movies are reasonable and broad minded enough to per-

ceive them as mere entertainment and not the vicious anti-Arab propaganda that they are. Otherwise, Hollywood has created its own time bomb with such a blatant pattern of racist or religious-based bias.

As 1995 got underway, and the tragic Oklahoma City bomb blast occurred, many news commentators and others were quick to point an accusatory finger at Middle East terrorists and Muslim fundamentalists. One Arab-American spokesman, when asked why people in the U.S. were so quick to lay blame on Arabs, included in his response a short list of recent Hollywood movies that included negative portrayals of such persons. Much of our nation's population, including political leaders and the press, had been seduced by Hollywood propaganda.

In summary, Hollywood, throughout its history, has portrayed Arabs as evil, barbaric, oversexed, depraved, villainous, shifty, possessed, hostile, fanatical, criminal, mystical, wicked and crazed. Arabs have also been portrayed as thieves, shady, kidnappers, enemies, mysterious, murderers, assassins, terrorists, blood-thirsty, saboteurs, extremists, cult-ridden, curse-stricken, oily, shifty-eyed, violent and as idiots.

This review of Hollywood movies involving Arab characters clearly demonstrates that the U.S. film community consistently portrays Arabs in a stereotypical or negative manner and that little or no effort has been made by Hollywood filmmakers to balance their portrayals of Arabs with positive portrayals in the same movies or a similar number of positive portrayals in other movies. Thus, the overall presentation of Arabs in American movies is clearly one sided, clearly negative, and propagandistic to that extent. In my view, there is nothing more unethical in the extreme than to see a specific population such as that small group of Jewish males of a European heritage, who are politically liberal and not very religious, using the power of the moving image in American motion pictures to consistently portray some of their long suffering arch enemies in a negative manner, thus, in effect seeking to brainwash the American and world publics with a very powerful form of propaganda.

Research Projects—How many of the above cited films, which appear to negatively or stereotypically portray Arabs, were written, produced, directed or financed (with significant creative control) by Arabs or Arab-Americans? How many movies has Hollywood produced and released that contain only positive portrayals of Arabs or Arab Americans?

Asians and Asian-Americans—Asian-American groups have also protested from time to time about their portrayals in Hollywood movies. As noted in the book *Movies and Propaganda*, Hollywood's anti-Japanese films of World War II, were often "blatantly racist."[65] For example, the 1942 Warner Bros. film *Across the Pacific* dealt with Japanese treachery before Pearl Harbor, and as stated by Harry Warner, was "one of the first films to depict our Oriental enemies[5] as cold, calculating and ruthless, completely efficient and not at all the nearsighted, weak and stupid enemy who can be 'knocked off the map in six weeks.'"[66]

In any case, as recently as 1990, the Japanese movie *Black Rain* (directed by Shohei Imamura) told "the story of survivors of the Hiroshima atomic bomb who were contaminated by the fallout[73]." The movie was not released, however, in the U.S. until a year after is premiere "at the Cannes Film Festival in May 1989 . . . ," ostensibly to avoid confusion with "the 1989 Michael Douglas thriller of the same name" that portrayed "a canny, aggressive (Japanese) society with (modern) criminals."[74] Aside from the fact that U.S. filmmakers have only rarely focused attention on the Japanese experience in World War II, and that foreign films generally do not get much exposure in the U.S., in this case, the U.S. film industry went one

5 It is also interesting to note that even though the Japanese have consistently been portrayed in a negative or stereotypical manner in U.S. movies, far more films since World War II have featured Nazi villains as opposed to Japanese villains. The U.S. fought both the Nazis and the Japanese in that war, thus we could reasonably expect that both would receive fairly equal treatment as movie villains in the years following the war. This imbalance, however, seems to suggest a correlation between the facts that Jews were significantly harmed during World War II by the Nazis as opposed to the Japanese and that Hollywood is controlled by Jewish males of European heritage, thus their cultural bias appears to be showing through in such movies.

step further and effectively preempted an audience for the Japanese film by presenting a negative portrayal of Japanese society through a film with the same name, prior to the release of the Japanese film in the U.S. Was this an ironic accident or another example of Hollywood hardball?

In addition, recent Hollywood movies have continued the negative and stereotypical portrayal of Asians and Asian-Americans. For example, *1,000 Pieces of Gold* (1991) was a movie about the fact that "years after slavery was abolished in America, Asians were still held in involuntary servitude." According to film critic Roger Ebert, the movie "paints an overwhelmingly negative portrait of Chinese men . . . [t]he only man portrayed positively in the film is . . . [a white man] — Charlie" (played by Chris Cooper).[75] The following year, many Asian-American groups held a "nationwide protest against the movie *Rising Sun*, saying the film could incite a wave of anti-Asian violence."[76] "Michael Crichton's 1992 thriller (was) about two L.A. cops who uncover a Japanese business conspiracy." The film "met with a storm of controversy . . . (and) was attacked by Asian groups who said it perpetuated the book's Japan bashing."[80]

In March of 1993, a Korean-American coalition blasted the Warner Bros. film *Falling Down* for its "portrayal of minorities—a prime target of Michael Douglas' character, an unemployed defense worker who goes on a gun-toting tirade[83]." The Joel Schumacher directed film features Douglas as "a crew-cut white man" going berserk due to the pressures of work and urban life. Douglas then takes his frustrations out on a series of African-Americans, Latinos, Koreans and other whites including "a neo-Nazi gun-shop owner."[87] As John Simon also reports, "Korean and Hispanic protestors" demonstrated outside movie houses presenting this feature.[87]

It is difficult to tell with this movie, who ought to be offended the most—the crew-cut white men Douglas is supposed to represent, or his many victims. On the other hand, it may be that the Korean and Hispanic protestors were mostly concerned about movies which suggest that a remedy to frustration is to start shooting at minorities. That was the same concern expressed by Jewish groups who objected to the movie *Crossfire* back in 1947.

Some may fail to be persuaded by this small sampling of anti-Asian films, that such a bias exists in Hollywood. On the other hand, such counter-arguments need to be supported by a similar number of Hollywood films that provide a positive portrayal of such persons. The record reflects that Hollywood's portraits of Asians includes portraying such persons as enemies, cold, calculating, ruthless, aggressive, criminal, slave owners and as conspiring businessmen.

Hispanics and Latinos—Hollywood motion pictures about "the Latino experience in America seem ineluctably tied to despair, whether rooted in the lives of East Coast Cubans, and 'Newyoricans,' of West Coast Chicanos, or of other groups in other places . . . " according to *Entertainment Weekly's* Ty Burr[89]. Burr goes on to report that the "link between such disparate films as the fablelike *The Ballad of Gregorio Cortez*, the shimmeringly tragic *El Norte*, the worshipful *La Bamba*, and the cautionary *Crossover Dreams* lies in their knowledge of assimilation's paradox: that you can live the American dream only by losing your cultural soul."[93]

Other Hollywood films with Hispanic or Latino characters seem to exhibit the same pattern of bias. For example, *The Ring* (1952) stars Gerald Mohr, Lalo Rios and Rita Moreno in the story of a "Mexican lad from the Los Angeles slums (who) is turned into a boxing prospect, (but he) gets too cocky as a result." Kurt Neumann directed.[94]

The Tijuana Story (1957) starred James Darren and Joy Stoner in a "drama about a youth's involvement with the 'drug traffic' in the open city of Tijuana." Leslie Kardos directed.[95]

In the '60s, *The Appaloosa* (1966) featured Marlon Brando "pitted against a Mexican bandit."[97] *The Professionals* (1966) starred Burt Lancaster, Lee Marvin, Claudia Cardinale and Jack Palance in a story about a man who hires another "to fetch his allegedly kidnapped wife . . . back from Mexico where she has been taken by bandito Jack Palance." Richard Brooks directed.[98] *Backtrack* (1969) was about a man who "is sent . . . to pickup a bull in Mexico. On the way he runs into mucho mean hombres."[99] Also, *Viva Max!* (1969) starred Peter Ustinov, Jonathan Winters, Pamela Tiffin and Keenan

Wynn in the story of "a modern-day Mexican general with a thick accent, (who) leads a scraggly group of men over the border and into the Alamo, reclaiming the tourist attraction for his homeland." Jerry Paris directed[100]. Finally, in 1969, *The Wild Bunch* starred William Holden, Ernest Borgnine, Edmond O'Brien, Warren Oates and Robert Ryan in a film about "violence on the Texas-Mexican border . . . (as) a cynical band of outlaws join . . . a rebel Mexican general against law, order, and the Mexican army." Sam Peckinpah directed.[101]

In the '70s, *Cannon for Cordoba* (1970) starred George Peppard as the head of "a contingent of soldiers safeguarding the Texas border in 1912[102]." In *Breakout* (1975) Charles Bronson "plays a helicopter pilot who engineers the escape of a falsely accused prisoner from a Mexican prison[103]." *Walk Proud* (1979) starred Robby Benson and Sarah Holcomb with Benson as a Chicano who falls in love with well-off WASP Holcomb." The film presents the story of "a gang member and his conflicts in the Los Angeles barrio." Robert Collins directed. The film was written by Evan Hunter[104]. Also, in 1979, *The Streets of L.A.* was another so-called made for TV movie starring Joanne Woodward and Fernando Allende in the story of "a harried Los Angeles realtor, a plucky middle-aged divorcee worn down by life's slaps in the face. When her tires are slashed by Chicanos, she invades the Barrio to demand repayment." Jerrold Freedman directed.[105]

Finally, in 1983, film critic Ebert is able to report that *El Norte* is one of the "rare films that grants Latin Americans full humanity." The film "tells the story of two young Guatemalans . . . and of their long trek up through Mexico to el Norte—the United States. Their journey begins in a small village and ends in Los Angeles, and their dream is the American Dream." Ebert says the picture is the first "to approach the subject of 'undocumented workers' solely through their eyes." Not surprisingly, the film was "made entirely outside the (Hollywood) studio system." [107]

Back to business as usual in 1988, *Spike of Bensonhurst* was a movie about the "domestic arrangements of a middle-class Mafia household." It seeks to generate humor by painting "broad racial

stereotypes" and some of those who saw it complained that it was nothing more than an "extended racist slur against . . . Puerto Ricans," among others.[108]

In 1991, the Warner Bros. feature *The Mambo Kings* focused on two Cuban musician brothers who were trying to cross over to Anglo audiences. The film is directed by "a non-Hispanic neophyte" (although an experienced producer) and one of the two lead roles is played by an actor of Italian-Irish heritage, not Spanish.[109] The next year, the Edward James Olmos movie *American Me* (1992) tells a story about Mexican-Americans in Southern California. That sounds promising enough at first blush. But the story traced "the sordid life of [a] jailhouse drug kingpin."[109]

In a 1992 interview, young Hispanic filmmaker Robert Rodriguez complained that there are not enough "positive Latin roles" in Hollywood films.[109] Rodriguez subsequently stated that he was anxious to create more Hispanic characters. "Growing up Mexican American," he said, "the role models I had were Cheech & Chong. If I want to see myself depicted differently, I have to go out and make my own films, because nobody else really cares."[112]

Buena Vista's 1993 offering, *Blood In Blood Out*, seems "preoccupied with capturing the feel of Latino culture and life in East Los Angeles" while also "detailing a bloody prison gang war (and) . . . exploring the tough choices and different paths that can lead to salvation or tragedy in the inner city."[114] Also, that year, *Bound by Honor* (1993) tells the story of "a young man with a white father and a Chicano mother, who fights for acceptance by the barrio gangs of East Los Angeles." In addition to showing a stereotypical view of East Los Angeles, the movie shows that "prisons are divided into three camps: the Chicanos, the blacks, and the whites, who are . . . portrayed as racist, although in fact they're exactly as racist as the others[115]." *Bound By Honor* traces "the intertwined fortunes of three Hispanic toughs who have been raised in the inflammatory criminal culture of East L.A."[115] True to form, the Sylvester Stallone/ Sharon Stone film *The Specialist* (Warner Bros.—1994) features an entire cadre of Latino drug dealer villains. The film was produced by Jerry Weintraub, directed by Luis Llosa with the screenplay by

Alexandra Seros. The film also starred James Woods, Rod Steiger and Eric Roberts.

Again, Hollywood movies have consistently portrayed Hispanics/Latinos in a negative or stereotypical manner. These people have been portrayed as cynical, gang members, in despair, kidnappers, macho, mean, prison inmates, racists, scraggly, tire slashers and violent. Such a pattern of bias appears to be a direct result of the systematic exclusion of Hispanic/Latinos from positions of authority in the Hollywood power structure. After all, if there were more Hispanic/Latinos in decision-making positions at the studios, surely it would follow that more films would include better informed and more sensitive portrayals of such populations. This explains why widespread employment discrimination in Hollywood contributes to a narrowly focused perspective represented in Hollywood films.

African-Americans—Eddie Murphy's "moral outrage about the treatment of blacks in the motion picture industry led to two remarkable protests. At the 1988 Academy Awards show, Eddie was the presenter for Best Picture . . . he delivered an unscheduled, rambling diatribe against the Hollywood establishment. An angry Eddie announced to shocked viewers that he almost did not show up, because 'they haven't recognized black people in motion pictures,' only three blacks have won Oscars in over sixty years. At this rate (Eddie said), 'we ain't due until 2004.' A year earlier, Eddie had refused to pose for Paramount's seventy-fifth anniversary group photo of the studio's great stars "because he thought there would be no other blacks in the photo." Actually there was one other, Lou Gossett, Jr., although that is clearly not enough to suggest that Eddie Murphy's original sentiment was in error.[115]

Of course, Hollywood has a long history of portraying African-Americans in a negative or stereotypical manner, pre-dating World War II. The federal government's Office of War Information, reported during the war, however, that one of the "most serious home-front problem[s]" with respect to film during WWII, related to "the portrayal of blacks." The OWI said, "Hollywood found it difficult to abandon its time-worn demeaning portrayals of blacks."[118]

As screenwriter Dalton Trumbo stated, the "movies made 'tarts of the Negro's daughters, crap shooters of his sons, obsequious Uncle Toms of his fathers, superstitious and grotesque crones of his mothers, strutting peacocks of his successful men, psalm-singing mountebanks of his priests, and Barnum and Bailey side-shows of his religion' . . . In an analysis of the depiction of blacks in wartime movies in 1943, (OWI's Bureau of Motion Pictures) . . . concluded that 'in general, Negroes are presented as basically different from other people, as taking no relevant part in the life of the nation, as offering nothing, contributing nothing, expecting nothing.' Blacks appeared in 23 percent of the films released in 1942 and early 1943 and were shown as 'clearly inferior' in 82 percent of them . . . The biased portrayals undermined black war morale at home and hurt America's image abroad."[118] Further, "a Columbia University study in 1945 found that of 100 black appearances in wartime films, 75 perpetuated old stereotypes, 13 were neutral, and only 12 were positive."[118]

In 1957, however, Harry Belafonte "became the first black matinee idol." On the other hand, "when he played Joan Fontaine's love interest in *Island in the Sun*, (1957) Darryl Zanuck refused to allow them to kiss, insisting that no scene demanded it."[118]

As noted earlier, in 1963 "the National Association for the Advancement of Colored People (NAACP) . . . threw the full strength of its national organization into the fight against racial bias in movies with threats of mass demonstrations and economic and legal offensives."[118] Unfortunately, the effort had little lasting effect.

The following year, *The Horror of Party Beach* (1964) included a stereotypical portrayal of a "black maid (Eulabelle Moore) who keeps repeating 'It's da voodoo' and thus according to film critic Steven Scheuer, "undoes decades of work by the NAACP." The film was directed by Del Tenney.[126] *The Take* (1974) starred Eddie Albert, Billy Dee Williams and Vic Morrow in the story of "a semi-crooked black cop who accepts bribes but won't take any guff from the syndicate kingpin ruling the local ghetto." (Robert Hartford-Davis-Director).[126]

Paramount's film *White Dog* was "completed in 1982 (but) . . . was withheld from domestic release, mostly due to pressure from NAACP leaders, who felt the film promoted racism." The film "concerns a German shepherd trained to attack blacks." Apparently "there have been and perhaps still are some real white dogs, which is truly appalling, but, according to the Hollywood Reporter, "this 'White Dog,' other than bringing this truth out in the open, is much less powerful than the bigotry that inspired it."[126]

A subsequent movie co-produced and directed by Steven Spielberg *The Color Purple* presented on screen "Alice Walker's raw, angry, black coming-of-age story set in the first half of this century. The 1985 movie was simplistic, critics felt, overlaid with a pretty, Hollywood gloss."[127] Regardless of what the critics say, would this movie have been made without Steven Spielberg? But, even more important, would the movie have been made differently if a black man or woman had been its director? This raises the question of whether the film industry is guilty of imposing a cultural bias on its interpretation of the human experience.

Movie critic Roger Ebert says that Spike Lee's *Do the Right Thing* (1989) "comes closer to reflecting the current state of race relations in America than any other movie of our time."[135] This comment by Ebert confirms the position of all interest groups who have been consistently excluded from the inner circles of decision-making in Hollywood, in that it says if you want a fairly accurate portrayal of such a group in a given movie, the picture should be made by members of that group; a statement which on the flip side points up the central defect of the present Hollywood system which is controlled by a small group of Jewish males of a European heritage who are, as a general rule, politically liberal and not very religious (again, see analysis in *Who Really Controls Hollywood*). By the very nature of modern film, it is virtually impossible for any such narrowly-defined cultural group to accurately interpret and portray other cultures. That does not keep the Hollywood filmmakers from trying, however. In 1991, The Samuel Goldwyn Co. released *Straight Out of Brooklyn*, which according to the *Hollywood Reporter*, "offers a close-up look at the lives and aspirations of African-Americans sentenced

to inner-city tenement dwelling...(and) a deep family crisis climax in a botched crime."[136] Also, in 1991 *Boyz n the Hood* (Columbia Pictures) is a "depiction of young black male survival in South Central Los Angeles." The film traces "the growth of one bright black boy...from elementary school to his senior year in high school in 1991 (by providing)...a portrait of (the) minute-by-minute struggle as...(he) must endure not only the common adolescent hangups but...keep from being gunned down."[139]

Meanwhile, that same year, former Secretary of the Army Clifford Alexander told a U.S. Senate panel probing the problems of black males in 1991 that "[n]egative images of blacks are fed by portrayals of blacks in movies, television and elsewhere."[143] Also, in 1991, the Coalition Against Media Racism in America issued a statement that [the movies]...*Jungle Fever* and...*Boyz n the Hood* are among the features targeted for a boycott called by [that]...coalition of diverse mainstream black groups...[who claimed that] films perpetuate black stereotypes."[144] Of course, the claim is accurate, but it takes more than protest by a single group to influence Hollywood.

As 1992 got underway, the film *Trespass* (a Universal release) starred rappers Ice-T and Ice Cube "as gang members out to defend their terrain."[146] Pierce O'Donnell and Dennis McDougal subsequently quoted Eddie Murphy in 1992, saying, that a "lot of blacks feel [the studios] don't want blacks to be portrayed as sexual on film."[148] That same year, a considerable amount of tension on the set was generated during the production of Disney's *Sister Act*. Star Whoppi Goldberg was reportedly "upset by what she calls 'stereotypical' dialogue and a scene that called for her character to steal." Goldberg also said "Disney treated her 'like a nigger' and (in response) she printed up blackface Mickey Mouse T-shirts reading 'Niggerteer' for the cast and crew."[149]

In an interview appearing in the Josephson Institute's *Ethics* magazine (1993) Dr. Prothnow-Stith stated:

> "I think that when you are only using characters of color, black or Hispanic, to depict negative influences or stereotypical influences, when you fail to use [them] to represent everyday charac-

ters you are contributing to an over-burdened situation, a group overburdened with stereotyped images . . . There's a willingness to portray the negativeness in an 'other' whether that person is 'other' by race or by gender. The danger in that is you make me and my community more of an 'other' for the rest of America."[149]

Dr. Prothnow-Stith went on to state that "as an African-American Protestant, I was particularly offended by the genre of movies that made buffoons of black preachers. Knowing the black church as critical to liberation in this country, knowing black preachers who run the gamut, including intellectual people, I was offended by this kind of regular portrayal." Dr. Prothnow-Stith went on to get at the heart of the problem by pointing out: "I never saw a movie where a rabbi was a buffoon character."[153]

Despite those comments, the treatment of African-Americans by Hollywood did not seem to improve in 1993. The *Amos & Andrew* movie told the story about "[u]pper-crust types [who] spot a black man . . . in one of their town's palatial homes and assume he's a robber."[154] Film critic Roger Ebert calls the film "a comedy about a wealthy African-American playwright who is mistaken for a burglar simply because he is black." Ebert says the "movie is trying to use this basic set up to say that we "cannot judge a man by the color of his skin."[154] As *Variety* reports, however, the movie, in effect "attempts a satire of contemporary racism that employs strictly stereotyped characters and typecast actors."[154] Obviously, when it comes to the consistent use of negative and stereotypical portrayals in movies about others, that small group of Jewish males of European heritage who control Hollywood simply do not get it.

Native Americans—Although a few somewhat more sympathetic portrayals in movies have occurred in recent years, American Indians have long been victims of the Hollywood stereotype. By 1964, Marlon Brando was making appearances at protests on behalf of American Indians. In 1973, when he won the Best Actor Academy Award for his portrayal of Vito Corleone, he "sent an Indian woman named Sacheen Littlefeather to reject the award, saying he could not accept it 'because of the treatment of American Indians in the

motion picture industry, on TV, in the movie reruns and the recent happenings at Wounded Knee.'"[154]

On the other hand, two more recent films, serve as examples of a change in Hollywood's portrayals of native Americans. Joe Roth's *Young Guns* (Morgan Creek, 1988) graphically throws in the theme of mistreatment of native Americans as the cowboy/outlaw gang member Lou Diamond Phillips describes how his mother, family and tribe were slaughtered by white men. Also, *Dances With Wolves* (1990) "is ostensibly about the nobility of the Sioux; even more, however, it's about how noble (Kevin) Costner's Lt. Dunbar is for recognizing the nobility of the Sioux." On the other hand, Peter Ranier asks, "why hasn't anybody cared, in this supposedly pro-Indian movie, how horribly the rival Pawnee Nation is portrayed? These whooping, scalping heathen look like punksters out of *The Road Warrior*." This is a movie where "New Age meets Old Hollywood."[154]

Even as recently as 1992, however, native American spokesperson Russell Means, in an Entertainment Weekly article, criticized Hollywood's depiction of Native Americans, from the films of the '40s to *The Last of the Mohicans*. In the same article, Means said the "educational system of the dominant culture doesn't let our children know that American Indians existed in the 20th century."[157] He went on to say that "[t]here's a danger in letting Hollywood define us." Of course, there is a danger in letting any narrowly defined interest group use a powerful communications medium to define any of us.

As George Fraser points out, a "stranger with no knowledge of U. S. history save what he got from films . . . would be puzzled at the change in status of the Indians, from the perpetual enemy, a mixture of noble savages and murderin' red varmints, into oppressed and cheated defenders of a precious culture—the conflicting images are all true, but the fashionable viewpoint has changed."[158]

CHAPTER 3

Sexual Stereotypes

Hollywood movies also have a tendency to exhibit consistent biases relating to sexual stereotypes. Two of the most blatant include the industry's treatment of women and its portrayals of gays and lesbians.

Women—Women have not fared much better than other minorities in the male dominated U.S. film industry. According to novelist Meg Wolitzer, "[m]ovies that address the complex emotional lives of girls are rare . . . " although "one of the few that did was Alfred Hitchcock's *Shadow of a Doubt* (1942) starring a very young Shirley MacLaine. "Unlike any other movie in Hitchcock's body of work (Wolitzer says), the emotional core of *Shadow of a Doubt* rests with an adolescent girl[158]." Of course, Wolitzer goes on to point out that Hitchcock's films as a whole reflect a "wrongheaded and . . . offensive . . . screen interpretation of women." She also says "misogyny and sheer ignorance about women abound in . . . movies . . . " generally, but that "many of Hitchcock's films contain a distinctly perverse brand of naivete[158]." Alfred Hitchcock's "movies seemed to lay the blame on women for stirring uncontrollable passions in men."[158]

In novelist Francine Prose's essay for the David Rosenberg book *The Movie That Changed My Life*, she writes about her favorite childhood movie *Seven Brides for Seven Brothers* (1954) which she came to realize as an adult was about "civilization and sex, about gender and socialization, about the civilizing mission of women . . . and the social necessity of rape." As Ms. Prose points out, in the movie "seven lusty mountain men decide they're needin' wives and just go down to town and throw blankets over the girls and toss 'em over their shoulders and take 'em back home to the mountains." Ms. Prose states that as an adult she was "astonished and shocked to see that a beloved childhood film was a glorification of rape." But she says, "what's more shocking is how much of our culture has changed very little indeed. One could (tediously list the major studio films, released every week, that endeavor to entertain by doing fairly frightful things to women. . . One could write books (and books have been written) about the ways in which the brutal treatment of women is not taken seriously or viewed as a critical social problem."[159]

Roger Ebert subsequently reports that *The Gambler* (1974) is "still another demonstration of the inability of contemporary movies to give us three-dimensional women under thirty[160]." It is also true that some movies not only provide negative portrayals of women, but negative portrayals of specific types of women. The movie *Arthur* (1981), for example, starred Dudley Moore as a wealthy alcoholic looking for love in Manhattan. "Arthur would like to marry Linda (Liza Minnelli), but his billionaire father insists that he marry a perfectly boring WASP (Jill Eikenberry) whose idea of a good holiday is probably the January white sales"[160]. Of course, this film is also an example of an anti-WASP movie.

In 1986, audiences were treated to *Rate It 'X'* which was described by Steven Scheuer as a ".narrowminded documentary, exploration of sexism in America that's composed entirely of interviews with men." The film was directed by Lucy Winder and Paul de Koenigsberg[160]. Ebert reports, however, that *Skin Deep* (1989) is an exception to the general rule that women are typically portrayed in a negative manner in Hollywood movies. In this film, starring

John Ritter and Alyson Reed, the women "all have something in common—they're interesting, opinionated individuals."[161] On the other hand, according to Princeton University professor Russell Banks, "Disney's *The Little Mermaid* (1989) is "essentially a drama-tized tract designed to promote the virtues and rewards of female submissiveness and silence."[161]

Problems with portrayals of women in Hollywood films contin-ued into the '90s. In *Wild at Heart* (1990) and several of his other movies, director David Lynch "uses his power as a director to por-tray women in a particularly hurtful and offensive light."[161] Also, the "only consistent theme of..*The Last Boy Scout* (1991) . . . is its hatred of women." The movie's "message is that a man can only really trust another man."[162] Also, according to a study conducted by Terry Kay Diggs, when women are portrayed as lawyers on screen, "Holly-wood typically changes the rules . . . Male lawyers play by the rules, discover truth and restore order. Female lawyers are outside the law, cloud truth and destroy order."[162]

Variety reports that "[a]fter coming across as a potentially three-dimensional working woman." Ellen Barkin's character in *This Boy's Life* is "placed squarely on the sidelines once she marries Dwight (played by Robert De Niro).[163] The rest of the movie is about the relationship between De Niro the step-father and the Barkin char-acter's son. Also, in 1993, and according to *Entertainment Weekly*, Al Pacino's role in *Scent of a Woman* reminds that "men have seldom been blind in movies. Sightlessness has been portrayed mostly as a feminine affliction."[163]

In actress Michelle Pfeiffer's speech at the Women in Film awards ceremony (1993), she "took aim at Hollywood for movies in which women were 'sold' to men, like *Pretty Woman* (1990), *Mad Dog and Glory* (1993), and *Indecent Proposal* (1993)."[164]

Academic Elisabeth Joyce, in her study of violent women in re-cent movies, concludes that such examples underline a depressing paradox: "that women of violence may appear in films and may on first look seem to be harbingers of a new social order which accepts women as equals in the power game, or which in fact presents the

patriarchy as giving way to female power, but which in reality only reaffirm the patriarchy and put women in their secondary place in the social order, a place which is in further reintrenchment."[166]

Finally, in December of 1994, the Warner Bros. release *Disclosure* (starring Michael Douglas and Demi Moore) tells the story of "a man accused of sexual harassment in the workplace" who, in fact, is himself the victim.[169] Following its release, women rightfully complained that Hollywood's first big-budget movie on the topic of sexual harassment in the workplace, portrayed a woman as the aggressor and the man as the victim, exactly the opposite of the more typical situation in the real world.[171] Barry Levinson produced and directed the screenplay written by Paul Attansio. Thus, with all of the progress for women in the rest of U.S. society, Hollywood still seems to be well behind the curve.

Gay/Lesbians—Gays and lesbians have also been victimized by consistent negative and stereotypical portrayals in American films. For example, *The Boys in the Band*, released in 1970 was about "a gay birthday party" in which the characters exhibit "the qualities of pathos, bitchiness, loneliness and jealously."[172] The 1976 release *Up* starred Robert McLane, Janet Wood, Raven de la Croix, Monte Blane, Foxy Lae, and Francesca 'Kitten' Natividad in what Steven Scheuer calls a "[m]ock Shakespearean murder mystery about some Nazis, a Southern sheriff, a pilgrim, trucker lesbians, a killer piranha, and a big-chested, one-woman Greek chorus (Natividad), who runs around the forest in the nude."[172] Russ Meyer directed.

That same year, (1976) a western comedy, *The Great Scout and Cathouse Thursday*, was "inhabited by such characters as a lesbian madam, a half-breed Indian who's a Harvard graduate, a teenage prostitute, and a money-hungry Indian scout, among others." (Don Taylor-Director)[173] Avco's 1978 release, *A Different Story*, was a "love story of a gay man and a lesbian woman who are thrown together by circumstances, come to feel a great deal for each other, get married, and have a baby."[173] This is not exactly the preferred scenario from the perspective of gay and lesbian individuals. The film thus appears to be another attempt to take away from gays and lesbians.

In 1980, "[g]ay activists protested and rioted over . . . (Friedkin's *Cruising*. . . " The film negatively portrayed "male homosexuality as a murderous impulse that can be 'caught' like a disease."[173] Scheuer says the film's director actually "pussyfoots around the gay subject matter . . . (in telling a story about a) policeman (who) may or may not be taking on the identity of a killer he's pursuing in a case involving the brutal slayings of homosexuals in New York City. William Friedkin directed[173]. Although, coming about 33 years later, this film should satisfy Steven Scheuer's preference for seeing movies about homosexual murders as opposed to murderers of Jews (see the discussion re the 1947 film *Crossfire* at "Stories and Portrayals of the Hollywood Control Group" in *Movies and Propaganda*).

In 1982, *Personal Best* starred Mariel Hemingway and Patrice Donnelly in an "exploration of the lesbian relationships, but (according to Steven Scheuer) the film fudges by having one of the women finally take up with a man." The film was produced, written and directed by Robert Towne[174]. Two years later, *Streamers* (1984) told a story "about young soldiers waiting around a barracks for their orders to go to Vietnam." The soldiers include a middle-class white, a middle-class black, "a dreamy young man who likes to tease the others with hints that he is a homosexual (and that they may be gay too) . . . (and) . . . an angry young black man who is gay." The film uses both sex and race as foreground subjects while the movie's real subject, war, hovers in the background." [174]

Also, that year, 1984, *Swann in Love* provides another negative portrayal of gay men. In this film Alain Delon plays "a gloomy homosexual who pursues an idealized form of misery." [174] Orion's *Hotel New Hampshire* (1984) features "a lesbian in a bear suit, a girl who becomes enamored of her rapist, and a blind man named Freud." Tony Richardson directed[174]. In addition to the negative portrayal of the lesbian, this film illustrates the proposition that Hollywood can find someone to film almost anything.

The 1985 film, *Kiss of the Spider Woman*, in addition to the movie-within-the-movie regarding the Nazi occupation of France in WWII (and the murder of Jewish smugglers) portrayed an openly gay man (played by William Hurt) who falls in love with a straight

man (Raul Julia) during a time when they shared a prison cell in a South American country. Although the gay man displayed some admirable traits and the talk regarding his sexual orientation was open and frank, there were also some negative aspects to his portrayal, after all he was in prison for having sex with an underage boy and the gay character was also portrayed in a stereotypical manner (e.g., he worked as a department store window dresser). William Hurt won the Best Actor Oscar for his performance and the film includes a full male on male kiss between the two lead actors.

In 1987, Vito Russo points out in his book about homosexuality in American movies (*The Celluloid Closet*), nothing is "more imbedded in industry culture than a belief that the public would never accept a gay hero . "For most of its history, therefore, the screen entertainment industry pretended homosexuals did not exist; when they did appear, they were portrayed as harmless buffoons or as murderers, murder victims, or suicides."[177]

A single possible exception to Hollywood's anti-gay/lesbian bias throughout the years is *Torch Song Trilogy* (1988). The film, independently produced by Palace and released by New Line, is "about a man (Arnold played by Harvey Fierstein) who slowly becomes more comfortable with himself. . . a man who was born gay, and has known about himself from an early age, and has accepted his homosexuality." The movie ends when Arnold confronts his mother (played by Anne Bancroft) and finally tells her exactly what he thinks "about his sexuality and her attitude toward it." He says: "There are two things I demand from the people in my life: love and respect." As Roger Ebert points out, "[h]e could have been speaking for anybody."[178]

It was back to the more typical Hollywood stereotypes in 1991, however, with 20th Century-Fox's *Mannequin Two*. The film includes a negative portrayal of a "gay (department store) display artist . . . with every gay designer cliche ever imagined, clearly (according to *The Hollywood Reporter*) trading on Middle America's stereotypes."[179]

Three other 1991 films were "particularly upsetting to homosexual activists, including the portrayal of homosexual villains in

best picture nominees *JFK* and *The Silence of the Lambs*, as well as the "delesbianizing" of two central characters in *Fried Green Tomatoes*.[182]

Also in 1991, gay activists were so outraged by the negative portrayals in *Basic Instinct* that they marched near the location shoot in San Francisco. They failed to stop the filming of the Tri-Star feature (starring Michael Douglas). "Protesters charge[d] it portrays lesbians in a negative light."[187] Jessea Greenman, co-chair of the Gay & Lesbian Alliance Against Defamation/San Francisco Bay Area said *Basic Instinct* was a film "in which all the lesbian and bisexual women are portrayed as potentially homicidal."[188] "This film is just one in a series of films which have defamed us," said Ellen Carton executive director of GLAAD/New York. "The lesbian and gay community is angry at Hollywood and tired of being consistently portrayed inaccurately[190]." Homosexual activists planned and implemented "a peaceful yet powerful demonstration . . . "at the 64th annual Academy Awards presentation "to show their disgust with Hollywood's alleged hateful portrayal of gays in movies."[190]

In 1992, *Swoon* reopened "the notorious thrill-killing of Bobby Frank, whose murder in the 1920s became an international scandal when it was revealed that two rich young Chicago homosexuals, Richard Loeb and Nathan Leopold, Jr., had committed the crime. . . Leopold and Loeb escaped the death penalty only because of an impassioned defense by Clarence Darrow, the best-known defense attorney of his time, who argued they were insane, and used their homosexuality as proof of insanity."[191] According to Halliwell's Film Guide (1995) this account of the murders "may be closer to the real events and the couple's motivations than either of the other movie versions, *Rope* or *Compulsion*," both of which camouflaged the ethnic identity of the killers, both of which happened to be Jewish.[191]

The premise of Jonathan Demme's 1992 movie *Philadelphia* is that homophobia is as dangerous as the AIDS virus itself. Some in the gay community suggest that the film is "a conscious effort on Demme's part to answer gays who protested his Oscar-winning *Silence of the Lambs* for what they felt was its negative depiction of a gay character."[191] Demme, on the other hand, claimed "[p]eople . . . misread the characters to a degree. But in one regard. . . " he said,

Demme agrees "with critics of *Silence*—(that) there is a terrible void of positive gay characters in American movies."[192]

Variety's Michael Fleming wrote in March of 1992: "If gay groups were upset by *Basic Instinct*, wait till they see a scene from Columbia's *Mo' Money*, starring Damon Wayans . . . In the movie scene . . . Wayans tries to pass a bad credit card. He escapes scrutiny by mimicking an effeminate character."[192] In August of that same year (1992), *Premiere* magazine subscriber (and/or reader) William Stosine responded to an earlier Michael Douglas article in the same magazine. Stosine stated: "As a gay man, I'd like to respond to Michael Douglas' question about why gays are so upset by *Basic Instinct*. Douglas asks: 'Should WASPS be the only villains?' Of course not. It's a matter of balance. The fact is that gays [as presented in movies] are never anything but villains and buffoons, and we're sick of it. It doesn't take an Einstein to figure out that constant negative portrayals of gays in the media result in homophobic attitudes in real life."[193]

Following the gay/lesbian criticism of *Basic Instinct* Hollywood reportedly has been developing more gay-themed properties, ostensibly with more favorable treatment of gay/lesbian characters. But, according to Michael Szymanski, "appearances can be deceiving, and many believe this apparent new tolerance is merely the movie industry's usual attempt at cashing in on headlines."[195]

Roger Ebert suggests that the 1993 film *Three of Hearts* may be the rare exception to the anti-gay/lesbian bias. But then, maybe not. According to Ebert the film is "about a lesbian whose bisexual girlfriend walks out on her—and about how she hires a male escort to seduce and abandon the girlfriend, who will then presumably hate men so much she'll come back home again." According to Ebert the "whole approach to gay life (depicted) in this movie is refreshingly unaffected."[203] Since I am not gay and have not seen the movie, I cannot make a judgment as to whether the "approach to gay life in this movie is refreshingly unaffected." However, it does seem to me that the very motivation of the lesbian and her actions, as described above, may be offensive to a great many members of the gay/lesbian community. In addition, it suggests that some women turn to les-

bianism because they hate men, a socially-based theory which conflicts with the theory that some women (and men) are born with body chemistry that commits them to a lesbian (or gay) lifestyle.

As *Variety* reported in January of 1994, the film *Philadelphia* performed well at the box office but also drew "quite a bit of criticism." First, *Normal Heart* playwright Larry Kramer hammered the movie for content," then "Scott Thompson, a member of the CBS sketch-com troupe Kids in the Hall and one of the few openly gay comic actors" added "fuel to the fire." He was "livid over the continuing depiction of gay characters by straight actors."[204]

It took an independent film company, the Lavendar Hill Mob to come out with a film (*Bar Girls*—1994) that "does for lesbians what numerous American movies have done for heterosexuals, examining courtship and dating, attraction and jealousy, separation and reconciliation." As *Variety* reviewer Emanuel Levy reports, although "the characters are types marked by just one or two traits," at least one performance that of Loretta (played by Nancy Allison Wolfe) "highlights the complexity of her character as a bright and attractive career woman who's . . . (only) slightly neurotic about relationships." Marita Giovanni directed and co-produced with Laura Hoffman (who wrote the screenplay). The other stars included Liza D'Agostino, Camila Griggs, Michael Harris, Justine Slater, Paula Sorge and Cece Tsou.[207]

Again, it would appear that, as a general rule, movies mirror the values, interests, cultural perspectives and prejudices of their makers. Thus, until the Hollywood establishment stops systematically excluding gays and lesbians from positions of authority in the Hollywood power structure, and more gays and lesbians are allowed to produce, write, act and direct Hollywood films, we are not likely to see any significant change in the number of films that provide more accurate and positive portrayals of such persons. In addition, until such developments occur, movie audiences are not likely to see more overall balance in the portrayals of gays and lesbians in mainstream cinema. These same observations are also true with respect to the consistent Hollywood bias towards women.

CHAPTER 4

Religious Bias

Especially Christianity—Contemporary Hollywood motion pictures also clearly portray a general anti-religious slant, although early films took a more supportive approach. As Neal Gabler points out in his book *An Empire of Their Own*, "the Jewish immigrants who founded the film business wanted more than wealth and power: they felt a powerful craving for acceptance as mainstream Americans . . . With this goal in mind, the films of Hollywood's Golden Era invariably portrayed clergymen in a sympathetic light."[208] In more recent years however, "Hollywood has swung to the opposite extreme—presenting a view of the clergy that is every bit as one-sided in its cynicism and hostility as the old treatment may have been idealized."[208]

Although, some have suggested that a drastic change occurred in Hollywood following the final demise of the Production Code in 1968, my own review of Hollywood films about religion indicate that prior to 1968, at least two parallel approaches to religious topics were represented, one sympathetic to mainstream religious beliefs (although limited to biblical stories), the other antagonistic.

The thing that appears to have changed, is that after 1968, the films that are antagonistic to religion clearly predominate.

That year, *What's That Knocking at My Door?* (1968) starred Harvey Keitel, Zina Bethune, Anne Collette in the story of "a young Italian Catholic whose 'Madonna complex' and rigid views on sexuality prevent him from making a commitment with his girlfriend, who'd been the victim of a rape." Martin Scorsese directed.[208] Also, in 1968, *Rosemary's Baby* starred Mia Farrow as an "innocent wife sold by her ambitious husband to a cult of devil-worshippers." Roman Polanski directed.[209]

Then in 1970 *The Ballad of Cable Hogue* featured Stella Stevens as a prostitute who takes up with Jason Robards, "a worn-out prospector who talks to God" and David Warner as "a disturbed preacher."[209] *Marjoe* (1972) was a "documentary about Marjoe Gorner, a charismatic former child prodigy on the evangelist revival circuit." Sarah Kernochan and Howard Smith directed[209]. As we shall see, the fundamentalist Christian evangelists have been a common target of Hollywood. *Marjoe* was followed by *Tommy* (1975) whose makers say it "is an attack on the hypocrisy of organized religion." The movie tells the story of a "blind deaf-mute (who becomes) . . . the pinball superstar of all time. . . but the people around him begin to commercialize on his fame."[210]

The following year, Art Linson and Joel Schumacher team up in *Car Wash* (1976) to provide, among other things, a satirical portrayal of a television evangelist."[210] Another '76 feature, *Carrie* portrays "shrill religious fanaticism" in the character of Carrie's mother, a character who has "translated her own psychotic fear of sexuality into a twisted personal religion. She punishes the girl constantly, locks her in closets with statutes of a horribly bleeding Christ, and refuses to let her develop normal friendships."[210]

That was also the year (1976) of *Nasty Habits*, a U.S./British production that provides an "acerbic satire on Watergate set in a convent." Michael Lindsay-Hogg directed.[210] That was followed in 1979 by John Huston's *Wise Blood*, a "searing satire of Southern-style religion,"[210] or, as Scheuer states, a film about a "psychotic who preaches a gospel of the Church of Jesus Christ Without Christ."[211] Also,

in 1979, *Hardcore* starred George C. Scott "as a Calvinist, (who) .
. . searches for his runaway daughter through a trail of sex films
to San Francisco. Writer-director Paul Schrader allowed Scott to
be excessively violent in his quest, possibly a comment on how a
man with a mission can forget his principles so quickly."[212] Schrader
was "the son of strict Calvinists of Dutch-German descent . . . the
director indicated he had modeled George C. Scott's character as
a Calvinist father searching for his runaway porno-movie actress
daughter after his own father."[212] That same year, Stanley Kramer
directed *The Runner Stumbles* (1979) starring Dick Van Dyke as "a
priest who falls in love with a spirited nun."[212]

In *KGOD* (1980) Dabney Coleman "turns a money-losing local
TV station into a hot property selling God to the ripe-for-the-fleec-
ing masses of Southern California." Rick Friedberg directed.[212] Also,
that year, director Gary Weis' *Wholly Moses* was denounced by "Or-
thodox Rabbi Abraham Hecht . . . as 'a savage mockery of our God,
Bible . . . and our teacher and prophet Moses."[213] It represented one
of the few Hollywood films that attracted the public condemnation
of Jewish religious leaders.

In 1981, *True Confessions* provides a negative portrayal of a "mon-
signor (who) . . . isn't above rigging a church raffle so that a city
councilman's daughter will win the new car." The character (played
by Charles Durning) is "honored as the Catholic Layman of the Year
(but is actually) . . . a grafter and former pimp." He is also a sus-
pect in a murder. The film paints the church as a "hiding place .
. . for hypocrites and weary, defeated men."[214] The following year,
(1982) *Sophie's Choice* portrayed Nazi concentration camp officials
who quoted Christian biblical teachings in support of what they
did. Also, in 1982, *Pray TV* starred Ned Beatty in all his "evangeli-
cal slickness and huckster charm as Reverend Freddy Stone, who
spreads God's Word over the Divinity Broadcasting Company."
Robert Markowitz directed.[215]

In 1984, *The Amazing Mr. X* portrayed "a fake spiritualist who's
out to bilk a widow of her fortune with the cooperation of her schem-
ing spouse . . . who's supposed to be dead."[215] Beth Henley portrayed
"a Bible pusher in Jonathan Demme's *Swing Shift* (1984)."[215] And in

Footloose (1984) "a student transfers into the Bible Belt and brings some big-city influences with him," making the local preacher seem somewhat petty. New York city-born Herbert Ross directed.[215]

Also in 1984, *Indiana Jones and the Temple of Doom* (1984) starred Harrison Ford and Kate Capshaw in a story in "which Indiana must rescue some missing children kidnapped by religious terrorists in the Orient." Stephen Spielberg directed[215]. That same year, in *Crimes of Passion* (1984) Kathleen Turner is a "fashion designer by day, prostitute by night." She becomes involved with "a deranged preacher (played by Anthony Perkins) who is obsessed with her."[215]

The following year, (1985) *King David* starred Richard Gere in what Steven Scheuer calls an "ambitious but seriously compromised attempt to do a legitimate biblical epic without an over-reliance on spectacle or Cecil B. DeMille campiness. The film has undeniable grandeur in the first half detailing King Saul's decline. But once the contemporary acting talents of Gere surface, the sweep of the project degenerates into 'great moments form the Bible.'" Australian Bruce Beresford directed[216].

Also, in 1985, "Catholic schoolboys run amok, chasing girls and running from authority . . . " in the Michael Dinner directed *Heaven Help Us*[217]. That same year, *Second Time Lucky* (1985) featured Diane Franklin and Roger Wilson "running around in the buff for most of the movie as reincarnations of Adam and Eve, used as pawns in a game between God and Satan." Michael Anderson directed.[217]

One of the few exceptions to Hollywood's apparent anti-religious bias in its contemporary movies may have occurred in the film *Witness* (1985). The motion picture provides a sympathetic portrayal of "an Amish settlement in Pennsylvania." The movie is about "adults, whose lives have dignity and whose choices matter to them[217]." American filmmaker Alan Metter returned to the more typical Hollywood handling of religious topics with *Girls Just Want to Have Fun* (1985), a film about a "shy teenager (who) must circumvent her strict papa's rules as well as the tongue-clucking admonitions of her Catholic school nuns, as she tries to dance her way onto the local dance video show."[218]

That same year, (1985) *Agnes of God* featured "an unbalanced nun who's accused of killing her newborn infant." [218]

In 1986, *The Name of the Rose* paints a picture of a dark and mysterious monastery where "starving peasants wrestle for scraps of food . . . [at its base and a] series of murders" are taking place within. At one time or another, all of the monks in the monastery are considered suspects.[218] According to Steven Scheuer, this 20th Century-Fox release, starring Sean Connery, F. Murray Abraham and Christian Slater, "recreates life among these monks and religious hysterics in the most squalid manner possible."[218] Also, in 1986, *Girls' School Screamers* features "[s]ix dumb-bunny women and one weird nun (who) take inventory of a haunted mansion's art treasures bequeathed to their school." John Finegan directed[219]. That same year, (1986) *The Mission* starred Robert DeNiro and Jeremy Irons in an "account of the missionary work carried on among the Indians of 18th-century South America, and the manipulative church politics that put an end to it." Roland Joffe directed.[219]

The following year (1987) *Salvation* provides a "glimpse at religious show biz (when a) . . . TV minister is blackmailed by an opportunist whose wife wants to be an evangelical singing star on the tube." Beth B. directed[219]. Also, in 1987, the movie version of *Dragnet* (starring Dan Aykroyd and Tom Hanks) offered "a phony TV preacher . . . and (a) . . . pagan-rite scene, in which oddly assorted would-be pagans stomp around in thigh-high sheepskins, while the Virgin Connie Swail (Alexandra Paul) is prepared for a sacrifice."[219]

Therese (1987) tells the story of a girl who "wanted to enter the strict cloisters of the Carmelite nuns, and when she was refused permission she went all the way to the Pope to finally obtain it." The movie "centers itself around the depth of her passionate love affair with Jesus." The film "makes a bold attempt to penetrate the mystery of Therese's sainthood, and yet it isn't propaganda for the church and it doesn't necessarily even approve of her choice of a vocation."[219] That same year, *The Believers* (1987) portrays "an ancient religion that rears its ugly head in modern-day American. A police psychologist becomes enmeshed in a strange case involving mystic rituals and discovers his family's safety is threatened."[219]

In the 1987 film *Murder Ordained*, Keith Carradine and JoBeth Williams are featured in a story supposedly based "on a real-life double murder case involving a small-town sexually promiscuous housewife and a clergyman." Mike Robe directed.[219] Also that year, *Heaven* (1987) is Diane Keaton's directorial debut. The film was "an offbeat sensory assault that explores the concept of the afterlife from a number of perspectives." According to Steven Scheuer, the film is primarily "a collection of statements about heaven made by some of LA.'s oddest citizens supplemented by various images of heaven clipped from old movies and edited together in a rock-video manner."[220]

The following year (1988), one of the leaders (Charlie Sheen) of the outlaw gang in Morgan Creek's *Young Guns* (produced by Joe Roth) is an active Christian who prays at various times throughout the gang's travels, while also participating in their killing rampage through the West. Also, in 1988, "Nkkos Kazantzakis' novel *The Last Temptation of Christ* was brought to America's theaters by Universal. Directed by Martin Scorcese, the film aroused indignation among millions of Christians world-wide for three reasons . . . Jesus' character as portrayed in the film was that of an anxious neurotic . . . the film took great liberties with the wording of key passages in the Gospels (and) . . . in an extended fantasy sequence in which Jesus imagines what his life would have been like had he chosen to live it as an ordinary mortal, he is shown in one fairly explicit scene engaging in sexual intercourse with his wife, Mary Magdelene." To say that most Christians were offended by this movie would be a pale understatement. One Protestant minister, Dr. Jack Hayford, summed up the reaction of many when he charged that it 'casts as mentally unbalanced the man who established the teachings that became the guideposts for an entire civilization. It's an outright distortion of history and a devastating assault on the personal values of hosts of people.'"[220]

Despite the fact (as Ebert rationalizes) that "the film . . . (was) clearly introduced as a fiction and not as an account based on the Bible,"[220] the anger directed toward the film and emanating from some segments of the Christian community is partly justified and

based on another fact: that films portraying a view of Jesus Christ and Christianity more acceptable to the vast majority of Christians are generally not produced or released by the Hollywood film community. Thus, the production and release of films portraying what most in the Christian community would consider negative portrayals of their religion are nothing more than Hollywood sponsored anti-Christian propaganda. And now that we recognize that Hollywood is controlled and dominated by a small group of Jewish males of European heritage, who are politically religious and not very religious, (see *Who Really Controls Hollywood*) this conflict over movies becomes an important element of the ongoing U.S. culture war.

Continuing our observation of the movie portrayal aspects of that war, in 1990, *We're No Angels* starred Robert DeNiro and Sean Penn and portrayed an entire monastery filled with unbelievably dumb priests.[220] Also, in 1990, "writer-director Francis Coppola shows far more sympathy to the Mafia (in 'Godfather III') than to the Church, and the leaders of organized crime display more scruples and human emotion than the leaders of organized religion."[221] In 1990, *Jesus of Montreal* suggests "that most establishments, and especially the church, would be rocked to their foundations by the practical application of the maxims of Christ." The movie is an "attempt to explore what really might happen if the spirit of Jesus were to walk among us in these timid and materialistic times."[221]

The following year, (1991) *Robin Hood: Prince of Thieves* portrays "priests . . . as corrupt or drunken swine."[221] *At Play in the Fields of the Lord* (1991) provides a negative portrayal of a group of "missionaries from North America" who go to the Amazon "to preach their religion to (an Indian) . . . tribe."[221] Another 1991 offering, *Black Robe* tells the story "of the first contacts between the Huron Indians of Quebec and the Jesuit missionaries from France who came to convert them to Catholicism and ended up delivering them into the hands of their enemies." The movie basically says that "the European settlement of North America led to the destruction of the original inhabitants, not their salvation."[221]

Michael Tolkin's *The Rapture* (1991) provides "a radical, uncompromising treatment of the Christian teachings about the final

judgment." Tolkin "seems to be saying if this is what the end of creation is going to be like, then we should stare unblinking at its full and terrifying implications."[221] The Fine Line Features film is about "a bored Los Angeles telephone operator (who) . . . fills her nights with sexually dangerous adventures (until she) . . . overhears several co-workers secretly talking about . . . Christ . . . coming back to Earth and (that) they must prepare for his return." The telephone operator "becomes obsessed with this message and gains a faith so strong she becomes an overnight convert (after which her) . . . belief in God is tested time and time again."[222]

Other 1991 films with religious themes, include *The Five Heartbeats* (1991) which portrays a "minister who thinks jazz and rock 'n' roll are the work of the devil." Also, *Cape Fear* (1991) presents an evil Robert De Niro covered "with tattoos spelling out dire biblical warnings" and talking with a Southern accent.[223]

In 1992, *Bram Stoker's Dracula* presents "Vlad the Impaler, who went off to fight the Crusades and returned to find that his beloved wife, hearing he was dead, had killed herself . . . Vlad cannot see the justice in his fate. He has marched all the way to the Holy Land on God's business, only to have God play this sort of a trick on him"[224] so "the monarch furiously renounced God and began his centuries-long devotion to evil (Satan and vampirism).[225] Also, in 1992, Disney's *Sister Act* drops in "a few tasty anti-clerical barbs" and shows Whoopi Goldberg transforming "a collection of largely ancient Carmelite sisters who haven't carried a tune in 50 years into a soulful, rockin' chorus."[228]

The 1992 Ridley Scott film *1492: Conquest of Paradise*, portrays the Christopher Columbus discovery of America showing that "Columbus administrates (the New World) ineptly and tries ineffectually to promote a policy of peaceful coexistence . . . (with the natives, but that) [m]inds dominated by military ambition, religious fervor and greed inevitably gain the upper hand and turn the lush tropical settlement into a living hell."[231] *Leap of Faith* (1992) is another manifestation of Hollywood's relentless attack on Christianity and religion generally. The movie is characterized by movie critic Roger Ebert as "the first movie to reveal the actual methods used by some

revivalists and faith healers to defraud their unsuspecting congregations." Ebert points out that earlier movies, from features like *Elmer Gantry* and *Uforia* to the documentary *Marjoe*, have had an equally jaundiced view of barnstorming evangelists, but (as Ebert says) this is the first exposé of the high-tech age, showing how electronics and computers are used to fabricate miracles on demand."[234]

There are at least two problems with this movie, (1) regardless of whether the film's view of religious "revivalists and faith healers" is accurate, it represents a single movie in an entire series of movies that are anti-Christian. In other words, the U.S. film industry, dominated by a small group of Jewish males of European heritage who are politically liberal and not very religious, does not allow the powerful motion picture communications medium to tell the other side of issues relating to Christianity. It relentlessly focuses on what it considers to be the most undesirable aspects of the religion and publicizes those. (2) As explained in this series of books on Hollywood, (my own "exposé" of the U.S. film industry), the MPAA companies and their upper level management are not in any way morally or ethically superior to the "revivalists and faith healers" depicted in *Leap of Faith*, after all they have been "defrauding" actors, directors, producers, screenwriters, outside investors and moviegoing audiences throughout the world for more than 100 years. So this movie and others like it, appear to me to be very much like the "pot calling the kettle black." The only difference is that the U.S. film industry controls the world's greatest PR machine and can effectively deceive most of the people most of the time.[6]

6 In the spirit of full disclosure, I must report that I grew up in the home of wonderful parents who, with respect to religion, were East Texas Baptists. On the other hand, I have been quite comfortable for all of my adult life as a person who is "not very religious", thus, in this regard, I share one of the values of many of the Hollywood filmmakers. Even though I personally may agree with much of the contemporary Hollywood point of view with regard to religion, I do not believe it is fair, nor in the best interest of this nation as a whole, to permit the consistent exclusion of other important points of view from this significant communications medium, or, even worse, to allow one narrowly-defined interest group within our diverse society to use such a powerful communications medium as its own private propaganda tool.

Back to the culture wars, a religious theme is also prominent in 1993's *Bad Lieutenant*. The film features Harvey Keitel as "a lying, stealing, murdering, drug-addicted New York cop who is seen spiraling downward, out of control, during the last days of his life." The theme of "guilt and its redemption" is the theme that is central to the work of Martin Scorsese and Harvey Keitel. In an interview with Keitel, movie critic Roger Ebert said "[t]hat whole idea of sin and redemption is central to your best characters . . . I know you're Jewish, but I keep thinking of you in Catholic churches."[235]

Finally, in 1994, the Columbia release *The Shawshank Redemption* featured a hypocritical Christian prison warden as the chief villain. Alan Parker's *The Road to Wellville* (Columbia Pictures—1994) also took several swipes at the Seventh Day Adventists. The film was written and directed by Alan Parker, who produced with Armyan Bernstein, Robert F. Colesberry, Tom Rosenberg and Marc Abraham[236]. Director Tim Burton's film *Ed Wood* poked fun at Baptists and their baptismal ritual. The 1994 20th Century-Fox release *Bad Girls* portrayed a lynch mob made up of religious reformers.[239] And, the 1994 Geffen Pictures/Warner Bros. release *Interview With the Vampire*, actually starring Brad Pitt (along with Tom Cruise), contains several anti-God references and focuses on the nothingness of life. The film was produced by David Geffen and Stephen Woolley, directed by Neil Jordan with the screenplay by Ann Rice.

In any case, even though Michael Medved holds himself out as a very religious person (specifically an Orthodox Jew), and I am not very religious, we do agree that Hollywood films have in recent years been consistently anti-religious. As Medved points out, "[t]he movie industry has ignored the success of films that look favorably on faith with the same sort of self-destructive stubbornness that has led to its continued sponsorship of antreligious-message movies[243]." Of course, this is occurring at a time when the Hollywood establishment still contends that movies are merely "entertainment".

Others besides Medved and myself have expressed similar concerns about anti-religious movies. In the Josephson Institute's *Ethics* publication, *Media & Values* founding editor Elizabeth Thoman said: "My concern would be, what is left out, rather than what is

shown. Why is normal religious practice left out of entertainment media? The only thing that religion gets are those perverted kinds of strange images with Madonna pushing the envelope, somebody who's very dissatisfied."[244]

Medved, however, also states that "[i]n addition to the obvious antipathy to various forms of Christianity displayed in so many recent movies, Hollywood has also attempted some significant jabs at Judaism . . . however, the ridicule of the rabbis has been less intense than the negativity that is injected into the caricatures of Christian clergy."[245] It would appear to me (based primarily on my analysis of the Roger Ebert and Steven Scheuer reviews) that there is huge disparity between the number of negative portrayals of Christians and Jews in Hollywood movies. In addition, there appear to be many more positive portrayals of Jewish film characters than Christians in Hollywood films. On this issue, Dr. Prothnow-Stith states that "[t]here should be an issue of fairness considered . . . For instance, If I'm Jewish and I'm willing to make fun of this Baptist preacher, would I be as willing to make fun of a rabbi?"[246] In present day Hollywood (and in the Hollywood that has existed for more than 100 years), apparently not.

Again, it is a basic issue of fairness and access to equal opportunities in a so-called free, democratic society. My contention is that, even if some segments of our society are not saying what we would like for them to say, it is not in the national interest to stand by and allow any single or narrowly defined interest group to prevent the important messages of others from being communicated through a significant communications medium such as film.[7]

Anti-WASP Films—Since, from a religious perspective, the American South is predominantly Christian-Protestant and of white Anglo-Saxon heritage, the entire body of the films cited in Chapter 6 for providing negative or stereotypical portrayals of people, places and things from the South can also be fairly considered anti-WASP films. Hollywood films, also more specifically portray

7 Speaking of fairness, in this survey of several thousand feature films, there were also very few, if any, positive portrayals of the Muslim, Buddhist or Hindu religions in U.S.-made films.

a more general anti-WASP sentiment (i.e., the WASPs portrayed are not from the South). No attempt has been made for purposes of this publication to quantify those many negative portrayals. But, examples include *The Swimmer* (Columbia—1968) which starred Burt Lancaster and Janice Rule in the "story about a loser (who) . . . gradually flip[s] . . . out of WASP society because he loathes the life-style and mores of affluent executives." He subsequently "swims his way down various pools in Westport, Conn."[247] The Indiana-born Sydney Pollack ("son of first-generation Russian-Jewish Americans")[248] and New York-born Frank Perry directed and Perry co-produced with Roger Lewis.

Also, *The Great Gatsby* (1974) was Paramount's "third film version of F. Scott Fitzgerald's enduring novel about the Beautiful People of rich WASP society in New York and Long Island of the 1920s . . . (a) rich if emotionally impoverished crowd." Gatsby this time is played by Robert Redford, but film critic Steven Scheuer claims Redford is "too genteel and civilized, given Gatsby's modest background and hustling business career with bootlegging connections." British-born Jack Clayton directed for producer David Merrick. The 1949 version of the film starring Alan Ladd was directed by Ohio-born Elliott Nugent for New York-born producer Richard Maibaum.[249] In another example, the 1980 Warner/Orion release, *Caddyshack* starred Chevy Chase, Ted Knight, Rodney Dangerfield and Bill Murray in a satire "aimed at the W.A.S.P. set . . . in an exclusive country club."[250] The film was directed by Chicago-born Harold Ramis for producer Douglas Kenney.

Of course, it would be even more offensive if a study of Hollywood movies demonstrated that an industry controlled by a small group of Jewish males consistently portrayed WASPs in a negative manner, although, clearly in the case of WASP film characters generally, there are at least some positive portrayals to balance the overall presentation, whereas the Hollywood anti-South bias seems much more consistently negative (again, see Chapter 6).

Research Project: Arbitrarily select a limited number of years and a body of films to study (e.g., all of the films released by the

major studio/distributors). Determine which of those films portray WASP villains as opposed to other villains.

Bad Guys From the Political Right

Considering the repetition of Hollywood character portrayals from a political perspective, it is quite apparent that one of the most consistent patterns of Hollywood movie bias comes in the form of the villain from the extreme right of the political spectrum. Seldom does Hollywood portray its movie villains as political liberals.

The Overly Popular Nazi Villain—There is also no question that the all-time champion villain for American movies since the '30s is the Nazi, and this alone tells us a great deal about who controls Hollywood. American films dealing with the Nazi threat during the years from 1934 through 1941 (prior to the U.S. entry into World War II) were considered in the companion volume *Movies and Propaganda*. Some 33 anti-Nazi films are considered there. Another 241 anti-Nazi movies were identified by this study, having been released from 1942 through 1994. On average, Hollywood released nearly 5 anti-Nazi films a year during this latter 52 year period. Although, this study did not go so far as to quantify the results, it would appear that more Hollywood films have featured the Nazis as villains than all other films focusing on other World War II enemies of the

U.S., considered together. The appearances of Nazis as villains in American-made motion pictures seem to far outdistance the appearances of any other consistently negatively portrayed human population. Interestingly, but not surprisingly, Michael Medved made little or no comment regarding this clear Hollywood bias, which has, over the years, risen to the level of movie propaganda.

Even though we might all agree that Nazis are appropriate movie villains, the concern expressed here centers on the fact that if a narrowly defined interest group that happens to control Hollywood is allowed to obsessively portray its most despicable enemies through a disproportionate number of movies showing them as villains, then all other groups that have any interest in portraying someone else as a movie villain are arbitrarily prevented from doing so. Thus, the proliferation of Nazi villains in Hollywood films, not only confirms the priorities and biases of the Hollywood film community, it precludes others from telling their important stories through films that are available to be seen by large segments of the American and world publics.

It may also be true that there have been more so-called anti-Nazi films produced or released for consumption by the American public than films about all of the other U.S. war-time enemies put together. If that were true, such a result, would once again suggest that those who control the American film apparatus, do in fact use their power and discretion to create and offer negative portrayals of the enemy most feared or hated by the filmmaking community itself. In any case, none of these references to movies that portray an anti-Nazi point of view or provide a sympathetic portrayal of Jews is intended to discredit the perspective portrayed, but only to illustrate that the excessive number of such movies support the contention of this book that a pattern of bias exists in Hollywood and that too many movies reflecting such views have been produced or distributed by the U.S. film industry to the exclusion of movies that could have been made by other groups within our society, who also have important stories to tell through this significant communications medium. This pattern of bias, in fact reflects the rather arrogant contention that the perspective of this small group of Jew-

ish males of European heritage is more important that the perspec-
tive of others in our society and thus deserves more attention in the
movies.

Again, this book does not argue that anti-Nazi films should not
have been made. Nor does this book argue that Nazis should not be
portrayed as villains. Anyone who makes such a suggestion, either
has not read the book, or is merely trying to discredit the book by
spreading malicious untruths. The book, instead, argues that the
proliferation of anti-Nazi and other themes of particular interest
to that small group of Jewish males with a European heritage who
control Hollywood, has crowded out other movie themes that re-
late important stories, just as important to other racial, cultural,
religious or ethnic groups in America, who ought to have an equal
opportunity to tell their stories to the rest of the world. In other
words, that small group of Jewish males of European heritage, who
are (generally speaking) politically liberal and not very religious,
should not be allowed to foreclose the opportunities of other inter-
est groups like African-Americans, Jewish and non-Jewish women,
Hispanic and Latinos, Asian-Americans, Arab-Americans, etc. in
our diverse society from portraying their villains in motion pictures
that are seen by mainstream America and the rest of the world.

The Anti-German Spillover—Of course, one of the problems
with an American film industry churning out so many anti-Nazi
movies is that the negative feelings for Nazis may spill over into a
more generalized negative feeling about Germans in general. There
seems to be some evidence to indicate that such a more generalized
prejudicial spillover has already occurred in the movies. A couple of
recent examples illustrate the point. For example, *Die Hard* (1988)
featured a villainous "multinational group, led by a German named
Hans Gruber (Alan Rickman) (who) . . . thinks he is superior to
the riff-raff he has to associate with."[252] Also, even more recently,
Alan Parker's *The Road to Wellville* (Columbia Pictures, 1994), while
on the surface, a "satire of health fanaticism in turn-of-the-cen-
tury America,"[253] contained numerous negative references to the
Germans.

In addition, the 1994 TriStar release *Legends of the Fall* was "set during the early 20th century." The story "focuses on the three sons of retired calvary officer William Ludlow (Anthony Hopkins)" who "left the military at issue with government treatment of plains Indians." The film includes an important segment portraying the horror of World War I and fighting against the German enemy. Much of the rest of the movie dealt with the effects of that war experience on the lives of a U.S. family. Edward Zwick directed for producers Jane Bartelme and Sarah Caplan. Susan Shilliday Wittliff wrote the screenplay.[257]

Thus, Hollywood's strong anti-Nazi prejudice appears to have evolved into a more generalized anti-German prejudice, which illustrates the problem with prejudice of all kinds. I suspect there are lot of Germans today who are very tired of seeing American movies showing German villains, regardless of whether they are Nazis or not, partly because such a pattern of bias is morally wrong and partly because, before long, the viewers of this kind of consistent propaganda begin to see all Germans as villains.

Fascism, Totalitarianism and Repressive Dictatorships—After the flurry of anti-Fascist and propagandistic motion pictures relating to the Spanish Civil War, (considered in the companion volume *Movies and Propaganda*), Hollywood films have continued to warn against the threat of fascism, totalitarianism and repressive dictatorships, even though, as Hortense Powdermaker reported, the Hollywood establishment is operated in a totalitarian manner.

A representative sampling of these films includes, Frank Capra's *Meet John Doe* (1941) which starred Gary Cooper, Barbara Stanwyck and Walter Brennan and came out early enough to be considered part of Hollywood's attempt to influence U.S. and world opinion prior to the U.S. entry into World War II. In the film, "Cooper plays a hobo who makes news by threatening to commit suicide to protest world conditions." According to film critic Steven Scheuer, director "Frank Capra creates a convincing portrait of latent American fascism." [261] Thus, Capra was apparently engaged in a thinly disguised attempt to create fear among Americans that some con-

servatives and isolationists might actually be fascistic, if the truth be known.

Another film expressing a similar theme, was released the next year (1942). *Keeper of the Flame* starred Spencer Tracy and Katharine Hepburn." In this picture, "Tracy is doing an article on the death of a great American and the excitement mounts when the widow, Miss Hepburn, finally admits that the great American was a fascist." George Cukor directed.[262] In 1943, *Pilot No. 5* starred Van Johnson, Franchot Tone, Marsha Hunt and Gene Kelly in the story of a pilot who "wanted to go on a dangerous mission." The film provides "numerous flashbacks conveying how nasty the Fascists were." George Sidney directed[263]. Also, in 1943, the Warner Bros. release *Watch on the Rhine* focuses "on a German underground fighter, Kurt Muller (played by Paul Lukas), who comes to America with his (Jewish) wife, Sara (Bette Davis), and their son, Joshua. While raising money to carry on the anti-Fascist struggle abroad, Kurt discovers Nazi sympathizers at work here as well." According to Patricia Erens, the film explicitly "points a finger at American complacency which has allowed the threat of Nazism to go unchecked."[265]

Other examples in this category, include the 1951 release *The Day the Earth Stood Still.* It was about "an enlightened spaceman who arrives unexpectedly in Washington, D.C. to warn Earth people against continuing their violent habits." According to Steven Scheuer, the film is "[t]houghtful rather than horrifying, with subtle antifascist hints scattered throughout." Robert Wise directed[266]. *The Angel Wore Red* (1960) offered "a love story against the turmoil (fight against the fascists) of the Spanish Civil War of the 1930s."[267] The Columbia TriStar release *Dr. Strangelove: Or How I Learned to Stop Worrying and Love the Bomb* (1964) featured Peter Sellers as the "fascistic professor Strangelove."[268] *Wizards* (1977) was an animation film directed by Ralph Bakshi about "a future civilization where an aged wizard battles his fascist brother."[271]

In 1982, *Vortex* starred Lydia Lunch, James Russo and Bill Rice in the story of a private eye . . . on the trail of a fascistic nuclear weapons manufacturer." Scott and Beth B directed.[272] The next year, *Jacobo Timerman: Prisoner Without a Name, Cell Without a Num-*

ber (1983) starred Roy Scheider and Liv Ullmann in a "glimpse at Argentinean fascism. When Argentinean newspaper publisher Jacobo Timerman printed names of missing citizens during the late 1970s he was imprisoned and tortured before being released." David Greene directed.[272]

The Evil That Men Do (1984) starred Charles Bronson as "a contract killer . . . who abandons retirement to stop a sadistic doctor who teaches torture techniques to repressive dictatorships."[272] *The Good Fight* (1984) is described by Steven Scheuer as a "political documentary about more than three thousand Americans who joined the Abraham Lincoln Brigade to fight (the fascists) in the Spanish Civil War from 1936–1939, although their participation was frowned upon in many quarters in America at the time." Noel Buckner produced and directed.[273] In other words, the film was a salute to those who fought the good fight against fascism.

In addition to its other messages (already discussed), *Kiss of the Spider Woman* (1985) also appears to be repeating a familiar theme, that is how ruthless fascist states can be. The film creates something of a running analogy between what was happening to the resistance movement in the film's fictional South American country and what was happening to the French resistance in WWII occupied France (portrayed in the film's movie-within-the movie). That same year, (1985) *Brazil* represented an attempt to provide a comedic, satire of "1984". "Instead of big Brother listening to you, here he bumps into you and knocks you over."[274]

In 1992, *The Inner Circle* was set in Stalin's Russia. It uses the story of "Stalin's official projectionist inside the Kremlin . . . " (Ivan, played by Tom Hulce) to make a statement about "states of mind under totalitarianism; about how a dictatorship, by denying the humanity of its subjects, inspires abject boot-licking in some, even as it inspires others to acts of heroism." The movie seeks to explain "the decades of collective compromise . . . Russia is only now freeing itself from."[276]

The 1994 movie version of *House of the Spirits* starring Meryl Streep, Jeremy Irons, Glenn Close and Winona Ryder, continues a long Hollywood tradition with respect to focusing on fascistic

movements. In addition to the love stories and spiritual aspects, the film provided strong statements about how too great a disparity between the haves and have nots within a society may lead to revolution, but that on the other hand, one of the risks in supporting the creation of a fascistic state is that it may trample on the rights and privileges of those who helped put its leaders in power. Of course, taking the *House of the Spirits* filmmakers at their word, it may also be true that "too great a disparity between the haves and have nots within . . . " an industry like the film industry, may also lead to a long overdue revolution.

Another interesting question is how can an industry that operates in such a fascistic manner make so many anti-fascistic films? On the other hand, maybe the filmmakers themselves are actually trying to say something about the system within which they must function.

The Continuing Attack: Neo-Nazi/Fascists, White Supremacists and the Klan—In addition to the long series of anti-Nazi and anti-fascist motion pictures, the Hollywood-based U.S. film industry also routinely churns out films that negatively portray neo-Nazis, neo-fascists, white supremacists and the Ku Klux Klan. For example, *The Quiller Memorandum* (1966) is a U.S./British production starring George Segal as "an American agent in Berlin looking for the head of a neo-Nazi party that is gaining momentum in present-day Germany." Michael Anderson directed[276]. Also, *Three the Hard Way* (1974) starred Jim Brown, Fred Williamson, Jim Kelly and Sheilia Frazier in the story of a "white supremacist out to exterminate blacks by putting a serum in the water supply." Gordon Parks, Jr. directed[277]. That same year, among those under suspicion in *Murder on the Orient Express* (1974) is "a neo-Nazi ladies' maid."[277]

The following year, *Attack on Terror: The FBI versus the Ku Klux Klan* (1975) offers a "recreation of the 1964 murder of three civil-rights workers in Mississippi." Steven Scheuer says the film "romanticizes the real performance of the FBI in the Deep South during the '50s and '60s,"[277] thus suggesting that Scheuer has his own prejudices against the FBI and in favor of Southern blacks, the group

he felt should have received more credit in the incident portrayed. On the other hand, Steven Scheuer is a film critic, not a historian.

Undercover with the KKK (1979) starred Don Meredith, James Wainwright in a supposedly "[r]eal-life story of an Alabama redneck (Meredith) who infiltrates the Ku Klux Klan for the FBI." Barry Shear directed[278]. The phrase "supposedly real-life" is used here simply because it is impossible for viewers to know whether the film is 95% true or 50% true and what is true and what is not. *Skokie* (1981) starred Danny Kay, John Rubenstein, Ed Flanders and Eli Wallach in "a re-creation of the dilemma faced by citizens of Skokie, Ill., when neo-Nazis attempted to march (forcing) . . . the locals to wrestle with free speech and First Amendment rights." Herbert Wise directed[278]. Also, in 1981, *Neighbors* featured Dan Aykroyd as the new neighbor of John Belushi. Aykroyd is portrayed (according to Roger Ebert) as "a loud neo-fascist with a back slap that can kill[279]." The following year, part of the Mahatma Gandhi biopic *Gandhi* (1982), depicts the white supremacist ideals which underlie "South Africa's system of racial segregation, in which Indians (and blacks) . . . are denied full citizenship."[280]

In 1983 *The Salamander* starred Anthony Quinn, Eli Wallach, Christopher Lee and Claudia Cardinale in a film "about a neofascist plot to take over the government of Italy." Peter Zinner directed.[281] *Defcon 4* (1985) was a "post-apocalypse nightmare. When astronauts who are orbiting the earth after the 'Big Bomb' drops are forced back to earth one is eaten by cannibalistic teenagers; the other[s] . . . must contend with a . . . survivalist and a sadistic ruler with a Neo-Fascist power base."[281] The 1986 film, *Salvador* includes a portrayal of "a neofascist general."[281] *My Beautiful Launderette* (1986) was "about a homosexual relationship between two very different men: a Pakistani laundry operator and his working-class, neofascist boyfriend."[282] *Avenging Force* (1986) was about a "secret agent (who) battles a white supremacist group . . . " while protecting "a black senatorial candidate."[282] The film was directed by Sam Firstenberg. The following year, *Surf Nazis Must Die* starred Barry Brenner and Gail Neely in a story about "Neo-Nazis surfers fighting for beach control." Peter George directed.[282] In 1988, the

Costa-Gavras' film *Betrayed* starred Debra Winger as an undercover FBI agent who falls for the Tom Berenger character, a Midwestern farmer who marries the Winger character "then reveals himself as a white supremacist."[282]

In the early '90s, *Blood in the Face* (First Run Features—1991) "purports to take a serious look at contemporary U.S. Nazism (but, according to the Hollywood Reporter, is) . . . actually a series of sneers directed at a bunch of misfits and malcontents having a weekend fascist retreat in rural Michigan . . . The bulk of the film is set during a couple of days in the late 1980s at the Cohoctah, Mich., country retreat of the Rev. Bob Miles, a former Ku Klux Klan official . . . (where the filmmakers) filmed various veteran and neophyte racists, Nazis, Klansmen (and women), Christian Identity fanatics and supporters of the Posse Comitatus . . . giving folksy variants on their poisonous philosophy in both speeches and interviews."[283]

The following year, *The Power of One* (1992) told "the story of a young English-speaking boy who is sent to an Afrikaans-language boarding school (in South Africa about the time of World War II) where a neo-Nazi clique makes his life miserable." The boy is portrayed as the "perpetual outsider who is victimized . . . by young students whose idol, in the years before World War II, is Hitler . . . the little neo-Nazis are led by a punk with a swastika tattooed on his arm."[287] It is interesting that just before World War II, Hollywood made a series of anti-Nazi and pro-war movies and subsequently the U.S. entered the war and helped to destroy the German Nazi war machine. Then Hollywood made a series of movies about apartheid in South Africa and subsequently the white minority government in South Africa had to step aside and allow majority black rule. Hollywood is now turning out movies with anti-smoking and environmental messages. All the while, Hollywood claims that movies do not influence behavior. On the other hand, what if Hollywood is not always on the right side?

In 1993, *Jack the Bear* starred Danny DeVito in a film about "a driven man in a ridiculous job (TV horror show host) who loves his children but has lost his bearings." Along the way, the movie portrays a neo-Nazi neighbor (Norman) who "circulates a petition for

the local white-supremacist candidate . . . (and) the DeVito charac-
ter drunkenly attacks him on television, after which Norman retali-
ates by abducting one of (DeVito's) . . . children."[288]

This section pointing out that movies sometimes use white su-
premacists as villains is not included as any form of argument that
they should not be cast as villains, only that if they are used as vil-
lains, so should extremists of other religious, cultural, ethnic and
racial groups. If the Hollywood-based U.S. movie industry takes the
position that only the white race has extremists on its fringe, then
that movie industry itself is racist.

Part of the danger of the anti-Nazi, anti-Fascist and anti-White
Supremacist movies that concerns me is that the underlying preju-
dice against such hate mongering can so easily and appears to have
in fact, evolved into a broader anti-neo-Nazi, anti-German, anti
White Supremacist, anti-Ku Klux Klan, anti-redneck and finally,
anti-Southern mentality in the movie industry, all of which tends to
stir prejudice based on stereotypes in our contemporary society and
lay the groundwork for a form of regional discrimination in the U.S.
that is encouraged by Hollywood motion pictures. It would ap-
pear, in fact, that the people who are making these movies are more
prejudice than some of the people portrayed. Interestingly enough,
although, as already noted, the Ku Klux Klan has had chapters in
states other than in the American South (e.g., Kansas, California,
Oregon, Ohio, Indiana, New York, New Jersey and Pennsylvania,[289]
the vast majority of Hollywood films portraying the Klan are cen-
tered in the Southern states.

As an example, *Sophie's Choice* (1982) told the story of "a Polish-
Catholic woman (Sophie, played by Meryl Streep), who was caught
by the Nazis with a contraband ham, was sentenced to a concen-
tration camp, lost her two children there, and then was somehow
spared to immigrate to Brooklyn, U.S.A., and to the arms of an ec-
centric charmer named Nathan (Kevin Kline). Sophie and Nathan
move into an old boardinghouse, and the rooms just below them are
taken by Stingo, a (naive) jug-eared kid from the South who wants
to be a great novelist. As the two lovers play out their doomed, ro-
mantic destiny, Stingo falls in love . . . with his image of himself as

a writer, with his idealized vision of Sophie and Nathan's romance, and, inevitably, with Sophie herself[290]." The film is thus, both anti-Nazi and it provides a negative portrayal of a young man from the American South.

Also, *No Mercy* (1986) combined the Hollywood overuse of Southern (see discussion below) and neo-Nazi villains in one movie. This film provides "two principal bad guys: An effete rich Southerner played by William Atherton, and a sadistic neo-Nazi vice lord, played by the Dutch actor Jeroen Krabbe." The Krabbe neo-Nazi character is supported by "redneck followers." The film also offers Kim Basinger as the white slave of a "sleazy (New Orleans) vice boss."

Again, there is nothing wrong with portraying neo-Nazis and others on the political right as movie villains, so long as the film industry also portrays extremists on all other sides of the political spectrum as villains from time to time. Otherwise, Hollywood's liberal bias is being converted into political propaganda and that is far afield from "entertainment". There is also nothing wrong with portraying Southerners as movie villains, so long as some Southerners are portrayed in a positive manner either in the same movie or in other movies during the period. The problem with the portrayal of those on the political right and Southerners, however, (as can be seen further from the discussion below) is that their portrayals in Hollywood movies have been consistently negative and/or stereotypical.

Regional Prejudice: Hollywood's Rape of the South

American films appear to consistently project a pro-bi-coastal prejudice and an anti-regional prejudice against the Mid-West and the South. As an example, negative portrayals of the American South in Hollywood films are particularly offensive and often include the negative or stereotypical portrayals of people, places or things in the Southern U.S. from Texas to Florida. Such portrayals appear to be the result of a form of regional stereotyping, based on the regional prejudice of the filmmakers themselves. The Hollywood film moguls (read bigots) must feel that prejudice based on pre-conceived notions about a group of people from a particular region of the country is more acceptable than prejudice based on pre-conceived notions about people of a certain race, religion, ethnic group or culture. But in reality, there is no substantial difference. Michael Medved also shows no interest in this blatant Hollywood bias, which again appears to be based on a widespread Hollywood prejudice against people, places and things of the American South.

The negative or stereotypical Hollywood portrayals of the South also started early. In 1928, *Steamboat Bill Jr.* starred Buster Keaton

as "a recent Yale graduate, (who) comes home to find his father, an irascible Mississippi riverboat captain, in deep trouble with a competing big company." Minneapolis-born Charles F. Reisner directed[292]. *Tom Sawyer* (1930) starred Jackie Coogan, Mitzi Green, Junior Durkin, Jackie Searle and Clara Blandick in a film based on the Mark Twain novel about kids growing up in the South. Ohio-born John Cromwell directed. The film was remade for TV in 1973 (with James Neilson directing)[292] and again in 1973 (UA/Readers Digest). The 1973 version was produced by Los Angeles-born Arthur P. Jacobs. The script was written by Richard and Robert Sherman (both of New York), and was directed by Pennsylvania-born Don Taylor.[292]

The following year, (1931) *Huckleberry Finn* was released as the "companion piece to 1930's popular *Tom Sawyer* with some of the same cast reprising their roles." Scheuer calls it "[l]ife on the Mississippi according to Hollywood." Chicago-born Norman Taurog directed.[293]

In 1932, Warners' *Cabin in the Cotton* starred Richard Barthelmess "as a poor sharecropper who is almost brought to ruin when he starts to run with rich-bitch Southern belle (Bette Davis)."[293] The film was directed by Michael Curtiz (born Mihali Kertesz in "Budapest, of Jewish parentage.")[293] Also, in 1932, Warner Bros. produced *I Am a Fugitive from a Chain Gang* an "account of the savage cruelty . . . suffered when (a man was allegedly) wrongly convicted of a crime and sentenced to a Georgia chain gang." The film "made the public aware of the brutality perpetrated by corrections officers. The outcry following the release of the film forced improvements in prison conditions."[293] The film starred the Austrian-born Jewish actor Paul Muni.[295] Steven Scheuer called it a "scathing indictment of life in a Southern chain gang . . . The movie and the book on which it was based caused quite a stir at the time and even led to some investigations." San Francisco-born Mervyn Le Roy (of "Jewish parents")[296] directed.[296]

In 1935, *The Little Colonel* starred Shirley Temple and Lionel Barrymore in what film critic Steven Scheuer calls a "[c]orny, contrived Temple vehicle of the old South." San Francisco-born David Butler

directed.[298] That same year, Butler directed *The Littlest Rebel* (1935) starring Shirley Temple as "the heroine of the Civil War."[299] Also, in 1935, *Mississippi* starred Bing Crosby, W.C. Fields and Joan Bennett in a "musical about a young man who refuses to fight a duel and takes refuge as a singer on a showboat." London-born Edward Sutherland directed.[300] Finally, that year, *So Red the Rose* (1935) starred Margaret Sullavan, Robert Cummings, Randolph Scott and Elizabeth Patterson in a "look at the Southern side of the Civil War." King Vidor, originally from Budapest, directed.[300]

The following year (1936), *Show Boat* starred Irene Dunne, Allan Jones, Helen Morgan and Paul Robeson in the tale of "two contrasting love affairs on a Mississippi riverboat." Dunne "ends up nursing a broken heart over her errant gambler husband . . . and the tragic mulatto (Helen Morgan) . . . loses the white man she loves." Britisher James Whale directed.[301] Also in 1936, 20th Century-Fox's *Banjo on My Knee* featured Joel McCrea, Barbara Stanwyck and Walter Brennan in a story about "the folks who live along the banks of the Mississippi."[302] Another non-Southerner, Ohio-born John Cromwell directed.[303]

In 1938, Paramount's *The Arkansas Traveler* was about "a wandering printer (who) comes to a small town and saves the local paper."[304] The film was directed by San Francisco-born Alfred Santell. That same year, *Kentucky Moonshine* (1938) featured the Ritz Brothers "as Kentucky hillbillies." San Francisco-born David Butler directed[305]. Also, in 1938, Warner's *Jezebel* starred Bette Davis and Henry Fonda in a story set "[j]ust before the War Between the States, (when) a high-spirited Southern belle (a so-called 'Confederate fallen angel') flouts convention, drives away the stalwart young man she loves with her unladylike behavior, and later redeems herself by risking her life to nurse him when he contracts yellow fever." German-born William Wyler, whose mother was a cousin of Universal's owner Carl Laemmle, directed.[306]

The following year, David Selznick's classic *Gone With the Wind* did not really explore the reasons for the U.S. Civil War, made several references to the mythical propensity in the South for marriage between cousins, showed a Christ figure blown out of a church

window during a Christian worship service, made Southern wom-
en appear shallow, self-centered and childish and made the men
generally appear as braggarts and inept, except for Rhett Butler
who is portrayed as a blockade runner who exploits the war for his
own profit. Otherwise, the film was ostensibly about the "siege of
Atlanta and the hardships of the South during the Civil War." Al-
though California-born Victor Fleming is credited as director, oth-
ers who worked on the film at one time or another include George
Cukor (New York-born), William Cameron Menzies (born in Con-
necticut) and Philadelphia-born Sam Wood[307]. Selznick had been
born in Pittsburgh. His father was Lewis Selznick (Zeleznik), one
"of 18 children of an impoverished Jewish family" from Kiev, Rus-
sia.[308] Interestingly enough, the Jewish Rothschilds of Europe also
had a preference for marrying within the family,[309] although little is
made of that in Hollywood films.

Novelist Valerie Sayers even argues that *Gone with the Wind*
(1939) is not a Southern movie at all. Ms. Sayers (born in Beaufort,
South Carolina) says that in *Gone with the Wind*, (the novel) she
"read a book suffused with Southern manners, a story narrated by a
Southerner who knew all about tradition and exaggerating history
so your side comes out noble. The very pace of the book, its careful
slow telling of every detail, is part of the South . . . [b]ut *Gone with
the Wind* the movie is not a Southern film at all, no matter how well
all those British actors finally speak their parts. It can't be South-
ern—it has to move too fast, and cover too much ground, and it has
to do it without the mediating voice of a narrator, or even a single
director[310]." In other words, to Sayers, *Gone with the Wind* the mov-
ie, represents another example of Hollywood retelling a Southern
story in the way Hollywood wants it told. It is filtered through the
cultural sensibilities of others; not told the way Southerners would
want the story told.

In the '40s, MGM released the Sam Zimbalist produced *Boom
Town* (1940), "a rousing tale about a pair of roughnecks who strike
it rich in the oil fields."[312] Minnesota-born Jack Conway directed.
Zimbalist was originally from New York. Also, in 1940, *An Angel*

from Texas portrayed people from the lone star state as "yokels". Indiana-born Ray Enright directed.[313]

The following year, (1941), the Paramount release *Virginia* starred Madeleine Carroll, Fred MacMurray, Helen Broderick, Sterling Hayden and Marie Wilson in what Steven Scheuer describes as "[o]ne of those hush-my-mouth melodramas about a magnolia-drenched heroine. Carroll (suffering from a case of Scarlett O'Hara fever) is forced to give up her plantation in order to make ends meet."[314] The film is actually about a "showgirl (who) goes home to claim her inheritance, but thinks of marrying a rich Yankee[315]." Edward H. Griffith, who was actually born in Virginia produced and directed. On the other hand, he was educated in England and Germany.[316]

Also, in 1941, *The Little Foxes* starred Bette Davis in a "film based on Lillian Hellman's . . . play about the double dealings of a Southern family presided over by a vixen named Regina." William Wyler directed for producer Samuel Goldwyn.[317] Hellman was the politically liberal playwright, screenwriter, originally from New Orleans, but educated at NYU. Wyler was originally from Germany and Goldwyn was from Warsaw. That same year, in *Lady for a Night* (1941) the "lady owner of a Mississippi gambling boat is accused of murdering a wealthy socialite."[319] New York-born Leigh Jason (Jacobson) directed.

Tobacco Road (1941) starred Charlie Grapewin, Marjorie Rambeau, Gene Tiernery, Dana Andrews and Ward Bond in a film based on the Broadway play about "depravity in the impoverished Georgia farmland." Maryland-born John Ford directed.[320] That same year, Paramount's *Louisiana Purchase* starred Bob Hope in a comedy "about an attempt to frame a senator down Louisiana way." New York-born Irving Cummings directed.[321]

The following year, (1942) *American Empire* told the pre-Civil War story of "two pals (who) build up a beef business in Texas"[322] then have a falling out[323]. Harry Sherman produced for United Artists. Pittsburgh-born William McGann directed. Also, 1942, the Warner Bros.' film *Juke Girl* offers the "sordid tale of conditions among Florida's migratory workers."[323] German-born Curtis Bern-

hardt directed for producers Jack Saper and New York-born Jerry (Jerome Irving) Wald.

In 1943, *Crystal Ball* featured Paulette Goddard (New York-born Pauline Marion Levee) as a "gal from Texas (who) takes a job as a fortune-teller's assistant, where she snags her man." [323] Goddard's character is actually a "failed beauty contestant (who) becomes a fortune teller and is involved in a land swindle[324]." Richard Blumenthal produced for United Artist. Ohio-born Elliott Nugent directed.

The following year, the 1944 Universal release *Ghost Catchers* was about two people who "run a night club next door to a house hired by a southern colonel in town to produce a show, and the house is said to be haunted.:[325] As Halliwell's Film Guide explains, the film features "a Southern colonel and his beautiful daughters (who) have spooks in their mansion—or bats in the belfry[326]." Wisconsin-born Edward Cline directed. Also, in 1944, *Dark Waters* was about a "girl (who) returns to her Southern mansion after a shipboard disaster, where she becomes convinced someone is trying to drive her insane."[327] Hungarian-born Andre de Toth directed for producer Benedict Bogeaus.

In 1945, *Saratoga Trunk* starred Gary Cooper as "a rough-edged Texas millionaire" and Ingrid Bergman as "a Creole beauty from the wrong side of the tracks, (but) bent on achieving a fortune."[328] Philadelphia-born Sam Wood again directed . Also, that year, the UA release, *The Southerner* told the story "of a determined sharecropper and his struggle for survival against the cruelties of both nature and his fellow man..."[329] Southerners to be sure. David Loew (the son of the Jewish exhibition executive Marcus Loew) and Egyptian-born Robert Hakim produced with Paris-born Jean Renoir directing. That same year (1945), *The Naughty Nineties* starred Budd Abbott and Lou Costello in an invasion of "the old Southern world of showboats and card sharks on the Mississippi[330]." Missouri-born Edward L. Hartmann and John Grant produced for Universal release. Arkansas-born Jean Yarbrough directed. Finally, in 1945, *Colonel Effingham's Raid* starred Charles Coburn as a "retired Southern colonel (who) decides to use his military background to straighten out a town." Pittsburgh-born Irving Pichel directed.[332]

In 1947, *The Romance of Rosy Ridge* starred Van Johnson, Thomas Mitchell and Janet Leigh in a story set "after the Civil War (with tensions still high)". In this film, a "mysterious stranger is looked upon with suspicion by a southern-sympathizing Missouri farmer." New York-born Roy Rowland directed.[333] The following year, (1948) *Feudin' Fussin' and A-Fightin'* is described by Steven Scheuer as a combination of "a little of 'Hatfield and McCoy Feud' and a lot of 'Li'l Abner', (with) . . . plenty of corn."[334] New York-born George Sherman directed.[335]

Also, in 1948, *Two Guys from Texas* starred Jack Carson, Dennis Morgan and Dorothy Malone in the story about a "[s]tranded vaudeville team (that) outwits city thugs down in Texas." The film is a remake of *Cowboy from Brooklyn*. San Francisco-born David Butler again, directed.[336] *Another Part of the Forest* (1948) told the "story of the . . . Hubbard family, a band of ruthless Southern industrialists who hated each other but loved money."[337] Denver-born Jerry (Jerome) Bresler produced with Maryland-born Michael Gordon directing. That same year (1948), *The Gallant Legion* was another western set in Texas. The film is about a "Texas Ranger (who) fights the leader of a powerful group desiring to split Texas into sections." California native Joseph Kane directed.[338]

The following year, (1949) *Roseanna McCoy* starred Farley Granger, Joan Evans, Raymond Massey and Richard Basehart in a film that depicts "the legendary feudin' hill families of the Hatfields and the McCoys." New York-born Irving Reis, directed.[339] Also, in 1949, *All the King's Men* was based on a novel "inspired by the career of (Louisiana Senator) Huey Long, who took a short step from democrat to demagogue and ended up a mirror image of the corrupt men he'd lambasted at the beginning of his career."[341] The film was directed by Robert Rossen, who was born in New York city, the "son of Russian-Jewish immigrants."[342]

That same year (1949), *Pinky* starred Jeanne Crain, William Lundigan, Ethel Barrymore and Ethel Waters in a "racial drama dealing with light-skinned Negro girl who comes home to the South." Constantinople-born Elia Kazan directed.[343] Also in 1949, *Streets of Laredo* starred William Holden and MacDonald Carey as "[t]wo

outlaws who have gone straight (and) meet up with their former partner after many years, who is still on the wrong side of the law." British-born Leslie Fenton directed.[344]

In 1950, 20th Century-Fox released *Panic in the Streets* starring Richard Widmark, Jack Palance, Paul Douglas, Barbara Bel Geddes and Zero Mostel. In this film, a "dead body in New Orleans is found to be carrying bubonic plague." Constantinople-born Elia Kazan, again directed.[345] Jack Palance played the part of "a gangster carrying the bubonic plague."[346] Jack Palance was born in Pennsylvania. New York-born Sol Siegel produced the film. Also, in 1950, the Warner release *The Glass Menagerie* starred Gertrude Lawrence, Jane Wyman, Kirk Douglas and Arthur Kennedy in the story of a "shy crippled girl (seeking to) . . . escape from the shabby reality of life in St. Louis and from her mother's fantasies." The film was directed by London-born Irving Rapper for producers Charles K. Feldman (Gould) and Jerome Irving "Jerry" Wald, both originally from New York. A 1973 so-called made-for-television sequel appeared in 1973 and the story was described by Steven Scheuer, as a "fading, southern belle (Katherine Hepburn) desperately trying to instill confidence in her sad crippled daughter (Joanna Miles) while steering her poetry-writing son toward a more remunerative career."[347] London-born Anthony Harvey directed . Ohio-born Paul Newman (whose father was Jewish)[348] directed another version of the same film in 1987.

The following year, (1951) *Storm Warning* starred Ginger Rogers, Ronald Reagan and Doris Day in a film about a model who "visits her mousy sister in the Deep South and ends up in deep trouble when she witnesses a KKK slaying involving her cretinous brother-in-law." Los Angeles-born Stuart Heisler directed[349]. Also, in 1951, Leonard Goldstein produced *Lady from Texas* for Universal. The film tells a "yarn about an eccentric old lady who turns a whole town upside down." New York-born Joseph Pevney directed.[350]

In 1951's *A Streetcar Named Desire*, starring Marlon Brando, Vivien Leigh, Karl Malden and Kim Hunter, the film tells the story of a "repressed southern widow (who) is raped and driven mad by her brutal bother-in-law." Constantinople-born Elia Kazan again, di-

rected, this time for New York-born producer Charles K. Feldman (Gould).[351] The film was remade for television with Ann-Margret, Randy Quaid, Treat Williams and Beverly D'Angelo in 1984. John Erman directed[353]. Also, in 1951, 20th Century-Fox released *I'd Climb the Highest Mountain* which told the "story of a Methodist preacher and his family in the hinterlands of cracker country."[8] Virginia-born Henry King directed for Atlanta-born producer Lamar Trotti.[354]

The following year, (1952) MGM's *The Bad and the Beautiful* featured Gloria Grahame as "a Southern belle" in a "drama about ambition and success in . . . Hollywood."[355] Chicago-born Vincente Minnelli directed for producer John Houseman (born Jacques Haussmann in Bucharest). That same year, *Untamed Frontier* starred Joseph Cotton, Shelley Winters and Scott Brady in what Steven Scheuer calls a "[s]prawling western . . . (about) the Texas frontier when cattle barons ran things and range wars were commonplace." Argentina-born Hugo Fregonese directed for producer Leonard Goldstein.[356] Also, in 1952, *Feudin' Fools* presented the Bowery Boys who "get involved in the hillbilly feudin' of the Smiths and the Joneses[357]." New York-born William Beaudine directed. Finally, in MGM's *Holiday for Sinners* (1952) the "future plans of a young doctor are changed when a broken-down prizefighter commits murder . . . in New Orleans during the Mardi Gras."[358] Montreal-born Gerald Mayer, "son of an MGM studio manager."[359] directed for producer John Houseman (who, as stated above, was born Jacques Haussmann in Bucharest).

In 1953, *Mississippi Gambler* starred Tyrone Power, Piper Laurie and Julie Adams in the story of a Southern "gambler who plays for high stakes in matters of love, honor, and reputation."[360] Poland-born Rudolph Mate (Matheh) directed. Warner Bros.' *A Lion Is In the Streets* (1953) starred James Cagney in the story about the "rise of a ruthless Southern politician . . . (and his exploitation of) the local townfolk."[361] New York-born Raoul Walsh directed for producer William Cagney. Also, in 1953, the Paramount release *Sangaree* starred Fernando Lamas, Arlene Dahl in a film that makes "San-

8 A cracker is a native or resident of Georgia or Florida, or thereabouts. The term is often used in an offensive manner.

garee, a Georgia plantation . . . the scene of (a) . . . turbulent drama about pirates and family jealousies." Russian-born Edward Ludwig directed.[362]

The Tall Texan (1953) starred Lloyd Bridges, Marie Windsor, Lee J. Cobb and Luther Adler in a stereotypical western in which a "group of assorted people band together on the desert to seek hidden gold which is cached in an Indian burial ground." Oklahoma-born Elmo Williams directed.[363] That same year, *Thunder Bay* (1953) starred James Stewart, Joanne Dru, Dan Duryea and Gilbert Roland in an "adventure yarn about oil prospectors and their run-in with shrimp fishermen in Louisiana when an off-shore drilling operation interferes with the routine of a small fishing community."[365] Anthony Mann (born Emil Anton Bundmann in California) directed for New York-born producer Aaron Rosenberg.

The following year, (1954) RKO's *The Americano* provides another stereotypical portrayal of a "Texas cowboy (who) gets mixed up with bandits in Brazil[366]." Robert Stillman produced with New York-born William Castle directing. That same year, the 20th Century-Fox release *The Raid* (1954) portrayed a "small group of Confederate soldiers (who) escape from a Union prison and plan the burning and sacking of a small Vermont town as partial payment for the destruction of Atlanta."[367] Argentina-born Hugo Fregonese directed for producer Robert L. Jacks.

In 1955, *Yellowneck* starred Lin McCarthy and Stephen Courtleigh in a story of "Civil War deserters (who) try to make their way through the Florida Everglades to freedom." R. John Hugh directed[368]. In Paramount's *Lucy Gallant* (1955) Charlton Heston "strikes oil and Jane Wyman builds the biggest fashion business in Texas but they find that marriage and careers don't mix."[369] Georgia-born Robert Parrish directed for Los Angeles-born producer William Thomas. That same year, (1955), Columbia's *Queen Bee* starred Joan Crawford as "a Southern socialite whose determination to dominate and rule everyone around her leads to destruction."[370] New York-born Ranald MacDougall directed for producer Jerry Wald (also from New York).[371]

The Phenix City Story (1955) starred Richard Kiley, John McIntire and Edward Andres in a story "dealing with the expose of one of the most corrupt 'Sin-Cities' in the United States: Phenix City, Alabama."[373] Phil Karlson (born Philip N. Karlstein in Chicago, of Jewish-Irish parentage),[374] directed for Allied Artists. The film was produced by Connecticut-born Sam Bischoff and David Diamond. According to the Katz Film Encyclopedia, the film was shot "on location in Alabama while the trial for the murder it depicted was still in progress. During the course of filming "new evidence was supposedly uncovered "that helped convict the murder suspects."[375]

20th Century-Fox's *The View from Pompey's Head* (1955) starred Richard Egan, Dana Wynter and Cameron Mitchell in the story of "an executive of a (New York) publishing house who goes back home (to the South) to investigate a claim of money due by an aging author who lives in an air of mystery."[375] The film was written and directed by New York-born Philip Dunne.[377] Also, in 1955, *Five Guns West* was "about five Civil War prisoners drafted into the Confederacy for a perilous mission involving a stolen gold shipment."[378] The film was produced and directed by Detroit-born Roger Corman.[379]

In 1956, Columbia's *The Houston Story* featured "Gene Barry striving for a top position in the (organized crime) syndicate centered in Houston, Texas[380]." New York-born William Castle directed for producer Sam Katzman, also originally from New York. Allied Artists' *The First Texan* (1956) starred Joel McCrea in another stereotypical western about Texas, this one during "the days when Texas fought for and gained independence from Mexico[381]." New York-born Walter Mirisch produced and Bryon Haskin of Oregon directed.

20th Century-Fox's *Between Heaven and Hell* (1956) was a WWII "tale about a group of less than exemplary soldiers . . . " in which Robert Wagner "plays a spoiled Southerner who learns things the hard way[382]." The film was directed by New York-born Richard Fleischer for producer David Weisbart (of California). Also, in 1956, Walt Disney's *The Great Locomotive Chase* featured Fess Parker as "a Union soldier who leads a dangerous mission behind the Confederate lines in order to destroy strategic railroad bridges[383]." North

Dakota-born Francis D. Lyon directed for producer Lawrence Edward Watkin.

The Republic release, *Come Next Spring* (1956) was about a "drunkard . . . "[384] who "returns home to his wife and family after eight years of wandering[385]." The film was directed by Tacoma, Washington-born R.G. Springsteen. Also, in 1956, *Written on the Wind* starred Rock Hudson, Robert Stack, Lauren Bacall, Dorothy Malone, Robert Keith and Grant Williams in an examination of the "decline and fall of the oil aristocracy, the film focuses on the sexual problems of a doomed family: the scion who's suffering from infertility and coping with suspicions about his wife's fidelity, and the sister, a nymphomaniac, who, having failed to get the man she loves, proceeds to sleep with every other man in Texas."[386] Douglas Sirk (born Claus Detleve Sirk in Denmark) directed.[387]

In *Kettles in the Ozarks* (1956) "Ma Kettle (played by Marjorie Main) visits Pa's lazy brother, played in the screen hillbilly tradition by Arthur Hunnicutt, and gets in the middle of a heap of trouble with bootleggers and the law."[389] San Francisco-born Charles Lamont directed.

Warner Bros.' *Giant* (1956) starred James Dean, Rock Hudson, Elizabeth Taylor, Carroll Baker and Denis Hopper in an "epic about the death of old Texas and the rise of the oil millionaires."[390] California-born George Stevens directed and co-produced with Henry Ginsburg.

The 1957 Columbia feature, *The Strange One* starred Ben Gazzara, Mark Richman and George Peppard in the story of "a Southern military academy as presided over by a sadistic upper classman."[391] Jack Garfein (a "survivor of the Auschwitz concentration camp . . ." originally from Czechoslovakia)[392] directed for Polish-born producer Sam Spiegel. Also, Warner's 1957 *Band of Angels* starred Clark Gable as "a New Orleans gentleman with a past . . ." and Sidney Poitier as "an educated slave."[393] The film was directed by New York-born Raoul Walsh.

That same year, 1957, *The Young Don't Cry* starred Sal Mineo and James Whitmore in a story "about a badly run Georgia orphanage

and one teenager in particular who gets involved with an escaped convict."[394] South Dakota-born Alfred L. Werker directed.

Also in 1957, MGM's *Raintree County* featured Elizabeth Taylor, playing "a cracked Southern belle, (who) unleashes a few miscegenational skeletons from her closet and goes mad."[395] Canadian-born Edward Dmytryk (born to Ukrainian immigrants)[396] directed for producer David Lewis (born David Levy in Trinidad).

Finally, in 1957, Disney's *Old Yeller* provides more Texans as stereotypical ranchers. The film was about "a terrific mongrel dog, redeemed from his bad ways by the love of a Texas ranch family."[397] London-born Robert Stevenson directed.

In 1958, 20th Century-Fox's *From Hell to Texas* is another stereotypical "western drama about a young cowboy, who tries to mind his own business and avoid trouble during a time when gunmen ruled the territory."[398] Henry Hathaway (born Henri Leopold de Fiennes in California) directed for Virginia-born producer Robert Buckner. Also, that year, UA's *Terror in a Texas Town* (1958) starred Sterling Hayden, Sebastian Cabot and Carol Kelly in the story about a "wayfaring sailor's visit back home (that) proves turbulent for him and troublesome for a greedy land-baron who's been gobbling up the local farmlands."[399] New York-born Joseph H. Lewis directed for producer Frank N. Seltzer.

That same year, (1958), Paramount's *Hot Spell* was another stereotypical "[f]amily drama set in the South." In this film, Shirley Booth "plays a disillusioned housewife whose family has grown away from her but she refuses to face the brutal truth[400]." Daniel Mann (born Daniel Chugerman in New York)[401] directed for Chicago-born producer Hal Wallis. In Warner's *No Time for Sergeants* (1958) Andy Griffith and Myron McCormick starred in the story of a "Georgia farm boy who gets drafted into the Army and creates mayhem among his superiors and colleagues." [402] San Francisco-born Mervyn Le Roy (of "Jewish parents")[403] produced and directed.

20th Century-Fox's *The Long Hot Summer* (1958) "spins out a steamy interlude in a Mississippi delta town." Orson Welles plays (the stereotypical tyrannical head of a Southern family)[404] Welles is "a blustery plantation owner, the cigar-chomping widower Will

Varner . . . When a young drifter (Paul Newman) comes to town it is a meeting of the minds. 'You're no better than a crook,' Welles says. 'You're no better than a con man,' Newman answers."[405] The action includes "[b]arn burnings, lengthy seductions, and a lynching party."[406] The film was directed by Martin Ritt (who was born in New York to "Jewish immigrants")[407] for New York-born producer Jerome Irving "Jerry" Wald. That same year, MGM's *Cat on a Hot Tin Roof* was released. The film is described by Steven Scheuer as one "of Tennessee William's most powerful studies of a southern family," which, of course, does not make the portrayal any more accurate or representative. The film features Elizabeth Taylor . . . as the wife of a former athletic hero (Paul Newman), who is dominated by his father and has taken to drink." The wife is constantly "plotting to get her petulant husband Brick back in her bed." The alcoholic former athlete, on the other hand, is "suspected of triggering his dead buddy's latent homosexuality."[408] Philadelphia-born Richard Brooks directed for Chicago-born producer Lawrence Weingarten. Jack Y. Hofsiss directed a remake of the film in 1984 starring Jessica Lange and Tommy Lee Jones.

UA's *Thunder Road* (1958) starred Robert Mitchum, Keely Smith and Gene Barry in a "drama about a group of people in the Kentucky hills who make moonshine whiskey and sell it[410]." New York-born Arthur Ripley directed. The Connecticut-born Mitchum also produced. That same year, (1958), Elvis Presley starred in Paramount's *King Creole*, a film about a "[y]oung busboy on the verge of delinquency (who) gets a break when he is forced to sing at a New Orleans nightclub." [411] Michael Curtiz (born Mihali Kertesz in Budapest of "Jewish parentage")[412] directed for Chicago-born producer Hal Wallis. In the 1958 release *God's Little Acre* (based on Erskine Caldwell's famous novel) is "about dirt farmers in Georgia . . . (and) the head of the Walden clan, whose mad obsession that there's gold on his land leads him to near tragedy[413]." Anthony Mann (born Emil Anton Bundmann in California) directed for producer Sidney Harmon.

In the 1959 UA release, *The Wonderful Country* (1959) Robert Mitchum, Julie London, Jack Oakie and Gary Merrill star in another

stereotypical "western tale with Mitchum cast as a Texan who has a strange allegiance to the Mexicans and consents to buy arms to be used in the revolution[414]." Georgia-born Robert Parrish directed for Vienna-born producer Chester Erskine[415]. Also in 1959, 20th Century-Fox's *The Sound and the Fury* starred Yul Brynner, Joanne Woodward, Stuart Whitman and Ethel Waters in a "version of William Faulkner's novel of the decadent South . . . the story of a young girl trying to find a life of her own away from the tyrannical rule of her uncle."[416] Martin Ritt (the New York-born "son of Jewish immigrants")[418] directed for New York-born producer Jerome Irving "Jerry" Wald[419]. Paramount's *Li'l Abner* (1959) was the film version of the "Broadway musical based on the famous cartoon characters of Dogpatch." [420] Melvin Frank directed with co-producer Norman Panama. Both men were originally from Chicago.

As the '60s decade began, MGM's *Home from the Hill* (1960) starred Robert Mitchum in a "yarn of a southern town, a roistering landowner, his son, and the youth whose relationship to the family causes tragedy[421]." Chicago-born Vincente Minnelli directed for New York-born producers Sol Siegel and Edmund Grainger. Also, that year, 20th Century-Fox's *Desire in the Dust* (1960) provides another "dose of lust and desire in a southern town." The film is about a "[t]yrannical landowner with skeletons in his closet (who) sees his political ambitions in jeopardy, (and) tries unscrupulous means to rid himself of his troubles."[422] The film was produced and directed by William F. Claxton.

Also, in 1960, *Young Jesse James* starred Ray Stricklyn, Robert Dix, and Willard Parker in "another version of how Jesse went bad—this time he joined Quantrill's Raiders because Union soldiers killed his father." William Claxton again directed.[423] UA's 1960 release, *Inherit the Wind*, featured Spencer Tracy, Fredric March and Gene Kelly in a motion picture "dealing with the famous trial (the Scopes trial) in the twenties in which a school-teacher was arrested for teaching Darwin's theory of evolution."[424] Halliwell's Film Guide says the film is "enhanced by a realistic portrait of a sweltering southern town[425]." New York-born Stanley Kramer produced and directed.

The 1961 release *Shame* starred William Shatner, Jeanne Cooper in a "drama about a racist who visits Southern towns to incite the locals against enforced school integration."[426] Detroit-born Roger Corman[427] directed. Corman also produced and directed *The Intruder* that same year. That film was about a "mild-mannered stranger (who) arrives in a southern town and stirs up racist trouble[428]." Corman said it was the first film he "directed from a deep political and social conviction (it was about racial-prejudice, busing and desegregation in a small Southern town)." Corman said it "was important to the filmmakers and to me that we have something to say within the film."[430]

20th Century Fox's 1961 release *Sanctuary* featured Lee Remick, Yves Montand, Odetta Holmes and Bradford Dillan in "Faulkner's seamy tale of the South in the 1920s . . . " the story of a "Governor's daughter (who) is seduced by a Cajun, who returns after she's married to cause her further trouble."[431] British-born Tony Richardson directed for Los Angeles-born producer Richard D. Zanuck. Also, in 1961, *The Little Shepherd of Kingdom Come* was about the stereotypical "Kentucky mountain boy (who) is a wanderer until taken in by a loving family; but he takes the side of the North when the Civil War begins."[433] London-born Andrew V. McLaglen directed.

Paramount's 1961 release *Summer and Smoke* starred Geraldine Page, Laurence Harvey and Una Merkel in a film set in "a small Mississippi town in 1916." The film focuses on a "minister's spinster daughter (who) nurses an unrequited love for the local rebel."[434] Scheuer says the film is about "a frustrated spinster grappling with the extremes of carnal and romantic love" and that the subject matter is "given a vulgar . . . screen treatment." [435] British-born Peter Glenville directed for Chicago-born producer Hal B. Wallis.

The following year, in *Young Guns of Texas* (1962) James Mitchum, Alan Ladd, Jody McCrea and Chill Wills are featured in a film about a chase "after a group of Confederates as the Civil War ends."[436] Maury Dexter directed. Also, in 1962, Columbia's *Walk on the Wild Side* starred Laurence Harvey, Capucine, Jane Fonda, Anne Baxter and Barbara Stanwyck in the story of a man who "finds his childhood love working in a New Orleans brothel during the De-

pression."[437] Canadian-born Edward Dmytryk (born to Ukranian immigrants)[438] directed for producer Charles K. Feldman (born Charles Gould in New York). The script was based on the Nelson Algren novel.

The UA 1962 release *Follow that Dream* starred Elvis Presley in a "comedy about a group of hillbilly homesteaders who settle in a small Florida town." [439] New York-born Gordon Douglas directed for Los Angeles-born producer David Weisbart. Also, in 1962, *To Kill a Mockingbird* starred Gregory Peck, Mary Badham, Philip Alford and Brock Peters in the film based on Harper Lee's book "about an Alabama lawyer bringing up his two motherless children"[441] and defending "a black man accused of rape."[442] According to Steven Scheuer, the film is "one of the best movies dealing with race relations that the American film industry has ever made."[443] Robert Mulligan directed for Jewish producer Alan Pakula.[444] Both were born in New York. Finally, in 1962, *Poor White Trash* starred Douglas Fowley, Bill Hays, Peter Graves, Lita Milan and Tim Carey in a film "about a Cajun girl romanced by a northern pretty boy to the jealous outrage of a local he-man, a Cajun suitor who does a sweaty folk dance to express his sex drive."[445] Harold Davids directed.

In 1963, *Hootnanny Hoot* portrayed a "bunch of college hottenannyans from Missouri (who) take their down-home act to TV-land." Steven Scheuer calls it "[d]rivel about country music."[446] Seattle-born Gene Nelson directed. Also, in 1963, Warner's *Four for Texas* presents Dean Martin, Frank Sinatra and Anita Ekberg in another stereotypical Texas "western comedy that pits the two stars against each other until they join forces against a third party."[447] Rhode Island-born Robert Aldrich produced and directed.

MGM's *Come Fly with Me* (1963) was a U.S./British production "about a trio of attractive girls . . . (who are romantically interested in) a pilot, a titled jewel thief and a Texas millionaire."[449] New Jersey-born Henry Levin directed this additional stereotypical treatment of a Texan for Russian-born producer Anatole de Grunwald. That same year (1963), *Gone Are the Days* starred Ossie Davis in a film described by Scheuer as "a brash, satiric swipe at racism and Uncle Tomism in the South by updating Negro folk tales to contempo-

rary struggles."[450] Nicholas Webster directed. The UA 1963 release *Toys in the Attic* starred Dean Martin, Geraldine Page, Wendy Hiller, Yvette Mimieux and Gene Tierney in the story about a "no-good rover (who) returns to his New Orleans home with his childlike bride, (and) brings trouble for his spinster sisters."[451] Minneapolis-born George Roy Hill directed for New York-born producer Walter Mirisch.

In 1964, *It's Alive* told the story of "[m]otorists (who) break down in the Ozarks and are imprisoned along with a geologist in the cave of a demented man."[452] Larry Buchanan directed. Also, in 1964, MGM's *Kissin' Cousins* starred Elvis Presley in a "musical about trying to build a missile site despite resistance from some hicks."[453] in the Smoky Mountains.[454] Gene Nelson (born Gene Berg in Seattle) directed for New York-born producer Sam Katzman. Also, that year, (1964), *2,000 Maniacs* starred Thomas Wood, Connie Mason, Jeffrey Allen and Shelby Livingston in the story of a "group of young swingers (that) is held captive and tortured by a warped Southern ghost town, which comes alive every hundred years to avenge the sacking of their village during the Civil War."[455] Hershell Gordon Lewis directed.

The next year, (1965) *Nothing But a Man* starred Ivan Dixon and Abbey Lincoln in a film "about a Negro couple who strive for dignity in an Alabama town . . . (and) meet with more than their share of opposition as they try to make a life for themselves."[456] German-born Michael Roemer directed. Then in 1966, *That Tennessee Beat* starred Merle Travis and Minnie Pearl in the story of an "[a]mbitious country singer (who) robs to get ahead, (and) is reformed under sympathetic guidance of a lady preacher after being mugged[458]." Richard Brill directed. That same year, (1966), *Las Vegas Hillbillies* portrayed a "[c]ountry boy (who) inherits a broken-down salon, (and) turns it into a success by bringing hillbilly music to Las Vegas."[459] Arthur C. Pierce directed.

Columbia's 1966 release, *The Chase* starred Marlon Brando, Jane Fonda and Robert Redford in a "story about sex and sin in a small Texas town."[460] Arthur Penn (born in Philadelphia "of Russian-Jewish descent")[461] directed for Austrian-born producer Sam Spiegel.

Also in 1966 Paramount released *This Property is Condemned* starring Natalie Wood and Robert Redford. The film is about the "[s]exual adventures of a tubercular but beautiful girl in her mother's board-ing house in a Mississippi town[462]." The film was produced by Ray Stark and John Houseman (born Jacques Haussmann in Bucharest) and directed by Sydney Pollack (who was born in Indiana the "son of first-generation Russian-Jewish Americans")[463] Also, in 1966, *Af-rica—Texas Style* presents another stereotypical "adventure about a cowboy who hunts and tames wild game."[464] Andrew Marton (born Endre Marton in Budapest) directed.

In 1967, the Warner release, *Hotel* provided more Southern ste-reotypes in telling about the "[t]rials and tribulations at a posh New Orleans hotel, mainly the efforts made to keep it from falling into the wrong hands."[464] Detroit-born Richard Quine directed for Missouri-born producer Wendell Mayes. Also, in 1967, UA's *In the Heat of the Night* (1967) was "about prejudice, manners and morals in a small Mississippi town." Film critic Steven Scheuer credits the film's director, Norman Jewison with doing "an outstanding job in creating the subsurface tension of life in a 'sleepy' Southern town."[465] The Toronto-born Jewison directed for New York-born producer Walter Mirisch.

That same year, (1967) the Warner/Seven Arts release *Reflections in a Golden Eye* starred Elizabeth Taylor and Marlon Brando in an "examination of frustrated passions on a military base." According to film critic Steven Scheuer, the film is a "spirited slice of South-ern Gothic . . . (offering) whippings, adultery, fetishism, and nude horseback riding." The plot revolves around "an ineffectual Major who plays soldier with his men, and house with his lusty wife, while sublimating his fierce love for a taciturn private who only has eyes for the Major's wife."[467] Missouri-born John Huston directed for producer Ray Stark. Seven Arts, which owned Warner Bros. for a short period in the '60s was controlled at the time by Elliott and Kenneth Hyman.

Also, in 1967 Columbia's *The Long Ride Home* (aka *A Time for Kill-ing*) portrayed a "Union officer (Glenn Ford) on the trail of escaped Confederate soldiers."[468] Phil Karlson (born Philip N. Karlstein in

Chicago) "of Jewish-Irish parentage."[469] directed for Pittsburgh-born producer Harry Joe Brown. MGM's *The Fastest Guitar Alive* (1967) starred Roy Orbison and Sammy Jackson as "a couple of Confederate operators . . . out to rob a mint."[470] Michael Moore directed for New York-born producer Sam Katzman.

In the 1967 Warner release *Cool Hand Luke*, Paul Newman starred as "a prisoner on a southern chain gang"[471] and George Kennedy played "the brutal leader of the chain-gang crew."[475] New York-born Stuart Rosenberg directed for Baltimore-born producer Gordon Carroll. The Cleveland-born Newman was the "son of the Jewish owner of a sporting goods store and a Catholic mother of Hungarian descent."[476] Halliwell's Film Guide claims the film was intended to be "a Christ-allegory."[477]

Movie critic Steven Scheuer calls another 1967 release, Paramount's *Hurry, Sundown*, a "lurid and laughable tale of passions and predicaments of the black and white inhabitants of a Georgia town. Southern movie cliche's abound, as bad white guys will stop at nothing to acquire land."[478] Vienna-born Otto Preminger produced and directed.

The 1968, Warner/Seven Arts release, *The Heart is a Lonely Hunter* starred Jewish actor Alan Arkin[480] in a film about "the life of a deaf-mute in a small Southern town . . . (a) story of loneliness, human boorishness and cruelty."[481] New York-born Robert Ellis Miller directed for producer Joel Freeman. Also, in 1968, *Journey to Shiloh* was "about a group of green young men who set out for Virginia to join up and fight for the confederacy."[482] William Hale directed.

The following year, (1969), *Salesman* was presented as a "documentary . . . about the lives of several Bible salesmen in the South."[483] Massachusetts-born brothers Albert and David Maysles directed. Also, in 1969, *Slaves* starred Stephen Boyd, Ossie Davis, Barbara Ann Teer and Gale Sondergaard in a "serving of lust and villainy on the old plantation as a sensitive slave (Ossie Davis) fights for freedom against the dastardly overseer (Stephen Boyd)."[484] Philadelphia-born Herbert J. Biberman directed for producer Philip Langner. UA's *Midnight Cowboy* (1969) starred Dustin Hoffman and Jon Voight in the story of a "slightly dim-witted Texan (who) comes to

New York to offer his services as a stud for rich ladies, but spends a hard winter helping a tubercular con man."[485] John Schlesinger (born in London, "the son of a Jewish pediatrician")[486] directed for New York-born producer Jerome Hellman.

In 1970, the MGM release *Brewster McCloud* told the story of a man who "hides out under the roof of the Houston Astrodome, prepares to learn to fly with man-made wings, and refuses all offers of help; when he launches himself, he falls to his death."[487] Missouri-born Robert Altman directed for producer Lou Adler. Also, in 1970, *My Sweet Charlie* starred Patty Duke and Al Freeman Jr. in a film about "a young pregnant Southern girl, thrown out by her father, (who) takes refuge in a cottage." The film is set in "a remote Louisiana resort area, closed up during the off-season."[488] California-born Lamont Johnson directed. In *Last of the Mobile Hot Shots* (1970) James Coburn stars as "the last of the Thoringtons, (who) marries a hooker . . . so he can return to his decaying plantation and try to germinate an heir before cancer kills him."[490] Philadelphia-born Sidney Lumet directed.

WUSA (1970) starred Paul Newman, Joanne Woodward, Laurence Harvey and Anthony Perkins with Newman as "an ex-drunk who gets a job as a disc jockey on WUSA, an all-the-way-to-the-right radio station in New Orleans." Steven Scheuer calls it a "pretentious film with unfulfilled aspirations to dissect the Southern right-wing political ideology." Scheuer also claims Newman was miscast in this film.[491] New York-born Stuart Rosenberg directed. The 1970 Paramount release *Norwood* starred Glen Campbell, Kim Darby and Joe Namath in the "saga of a country boy, fresh from Vietnam, who sets out from Texas to New York to become a TV singer."[492] Jack Haley, Jr. directed for Chicago-born producer Hal Wallis.

MGM's ... *tick* ... *tick* ... *tick* (1970) starred Jim Brown, Fredric March and George Kennedy in a "drama about a Southern town's sudden shift from a peaceful community to a veritable powder keg. The incident which sets off the situation is the election of the town's first black sheriff, played by Jim Brown."[493] New York-born Ralph Nelson directed and co-produced with James Lee Barrett.

Also in 1970, Columbia's *I Walk the Line* (1970) starred Gregory Peck and Tuesday Weld in a story "set in the moonshine country of Tennessee . . . about bootlegging moonshiners and their constant bouts with the local law."[494] New York-born John Frankenheimer (born "to a German-Jewish stockbroker father and an Irish Catholic mother")[495] directed and co-produced with Harold D. Cohen.

That same year, the MGM release, *The Moonshine War* starred Alan Alda, Patrick McGoohan, Richard Widmark and Melodie Johnson in a story about a time when the "repeal of Prohibition is only a few months away, (and) . . . revenue agent McGoohan is interested in getting the 150 bottles of aged moonshine hidden on Alda's property"[496] in Kentucky.[497] Detroit-born Richard Quine directed for producers James C. Pratt and Leonard Blair.

In the 1971 release, *The Scavengers*, "renegade Southerners engaged in gang rape."[499] Also, in 1971, Universal's *The Beguiled* was Chicago-born producer/director Don Siegel's Civil War gothic horror tale about "a wounded Union soldier taking refuge in a (Confederate) girls' school."[500] The "teachers fend for him until he causes trouble among the sexually frustrated women, who eventually kill him[501]." The Peter Bogdanovich film *The Last Picture Show* (Columbia—1971) starred Jeff Bridges and Cybill Shepherd. It is a depressing tale about the significance of the closing of a movie theatre in a small West Texas town (Archer City) and is intended to represent "a great many things that happened to America in the early 1950s". The people in the town suffer from "a general malaise, and engage in sexual infidelities partly (according to Roger Ebert) to remind themselves they are alive. There isn't much else to do . . . no dreams worth dreaming, no new faces, not even a football team that can tackle worth a damn[501]." The New York-born Bogdanovich directed for producer Stephen J. Friedman.

The Last Rebel (1971) is a Civil War action-pic featuring Joe Namath "saving blacks from lynchings."[501] Denys McCoy directed. In Columbia's *Brother John* (1971) Sidney Poitier plays "an angel . . . who returns to his hometown in Alabama to see how the folk are faring in this day and age of hate and violence[501]." The Los Angeles-born James Goldstone directed for producer Joel Glickman.

The 1972 film, *Boxcar Bertha* was about "a woman labor organizer in Arkansas during the violence-filled Depression era of the early '30s[502]." New York-born Martin Scorsese directed for Detroit-born producer Roger Corman. The 1972 20th Century-Fox release *Sounder* starred Cicely Tyson, Paul Windfield, Kevin Hooks and Carmen Mathews in the story of "a family of sharecroppers in rural Louisiana during the Depression. The father is imprisoned for stealing a ham, and injured at the prison work farm before he returns home." In the meantime, the Tyson character "carries her family through various crises[503]." Roger Ebert explains that the film is about the "trap that Southern society set for black sharecroppers (and) . . . dealing with the white power structure (and) . . . the Southern growth of black pride."[504] New York-born Martin Ritt (the "son of Jewish immigrants")[505] directed for New York-born producer Robert B. Radnitz. Again, neither this individual film nor its subject-matter is objectionable in and of themselves. It only becomes objectionable when it is realized that this is one of a very long-list of films focusing on the more negative aspects of the South and that there are few, if any, films coming out of Hollywood that focus on the more positive aspects of the South. Such a clear pattern of bias leads to the conclusion that these films taken together are nothing more than Hollywood propaganda regarding the American South.

Interestingly enough, for twelve years after the Civil war (during Reconstruction) the legislatures of the Southern states were run by carpetbaggers and scalawags[506]. On the other hand, Hollywood has chosen to make their activities in the South during this period the focus of few, if any, of its movies.

In *The Legend of Nigger Charley* (1972) a slave "flees Virginia after murdering an inhuman slave overseer[510]." Martin Goldman directed. This is the kind of film that helps to create the impression that a U.S. film industry controlled by Jewish males of a European heritage are in fact attempting to utilize a "divide and conquer" strategy by stirring hatred among African-Americans in the U.S., hatred directed against whites generally, and White Southern males specifically. Also, in 1972, Columbia's *Buck and the Preacher* starred Sidney Poitier and Harry Belafonte as "escaped slaves heading West."[511]

Poitier directed for producer Joel Glickman. Poitier was born in Florida and raised in the Bahamas.

Payday (1972) starred Rip Torn, Elayne Heilveil and Ahna Capri in a "film about a second-rate country and western singer (Torn) whose road to . . . Nashville . . . is littered with men and women used and abandoned when he no longer needs them[512]." Daryl Duke directed for producer Ralph J. Gleason. Also, in 1972, the Warner release *Deliverance* was about "[f]our businessmen . . . (who) set out on a canoe trip down a wild Georgia river and look forward to nothing more hazardous than riding the rapids, but their adventure becomes a nightmare. They encounter two demented hillbillies, one of whom physically violates Beatty, and the nature trek turns into a struggle laced with killing[513]." British-born John Boorman produced and directed.

Dear Dead Delilah (1972) featured the "heirs to an old southern mansion (who) are being axed to death over a hidden fortune."[514] John Farris directed. That same year, in *The Life and Times of Judge Roy Bean* (1972) Paul Newman "postures as the self-appointed Texas judge (circa 1880)."[515] Missouri-born John Milius directed for producer John Foreman.

The following year (1973), *The Legend of Boggy Creek* was "allegedly based on the true experiences of the residents of Fouke, Arkansas, terrorized for years by the hairy monster that lived in the woods."[516] Charles B. Pierce directed. More Southern stereotypes were portrayed in 1973's *Walking Tall*. The film starred Joe Don Baker, Elizabeth Hartman, Gene Evans and Rosemary Murphy in the supposed story of a "real Tennessee sheriff, Buford Pusser, (who took) . . . a stand against his hometown syndicate-owned gambling operations, and one brutal beating from the mobsters almost cost him his life."[517] The script was written by and the film was produced by Mort Briskin. It was directed by Phil Karlson (as noted earlier, born Philip N. Karlstein in Chicago, "of Jewish-Irish parentage").[519] The sequel *Walking Tall, Part II* (1975) starred Bo Svenson, Luke Askey and Noah Beery. The sheriff, "now played by Svenson, attempts to track down the man who killed his wife in an ambush which left him severely wounded."[519] Minnesota-born Earl Bellamy

directed. Another sequel, *Walking Tall: Final Chapter*, followed in 1977.

That same year, the UA release *White Lightning* (1973) starred Burt Reynolds, Jennifer Billingsley, Ned Beatty, Louise Latham and Bo Hopkins in a "melodrama about murder, revenge, and moonshine in the new South. Reynolds is a convict who's released in order to help the Feds nail sadistic sheriff Beatty."[521] Joseph Sargent (born Giuseppe Danielle Sorgente in New Jersey) directed for the Levy-Gardner-Laven production group. Also, that year, Paramount's *Bang the Drum Slowly* (1973) was "mostly about baseball and the daily life of a major league club on the road" but the film presents a "dumb (and mediocre) catcher from Georgia . . . who is constantly being ragged by his teammates."[522]

The catcher eventually "finds that he is dying of leukemia."[523] Missouri-born John Hancock directed for producers Maurice and Lois Rosenfield.

In MGM's *Lolly-Madonna XXX* (1973) Rod Steiger, Robert Ryan and Jeff Bridges star in a "family feud in Tennessee." Steiger and Ryan are the opposing fathers who let a small squabble over some disputed land escalate into a bloody war[524]." New York-born Richard C. Sarafian ("of Armenian descent")[525] directed for Rodney Carr-Smith. The 1973 20th Century-Fox release *Hard Driver* (aka *The Last American Hero*) starred Jeff Bridges as a stock-car racer in North Carolina" who started out as "a young moonshiner, running whiskey past the revenuers."[526] California-born Lamont Johnson directed for producers John Cutts and William Roberts.

In 1974 *The Virginia Hill Story* was a so-called made for TV movie starring Dyan Cannon, Harvey Keitel, Allen Garfield and Robby Benson (born Robert Segal), with Cannon starring in this so-called "true-life tale about a poor Southern girl who hits the big time as the girlfriend of (Jewish mobster) Bugsy Siegel, who was murdered in Beverly Hills back in 1947[527]." New York-born Joel Schumacher directed. Interestingly, Cannon, Keitel and Garfield are identified as Jewish actors by the respective Lyman, Ebert and Katz publications (see bibliography) making this film a predominantly Jewish production about a girl from the South.

Also, in 1974, *Where the Lilies Bloom* (1974) starred Julie Ghol-son, Jan Smithers, and Harry Dean Stanton in a story "about four (North Carolina) children orphaned when their father dies. The plucky 14-year-old daughter (Gholson) assumes command of the household and conspires to keep the news of her father's passing from their neighbors for months."[528] William A. Graham directed.

The 1974 Disney release, *The Castaway Cowboy* featured James Garner as another Texan who is a cowboy, this time the "Texan . . . finds himself in Hawaii in 1850 where he gives in to the pleadings of a widow and her charming son to turn their farm into a cattle ranch."[529] The film was directed by Vincent McVeerty and pro-duced by Los Angeles-born Ron Miller and Winston Hibler. UA's *Thieves Like Us* (1974) was "about a gang of fairly dumb bank rob-bers, and about how the youngest of them falls in love with a girl, and about how they stickup some banks and listen to the radio and drink Coke and eventually get shot at." "They play out their sad little destinies against . . . the pastoral feeling of the Southern countryside." Roger Ebert describes them as "are small people in a weary time."[531] Missouri-born Robert Altman directed for producer Robert Eggenwiler.

The Texas Chainsaw Massacre (1974) starred Marilyn Burns, Al-len Danzinger and Paul A. Partain in the story of a "group of young people (who) ventur[e] into the Texas desert (and) run afoul of a demented family who use human flesh in the meats that they eat and sell[532]." As Roger Ebert reports, the film is "as violent and grue-some and blood-soaked as the title promises . . . It's also without any apparent purpose, unless the creation of disgust and fright is a purpose."[533] Texas-born Tobe Hooper directed. Of course, in an industry with as many struggling directors as the film industry, it is not difficult at all to find someone from the South who is willing to make a thoroughly disgusting movie about the region. *The Texas Chainsaw Massacre, Part 2* was released in 1986.

It is often true that some people cannot see the forest for the trees. With these movies, more negative portrayals of people, places and things from the South are added to that long list of movies ex-hibiting such a Hollywood bias. If a film critic is merely evaluat-

ing the specific films and is not sensitive to the views of much of the population of an entire region of the country, it is easy to see why such a critic would overlook the larger "purpose" (or effect) to which this movie contributes, a cumulative negative perception of people, places and things in the American South.

Columbia's *Buster and Billie* (1974) was "about high-school students in rural Georgia, circa 1948. Joan Goodfellow (plays) . . . the acquiescent town tramp who finally falls for Buster (Jan Michael Vincent)."533 The film was directed by Canadian-born Daniel Petrie. Also, in 1974, *Thomasine and Bushrod* starred Max Julien, Vonetta McGee and George Murdock in a so-called "blaxploitation" film; a "comedy-adventure about a black outlaw duo cutting a swath through Texas in the early 1900s."533 Kansas-born Gordon Parks, Jr. directed. Roger Corman's New World Pictures produced and distributed *Cockfighter* (1974), a story "about a Southern man who owns a stable of fighting cocks." The Detroit-born Corman considered the picture "an interesting, commercial film about the dark side of rural America . . . a fascinating look at a subculture of American life."534 Isn't it odd that Corman could not obtain Hollywood financing for and find any dark and fascinating "subculture" in his hometown of Detroit about which to make an "interesting" film?

Universal's *The Sugarland Express* (1974) starred Goldie Hawn and William Atherton in "story of a young Texas couple . . . running from the law, trying to regain custody of their baby who has been farmed out to a foster family while they were in prison for some petty thefts."535 Ohio-born Steven Spielberg ("of Jewish descent")536 directed for producers Richard Zanuck (born in Los Angeles).537 and New York-born David Brown. Goldie Hawn was "born of a Jewish mother and Protestant father in Washington, D.C."539 Thus, this film appears to be another in a long series produced by non-Southern and Jewish filmmakers who provide another negative or stereotypical portrayal of people, places and things from the American South.

Macon County Line (1974) is about "a vengeful southern sheriff who is out for blood after his wife is brutally killed by a pair of drifters."540 Richard Compton directed for Nebraska-born pro-

ducer Max Baer. Also, in 1974, *The Godchild* was a "remake of the 1948 John Ford-John Wayne film *Three Godfathers*, which told the story of three Civil War prisoners who are running from the Confederates and Apaches, and come across a dying woman about to give birth."[541] John Badham (British-born, but raised in Alabama)[542] directed. *Lovin' Molly* (1974) was about "a Texas lass who wouldn't let convention stand in the way of loving two men at the same time, for a period covering four decades."[543] Philadelphia-born Sidney Lumet (son of Yiddish stage actors)[544] directed for producers Stephen Friedman and David Golden.

The 20th Century-Fox feature *Conrack* (1974) starred John Voight and Paul Windfield. The film tells the "story about a young white school teacher who goes to help a group of culturally deprived black youngsters on an island off the coast of South Carolina."[545] New York-born Martin Ritt ("son of Jewish immigrants")[546] directed and co-produced with New Jersey-born Irving Ravetch. One of the questions that may be asked about his movie might be: "Are there isolated groups of culturally deprived black youngsters anywhere else in the U.S.?" And, if so, why did Hollywood choose to make a movie about such children in South Carolina? In the meantime, that same year, *The Autobiography of Miss Jane Pittman* (1974) told the story of "a 110-year old woman who was an ex-slave, and lived to take part in a civil rights demonstration in 1962." The film uses extensive flashbacks "depicting various episodes in the life of Miss Jane, a fictional character, but the incidents (according to Steven Scheuer) are based on real incidents that happened throughout the South after the Civil War."[547] The film was directed by Indiana-born John Korty.

Paramount's 1974 feature, *The Klansman* starred Lee Marvin, O.J. Simpson and Linda Evans in a story "about racial tensions in the big bad South. Marvin's the sheriff who's got to put a lid on the brewing hostilities after Evans gets raped and the KKK get their sheets in an uproar."[548] Terence Young (born to British parents in Shanghai)[550] directed for producer William Alexander.

In 1975, *The Deadly Tower* was a "dramatization of the chilling tale of a young sniper, who climbed up the tower at the University

of Texas (at Austin) and fired upon innocent passersby, killing 13 people and wounding 33 others."[550] Jerry Jameson directed. That same year, in *Return to Macon County* (AIP—1975) Nick Nolte and Don Johnson portray "a pair of itinerant drag-racing bums . . . as they again get in trouble with the law."[552] Richard Compton directed for producer Eliot Schick. Also, in 1975, "[t]he old Hatfield-McCoy feud is trotted out again (the tale of feuding Kentucky clans) in the so-called made for TV movie *The Hatfields and the McCoys*[553]. Clyde Ware directed.

Red Neck County (1975) starred Leslie Uggams, Shelley Winters and Michael Christian. According to Steven Scheuer, the film was based on the racist premise that "[t]hey don't cotton to wealthy Yankee ladies, especially black ones, way down South. But they pick the wrong rich black northern chick to pick on when they mess with Leslie[554]." Richard Robinson directed. That same year, (1975) *The Moonrunners* starred James Mitchum, Waylon Jennings and Joan Blackman in what Steven Scheuer refers to as a "[s]our-mash action-comedy about a band of bootleggers, (supposedly) based on the real-life exploits of Jerry Rushing, a North Carolina celebrity[555]." Gy Waldron directed.

Columbia's *Hard Times* (1975) starred Charles Bronson as a "bare-knuckle street fighter slugging his way to a couple of paydays in New Orleans during the Depression era of the 1930s." James Coburn plays "an on-the-make small-time hustler and boxing promoter."[556] California-born Walter Hill directed for Mississippi-born producer Lawrence Gordon. Also, in 1975, *Murph the Surf* (aka *Live a Little, Steal a Lot*) was supposedly "based on the real-life crimes of two Florida ne'er-do-wells who figured a way to steal the 'Star of India' gem from New York's American Museum of Natural History."[557] Marvin Chomsky directed for producer Dominick Galate.

Mandingo (1975) starred James Mason, Ken Norton, Susan George and Perry King in a film about "a hard-lovin', hard-fightn' stud-slave . . . (on) a slave-breeding plantation in Louisiana circa 1840."[558] New York-born Richard Fleischer directed for producer Peter Herald and Dino de Laurentiis from Italy. Steven Scheuer describes Paramount's *Nashville* (1975) as a film "commenting on the

American dream, while focusing on Nashville, the dream center and cultural capital of country music."[559] On the other hand, the film actually provides a rather absurd portrait of "the losers and the winners, the drifters and the stars in Nashville."[560] Missouri-born Robert Altman produced and directed.

In 1976, *Scalpel* starred Robert Lansing, Judith Chapman and Arlen Dean Snyder in a "Georgia-made thriller about a "[p]lastic surgeon (who) . . . makes the face of go-go dancer Chapman to resemble his missing daughter so that he can get his hands on the latter's inheritance."[561] John Grissmer directed. Also, in 1976, Columbia's *Drive-In* portrays "various illicit activities (that) find their climax at a (Texas) drive-in movie."[562] Rod Amateau directed for producer George Litto. *Nightmare in Badham County* (1976) was about "[t]wo college girls driving through the South during their summer vacation." They are "railroaded by a vicious sheriff and a corrupt judge, and sent to a prison farm."[563] British-born John Llewellyn Moxey directed.

Hawmps (1976) presents a story set before "the Civil War, (when) the Texas Calvary Corps experimented with camels rather than horses for desert duty." According to Seven Scheuer, this "historical incident was treated dramatically in *Southwest Passage* (1954) and comically (read: silly) here."[564] The film was directed by Missouri-born Joe Camp. That same year, (1976), *Creature from Black Lake* portrayed "two Chicago anthropology students who journey to a Louisiana swamp to search for an 8-foot 400-pound creature."[566] Joy Houck, Jr. directed.

The 1976 20th Century-Fox release *Moving Violation* was described by Steven Scheuer as a "terror-on-wheels action [picture] . . . (about) a beleaguered couple (who) is pursued by a Southern sheriff."[567] Charles S. Dubin directed for Detroit-born producer Roger Corman. Also, in 1976, *The Macahans* told the story of "scout Zeb Macahan . . . (who leads) his brothers' family west from Bull Run, Virginia, in time to avoid the Civil War."[568] Bernard McEveety directed. Also, in 1976, *Judge Horton and the Scottsboro Boys* was set in "Alabama back in 1931." The film was about "nine poor young black men (who) were arrested and tried for the alleged rape of two

promiscuous white women. Despite compelling evidence proving their innocence, they were convicted." Scheuer, says, this "disturbing, absorbing history lesson about racial bigotry in the South at that time focuses on one courageous white judge, who reversed the jury's verdict and may well have saved the young men from being hanged."[569] Georgia-born Fielder Cook directed.

In the 1976 film *Ode to Billy Joe* Robby Benson (Robert Segal) and Glynnis O'Connor star in a film that explains "why Billy Joe jumped off the Tallahatchee Bridge." Steven Scheuer calls the film an "adolescent romance about youngsters coming of age in the South[570]." Nebraska-born Max Baer directed. Also, in 1976, *Up* offered another stereotypical and negative portrayal of a Southern sheriff[571]. California-born Russ Meyer directed. In Warner's *The Drowning Pool* (1976) Paul Newman and Joanne Woodward starred in a "film about murder and corruption in the deep South."[573] New York-born Stuart Rosenberg directed for producers Lawrence Turman (originally from Los Angeles) and David Foster.

In the 1976 Warner Bros. film *The Outlaw Josey Wales* San Francisco-born Clint Eastwood portrayed "an unreconstructed Southerner, bitter about the atrocities he's witnessed, refusing to surrender . . . in the unsettled post-war West."[574] Eastwood himself directed for New York-born producer Robert Daly. Also, in 1976, the UA release *Stay Hungry* featured "Jeff Bridges (as) . . . an Alabama blueblood of uncounted generations of aristocracy . . . " and "Sally Field [as a] . . . simple country [girl]." According to Robert Ebert, the movie makes "a subtle comment on Southern class structure[575]." The film was directed by New York-born Bob Rafaleson (born into a middle-class, Upper West Side, intellectual Jewish family")[576] who co-produced with Harold Schneider.

In 1977, *The Town that Dreaded Sundown* starred Ben Johnson, Andrew Prine, Dawn Wells and Charles B. Pierce in a supposedly "[r]eal-life tale of a lonestar looney terrorizing a town in Texas[577]." Charles Pierce directed. *Minstrel Man* (1977) focuses "on the efforts of a group of post-Civil War black minstrel performers to form their own troupe and to present material that would be less degrading to blacks[578]." William A. Graham directed. Also, in 1977,

The Lincoln Conspiracy alleged that "Lincoln's assassin, actor John Wilkes Booth, was in cahoots (involved in a conspiracy) with some members of the U.S. Senate in trying to get rid of the Great Emancipator[579]." James L. Conway directed.

That same year, (1977), *Moonshine County Express* starred William Conrad and Susan Howard in the story of "[m]oonshiners-three sexy sisters—(who) try to outrun the law and a big moonshiner who is after a valuable cache of prime drinking 'likker'."[580] Gus Trikonis directed. Also, in 1977, *Murder at the World Series* starred Bruce Boxleitner, Hugh O'Brien, Michael Parks, Lynda Day George and Janet Leigh in a story about the "Houston Astros . . . pitted against the Oakland A's at the Houston Astrodome. A young man, bent on revenge for not making the team in the tryouts, kidnaps a top player's wife—but he gets the wrong girl[581]." British-born Andrew McLaglen directed.

Thunder and Lightning (1977) starred David Carradine, Kate Jackson and Roger C. Carmel in what Steven Scheuer calls "[r]ubbish about moonshiners a-cussin' 'n' a-fightin' in the Everglades[582]." Corey Allen (born Alan Cohen in Cleveland, Ohio) directed. That same year, *Greased Lightening* (1977) starred Richard Pryor in a film about "the first black professional racing-car driver, who started out running moonshine before WWII and battled prejudice for many years before being allowed to race against whites[583]." Wisconsin-born Michael (or Michel) Schultz directed for producer Hannah Weinstein.

As mentioned above, *Final Chapter—Walking Tall* (1977) continued the stereotypes and the saga "of real-life Tennessee sheriff Buford Pusser, who died under mysterious circumstances after crusading against vice and corruption . . . "[585] Texas-born Jack Starrett directed. That same year, Universal's *Smokey and the Bandit* (1977) starred Burt Reynolds, Sally Field, Jerry Reed and Jackie Gleason in a film about "[t]wo oddly matched Texas millionaires who commission ace driver Smokey to race from Georgia to Texas with a load of illegal beer[586]." Tennessee-born Hal Needham directed for producer Robert L. Levy. Needham also directed *Smokey and the Bandit II* (1980) and Gleason reprised "his role as the sheriff spreading

Southern discomfort along the highways" in *Smokey and the Bandit III* (1983), a film that Dick Lowry directed.[587]

In 1978, *A Small Town in Texas* starred Timothy Bottoms, Susan George and Bo Hopkins in another "cops-and-corruption saga . . ."[588] Texas-born Jack Starrett directed for Samuel Z. Arkoff's company AIP. Also, in 1978, *Katie: Portrait of a Centerfold* featured Kim Basinger as "Katie, a Texas lovely . . . " who is not very bright. Her "modeling career turns sour in Hollywood after an assignment as a centerfold piece for a girlie magazine."[589] Robert Greenwald directed. Paramount's *Days of Heaven* (1978) portrayed "the story of a group of farmworkers (in Texas) and their relations with the sickly owner of the land."[590] As Roger Ebert describes the movie, it is "about a handful of people who find themselves shipwrecked in the middle of the Texas Panhandle—grain country—sometime before World War I." Ebert says the film "is an evocation of emptiness, loneliness, desolation, the slow accumulation of despair in a land too large for its inhabitants and blind to their dreams."[591] This movie follows the time honored Hollywood tradition of making most movies about the South, movies about despair. Illinois-born Terrence Malick (raised in Texas and Oklahoma)[592] wrote and directed for producers Bert and Harold Schnieder.

Also, in 1978, 20th Century Fox's *A Wedding* includes a negative portrayal of a Southern family of "new Southern money." The bride's parents are Carol Burnett, all sweetness and convention . . . and Paul Dooley, vulgar, hard-drinking, with a tad too much affection for his youngest daughter . . . (who) is pregnant—by her sister's new husband, perhaps, or (it develops) by any other member of his class at military school."[593] Missouri-born Robert Altman directed and co-produced with Tommy Thompson. That same year, *Convoy* (1978) was "about a trucking caravan that keeps on the move after insulting a sheriff."[594] The film stars country-western singer Kris Kristofferson as the leader of "a tri-state protest (by cowboy truckers) over police brutality, high gas prices, and other complaints."[595] The film features "[l]ots of smash-ups as the truckers fight the National Guard and head for Mexico."[597] California-born Sam Peckinpah directed for producer Robert M. Sherman.

Five Days from Home (1978) featured George Peppard as "an ex-lawman convicted of manslaughter for killing his wife's lover. With only six days left on his sentence, he breaks out of a Louisiana prison to see his critically injured son[598]." Detroit-born Peppard also directed. More Southern stereotypes appear in Disney's *The Million Dollar Dixie Deliverance* (1978), a pre-Civil War tale about a man who "helps five Yankee school kids who have been kidnapped for ransom cross the battle lines[599]." Russ Mayberry directed. *The Summer of My German Soldier* (1978) was a so-called made for TV movie starring Kristy McNichol in the story of "the relationship between a Jewish teenager, luminously played by McNichol, and an escaping anti-Nazi German POW." The film is set in a small town in the deep South during WWII (and) . . . deals with the hatred of the townsfolk for the German POW's interned in their midst, and the bonds of friendship that develop between the girl, rejected by her father, and the young man[600]." Michael Tuchner directed.

In 1979, John Huston directed "the searing satire of Southern-style religion, *Wise Blood* (1979)[601]." The Missouri-born Huston directed for producers Michael and Kathy Fitzgerald. Also, in 1979, *The Great Bank Hoax* concerns "the bumbling officers of a small-town Georgia bank, who stage a fake robbery to cover up their embezzlement[602]." Joseph Jacoby directed. Also, that year (1979) *Amateur Night at the Dixie Bar and Grill* (1979) was "set in a Dixie roadhouse." The film "focuses on the crowd that hangs out there and the help that serves them booze and small talk[603]." New York-born Joel Schumacher directed. *Murder in Music City* (1979) was "about a snoopy song-writer who drags his mate into a whodunit in Country Music Land[605]." Leo Penn directed.

Paramount's *North Dallas Forty* (1979) starred Nick Nolte and Mac Davis in a "comedy about the battered lives of pro footballers[606]." Canadian-born Ted Kotcheff directed for Jewish producer Frank Yablans[607] Also, in 1979, the 20th Century-Fox feature *Norma Rae* starred Sally Field as "the plain-spoken, spunky Southern textile worker . . . (in) . . . a film about labor unions or mill working conditions . . . (and) . . . a woman of thirty-one learning to grow into her own potential[608]." The film was produced and directed by Martin

Ritt (New York city born, the "son of Jewish immigrants")[609] Finally, in 1979 *Love's Savage Fury* starred Jenniefer O'Neill as a "Southern belle fallen on hard times . . . "[610] Joseph Hardy directed.

As the '80s decade began, Paramount's *Urban Cowboy* (1980) hit the screens. It starred John Travolta, Debra Winger, Scott Glenn, Madolyn Smith and Barry Corgin in the story of "a young oil-field worker who goes looking for love in Gilley's country-and-western bar and falls hard for Debra Winger, only to find the romance fading as their marriage begins." The film is described by Steven Scheuer as "..a honky-tonk revision of *Saturday Night Fever* . . . "[611] Arkansas-born James Bridges directed for the New York-born Jewish producer Robert Evans (Shapera)[612] and Irving Azoff. Winger is also identified in Daniel Lyman's book *Great Jews on Stage and Screen* as Jewish.[613]

Also, in 1980, *Pleasure Palace* starred Omar Shariff, Hope Lange, Jose' Ferrer, Victoria Principal, J.D. Cannon and Gerald S. O'Loughlin in the story of "a gentlemanly high roller, invited to Las Vegas to save casino owner Lange from a crude Texan and his associates[617]." Walter Grauman directed. Universal's *Coal Miner's Daughter* (1980) starred Sissy Spacek in what is promoted as the life-story of country singer Loretta Lynn[618]. Halliwell's Film Guide says the film is about the "wife of a Kentucky hillbilly."[620] British-born Michael Apted directed for producer Bob Larson.

The 1980 Warner release *Honeysuckle Rose* featured Willie Nelson as "the married, traveling music legend who can't help straying while off the homestead."[621]

New York-born Jerry Schatzberg directed for producer Sydney Pollack, who was born in Indiana the "son of first-generation Russian-Jewish Americans."[622] Also, in 1980, *Georgia Peaches* was what Steven Scheuer called a "down-home adventure with car chases and country music."[623] California-born Daniel Haller directed.

In 1981, the film *Vernon, Florida* supposedly provided "a profile of a small Southern town that exposed the eccentric side of seemingly ordinary people." The film was made by Errol Morris who was born on Long Island[624]. Also that year, *Mistress of Paradise* (1981) starred Genevieve Bujold and Chad Everett in what Steven Scheuer

calls a "claptrap drama about the turbulent love affair between a wealthy Northern heiress and a sophisticated Louisiana plantation owner[625]." Peter Medak (born in Budapest) directed.

Murder in Texas (1981) starred Katharine Ross, Sam Elliott and Farrah Fawcett in another supposedly "true story," this one about "a modern-day Bluebeard, an egomaniacal plastic surgeon who thinks disposing of wives permanently is preferable to divorce."[626] Bill Hale directed. Also, in 1981, *Hellinger's Law* starred Telly Savalas as "a Philadelphia attorney out in Houston, Tex., to defend an ac-countant who has infiltrated the Mafia."[628] Leo Penn directed. That same year, *Callie & Son* (1981) told the story of a "naive waitress who becomes a Dallas power broker." The film features the "Dallas rich, Mom's obsession with her son, murder under the oaks, and a dra-matic courtroom trial."[629] The film was directed by Waris Hussein, born in India.

Return of the Beverly Hillbillies (1981) "revolves around the Presi-dent's request to solve the energy crisis with Granny's moon-shine[630]." Robert Leeds directed. Also, that year, *Coward of the County* (1981) starred Kenny Rogers "as a country preacher who sins on the side." Rogers' "nephew Tommy . . . (is) labeled a small town coward for being a pacifist during World War II. The film was shot on loca-tion in Georgia and according to Steven Scheuer, "has an authentic rural feel . . . "[630] Dick Lowry directed.

According to Roger Ebert, Universal's *Raggedy Man* (1981) was a film that "remembers the small-town years of World War II . . . Sissy Spacek stars as the sole switchboard operator of a small-town telephone company somewhere in the wilds of Texas." In addi-tion to the relationship between Spacek and a visiting sailor (Eric Roberts), the film features "town gossips . . . the town louts, who inhabit the beer hall and lust after the slim, young telephone opera-tor . . . (and) . . . a strange, scarecrow character who hangs about in the background of several scenes and has a disconcerting way of disappearing just when you want to get a closer look at him."[630] The film was directed by Illinois-born Jack Fisk for producers William Wittliff and Burt Weissbourd. Also, in the 1981 film *Back Roads*, Sally Field "plays a street corner hooker (and), Tommy Lee Jones

(portrays) a footloose guy she takes up with on a journey from Mobile to California."[630] The film was directed by Martin Ritt (New York-born "of Jewish immigrants")[631] for producer Ronald Shedlo.

In *The Killing of Randy Webster* (1981) a "teenager steals a van in Houston, Texas." He gives "the cops a wild chase, and winds up with a bullet in his head."[632] Chicago-born Sam Wanamaker (described by Katz as a political leftist[633]) directed.

Southern Comfort (1981) was "set in the Cajun country of Louisiana, in 1973, and it follows the fortunes of a National Guard unit that gets lost in the bayous . . ."[634] and become involved in "a life-and-death struggle with the Cajun inhabitants."[635] Ebert calls the film a "metaphor for America's involvement in Vietnam."[636] California-born Walter Hill directed for producer David Giler.

The 1981 feature *Crisis at Central High* was a "docu-drama" recreating "the events at Central High School in Little Rock, Ark., during the school year 1957-58 when the governor of Arkansas, was bitterly opposed to the integration of black and white students at that school in the state's capital . . ."[637] California-born Lamont Johnson directed. Also, in 1981, the Avco/Embassy release *The Night the Lights Went Out in Georgia* starred Kristy McNichol and Dennis Quaid in a story about "a sister tagging after her country singing brother as they try to crack the recording business in Nashville."[638] Libyan-born Ronald F. Maxwell directed for producers Elliot Geisinger, Howard Kuuperman, Rondal Saland and Howard Smith. *Ruckus* (1981) was a "tale of a Vietnam soldier, Dirk Benedict, who escapes from an army psycho ward in Mobile and ends up in a little southern town where he is harassed by the locals . . . "[639] (these "locals" are referred to as "rednecks" in Steven Scheuer's description of the same film)[641]. Max Kleven directed.

In 1982, *Tootsie* starred Dustin Hoffman as an out-of-work New York actor who "dresses himself as a woman" in order to get work. The rather ridiculous character is portrayed with "a Southern accent . . ."[642] Indiana-born Sydney Pollack (son of first-generation Russian-Jewish Americans)[643] produced and directed. Also, in 1982, The Universal/RKO release *Best Little Whorehouse in Texas* was a film "about efforts to close down the Texas institution known as the

Chicken Ranch . . ."[644] Colin Higgins (born in the South Pacific to Australian parents)[645] directed for producers Thomas L. Miller, Edward K. Milkis and Robert L. Boyett. That same year, *Come Back to the 5 & Dime, Jimmy Dean, Jimmy Dean* (1982) portrays a "worn-out Woolworth's in a small Texas town . . . (and) . . . a reunion of the local James Dean fan club."[646] Missouri-born Robert Altman directed for producer Mark Goodman.

The Kevin Kline character in *Sophie's Choice* (Universal—1982) repeatedly made disparaging remarks about people from the South, including a remark by the Jewish character played by Kevin Kline referring to "Nigger lynching" as a Southern sport. In addition, the "Stingo" character played by Peter MacNichol, was portrayed as weak and naive. Further, a Nazi concentration camp official is seen stating that "all people who live in southern climes suffer from a dullness of mind." According to the Katz Film Encyclopedia, Dallas native Peter MacNicol, a "[s]lightly built" actor, was "suited for his . . . screen role as Stingo, the Southern writer who finds himself involved in a love triangle when he moves to Brooklyn, in 'Sophie's Choice' (1982)[647]." The film was written and directed by Alan J. Pakula (born in New York "of Polish-Jewish parents")[648] for California-born producer Keith Barish.

Also, in 1982, the Warner release *Honkytonk Man* was a movie about a "Depression-era loser (played by Clint Eastwood) who drifts through the South with his young nephew, aiming eventually to get to Nashville and maybe get on the Grand Ol' Opry." Movie critic Roger Ebert suggests that the movie is somewhat biographical since Eastwood a "child of the Depression . . . spent his early boyhood trailing a father who pumped gas along dusty roads . . ."[649] The only problem is that Eastwood was born in San Francisco and the dusty roads he toured as a child were on the West Coast. So why set this depressing Warner Bros. movie in the South? Eastwood also produced and directed the film. Finally, in 1982, *Waltz Across Texas* provided more Texas stereotypes and starred Terry Jastrow, Anne Archer, Noah Beery, Mary Kay Place, Josh Taylor, Richard Farnsworth and Ben Piazza in the story of a "romance between an oil man and a fetching geologist[650]." Ernest Day directed.

48 Hours (1982) with Nick Nolte and Eddie Murphy included a portrayal of a "redneck country joint, the kind where urban cowboys drink out of longneck bottles and salute the Confederate flag on the wall . . ."[652] The California native Walter Hill directed for producers Lawrence Gordon (originally from Mississippi) and New Jersey-born Joel Silver.

The year 1983 may have provided one of the few partial exceptions to the Hollywood bias against the American South with Paramount's *Terms of Endearment*. The film is set in a contemporary urban environment (Houston) and portrays some fairly likable characters from the South. The movie was "about two remarkable women, and their relationships with each other and the men in their lives." The men are all somewhat flawed, however, (Jack Nicholson is an "animalistic . . . swinging bachelor . . . a hard-drinking, girl-chasing former astronaut," Danny Devito is somewhat ridiculous as an admirer of Shirley MacLaine, who "only asks that he be allowed to gaze upon her," and Debra Winger's husband (played by John Lithgow) is a college professor "who has an eye for the coeds."[653]

It may be accurate to report that never in the history of the Hollywood-based U.S. film industry, has a movie been produced or released by a major studio/distributor that portrayed a White Anglo-Saxon male, set in a contemporary urban environment in the South as a hero, without serious character flaws. Is the Hollywood failure to provide positive movie role models for the white youth of the South a mere oversight, coincidence or natural result of the prejudices held by the specific subset of Jewish males of European heritage who control Hollywood? *Terms of Endearment* was written, directed and produced by New Jersey-born James L. Brooks.

Tender Mercies (1983) takes us back to the small towns in the South. The film was "about the rhythms of a small Texas town, and about the struggle of a has-been country singer (played by Robert Duvall) to regain his self-respect." The movie also "tells the story of the relationship between the singer and the young widow (played by Tess Harper).[654]

Australian Bruce Beresford directed for producers Horton Foote (from Texas) and California-born Robert Duvall. Also, in 1983, *Stro-*

ker Ace starred Burt Reynolds, Loni Anderson, Parker Stevenson and Jim Nabors in a film that features (according to Steven Scheuer) "[r]acecars, chicken suits, fat sheriffs and lame virgin jokes . . . in another of Burt Reynold's endless attempts to trade on the popularity of the 'good-ole-boy' character he established in *Smokey and the Bandit*[654]." Tennessee-born Hal Needham again directed. Maybe Scheuer has it turned around, and the truth is that Hollywood, because of its own prejudices, would not allow Burt Reynolds to appear in anything very far afield from this "good-ole-boy" character.

In any case, the assault on Texas continued in 1983 with *The Ballad of Gregorio Cortez*, a film about "a Mexican cowhand who becomes the victim of prejudice in Texas."[655] Robert Young directed. Also, in 1983, Orion's *Lone Wolf McQuade* starred Chuck Norris as "a renegade modern-day Texas Ranger who walks alone, likes to work with machine guns, deals out justice on the spot, and hardly ever says much of anything."[656] The film was directed by New York-born Steve Carver who co-produced with Yoram Ben-Ami.

Local Hero (Warner—1983) portrayed "a small Scottish town and its encounter with a giant oil company" intent on buying the entire fishing village and its shoreline and constructing "a North Sea oil-refining complex." The villainous oil company is based in Houston[657]. Peter Reigert stars as the "young executive with a Texas oil company run by a slightly batty tycoon more interested in astronomy than making money."[658] Scottish-born Bill Forsyth wrote and directed. British-born David Puttnam produced.

Last Night at the Alamo (1983) depicts "a run-down Houston saloon about to be razed to make room for a modern skyscraper, and the local denizens (are) taking a stand against the inevitable[660]." Eagle Pennell directed. That same year, *Kentucky Woman* (1983) starred Cheryl Ladd down in the coal mines with rats and jeering miners.[661] Walter Doniger directed. *Murder in Coweta County* (1983) starred Andy Griffith, Johnny Cash and June Carter Cash in a story about an "influential businessman who commits murder." The film is supposedly based on "a real case in '40s Georgia."[662] Gary Nelson directed. Finally, in 1983, *The Grand Baby* was about "a withdrawn

boy (who) . . . after his mom dies . . . must cope with a move to a hostile Southern neighborhood."[663] Henry Johnson directed.

The following year, (1984), *River Rat* starred Tommy Lee Jones, Martha Plimpton and Brian Dennehy in a "drama about an ex-convict (Jones) who returns to his Mississippi River home only to encounter difficulty with his plucky daughter (Plimpton) and to receive threats from his underhanded parole officer (Dennehy)[665]. Tom Rickman directed. Also, in 1984, *The Bostonians* portrayed a Southern lawyer (Christopher Reeves) who opposes the desires of a woman to work in the suffragette movement, to vote and to live a more complete life.[666] The film was directed by Oregon-born James Ivory for producer Ismail Merchant (from India).

TriStar's *Places in the Heart* (1984) starred Sally Field, Lindsay Crouse, Ed Harris, Amy Madigan, John Malkovich and Danny Glover in a "Depression-era tale"[667] set in 1935 Texas.[668] The film was largely shot on location in Waxahachie, Texas.[669] The story revolves around "the efforts of a recently widowed woman (Field) to hold onto her home and two children by farming cotton. A tornado, Ku Klux Klan threats, and an extramarital affair subplot are thrown into the narrative."[670] Texas-born Robert Benton wrote and directed for producer Arlene Donovan. As noted earlier, it would seem that the Ku Klux Klan appears in a disproportionately high number of films about Texas and the South. I grew up in a small town in Southeast Texas, went to undergraduate and law school in Texas and worked in the state for a number of years as an attorney, association executive and lobbyist, but during all of that time, never came into contact with the Ku Klux Klan or any of its supposed members. Hollywood's consistent association of the Ku Klux Klan with the South thus appears on the surface to be somewhat puzzling. On the other hand, this Hollywood preoccupation makes more sense when viewed as one of the many prejudices expressed through films by their makers.

According to Steven Scheuer, *A Flash of Green* (1984) captured "the sleepy tempo of a small Florida town . . . (in which Ed Harris accepts) a bribe from a local politician fighting environmentalists over proposed use of the local bay."[671] Victor Nunez directed. The

1984 Columbia release, *A Soldier's Story*, starred Howard E. Rollins, Jr., Adolph Caesar, Denzel Washington, Larry Riley and Art Evans in the story of the murder of "the Negro manager of a crackerjack black Army baseball team . . . in a red-neck Louisiana town in 1944 . . . during WWII . . . (and a) black Army captain, a lawyer, is sent from Washington to "investigate the crime.[673] Canadian-born Norman Jewison directed and co-produced with Patrick Palmer.

Also, in 1984, *Paris, Texas* was a film mostly set in desolate sections of Texas and partly in the urban canyons of Houston. It is "about loss and loneliness and eccentricity (and about) . . . vast, impersonal forms of modern architecture; the cities seem as empty as the desert did in the opening sequence."[674] The film starred Harry Dean Stanton, Nastassia Kinski, Dean Stockwell, Hunter Carson, Aurora Clement and Bernhard Wicki in a story set "against sun-baked landscapes . . . (about a) man, missing for several years, (who) is reunited with his brother's family, who've been raising the son he abandoned when his wife ran off . . . (and their subsequent) search for the free-spirited woman who walked out on them."[675] Wim Wenders (from Germany) directed. The film was actually a West German/French co-production, but was filmed in English and released in the U.S.[676] *Boggy Creek II* (1984) was a "fictional story of a college professor who takes three students into Southern swampland to search for the half-human Boggy Creek monster."[677] Charles B. Pierce directed.

The general Hollywood pattern of bias against the South continues in the 1984 release *Tightrope*, although with a twist. The movie is similar to other Hollywood films in that it contained an anti-Southern bias. It stars "Clint Eastwood as a New Orleans homicide detective." He is "a good but flawed cop, with a peculiar hangup: He likes to make love to women while they are handcuffed. The movie suggests this is because he feels deeply threatened by women." The film is unusual, however, and breaks out of the more typical anti-Southern genre, in that it features a major star "in a commercial cop picture in which the plot hinges on his ability to accept and respect a woman[678]." Eastwood produced with Fritz Manes. Richard Tuggle directed.

The following year, Horton Foote's *The Trip to Bountiful* (1985) presented another supposed "slice-of-life from Texas" another movie about loneliness and despair. The movie tells the story of an elderly woman who "wants to leave her miserable life in the city and pay one last visit to her childhood country home."[679] The film starred Geraldine Page, John Heard, Carlin Glynn, Richard Bradford, Rebecca De Mornay and Kevin Cooney in the story of a "fiesty old lady (from Texas) . . . [h]emmed in by life with her weak-willed son and his high-strung wife . . . (who) dreams of revisiting the family home."[680] So, she "takes a bus to the town where she was raised."[682] Texas-born Peter Masterson directed for producers Foote and Sterling Vanwagenen.

Also, in 1985, TriStar's *Alamo Bay* provides a rather "slanted examination of a Texas community unable to cope with Vietnamese refugees who outdo the locals in the fishing industry. The refugees are saintly; the red necks are beastly."[683] French-born Louis Malle directed and co-produced with Vincent Malle. That same year, *Fool for Love* (1985) portrayed "a cowboy who drives through the empty Texas reaches in the obligatory pickup truck with the obligatory rifle rack behind his head and the obligatory horse trailer behind" in a story involving "redneck passion" and incest. The film is described by Roger Ebert as a "classic tragedy, set there in the Texas badlands."[684] Missouri-born Robert Altman directed for Israeli-born producers Menaham Golan and Yoram Globus.

Warner's 1985 release *The Color Purple* portrayed "the growth of a Southern black family during the first half of the century."[684] The story focuses on a "black woman, who's cruelly separated from her sister and who endures a lifetime of brutalization by men before finding the courage to free herself."[685] Ohio-born Steven Spielberg ("of Jewish descent")[687] directed and co-produced with Los Angeles-born Frank Marshall, his wife Kathleen Kennedy and Chicago-born Quincy Jones. Also in 1985, *The New Kids* (1985) was "about two orphans who move to Florida, only to be picked on beyond belief by sadistic bullies."[688] New York-born Sean Cunningham directed.

Pee Wee's Big Adventure (1985) was about Pee Wee's search "for his beloved stolen bicycle last seen en route to Texas[689]." California-born Tim Burton directed for producer Robert Shapiro. In TriStar's *The Legend of Billie Jean* (1985) when "dirt poor but scrupulous Billie Jean is unjustly implicated in a shooting, she goes on the lam (in Texas)[690] with her kid brother and friends. Overnight, she turns into a full-fledged media event, righting wrongs, greeting throngs of adoring teens, and imitating Joan of Arc all over her backwater country while miraculously evading the police."[691] Matthew Robbins directed for producers Rob Cohen, Jon Peters (born in California to a Cherokee Indian father and a mother of "Neapolitan descent")[692] and Peter Guber (born in Massachusetts "into an upper-middle-class Jewish family)."[693]

In 1986, *Hard Choices* was set in the "backwoods of Tennessee" and presents a movie about "a fifteen-year-old kid with good prospects for making something out of his life . . . (but his) . . . older brothers are into drugs and robberies" and the kid gets dragged into that scene.[694] Rick King directed. Also, in 1986, the Island Pictures release *Down by Law* tells the story of "two people who choose to be losers and a third who has bought the American Dream . . . They meet in the same Louisiana jail cell through a series of misadventures in which two of the guys are framed and the third is severely misunderstood . . . the three prisoners escape, and the movie follows them through the swamps as they slog through every cliche (the film's writer/director Jim Jarmusch) . . . can remember . . ." from other movies he has seen.[695] Jarmusch was born in Ohio "of Czech-German-French-Irish extraction."[696]

In *A Smoky Mountain Christmas* (1986), country western singer Dolly Parton is featured as "a big movie star returning to her Smoky Mountain origins for the holidays, when she encounters a mountain witch, a mean sheriff, seven runaway orphans, and a bonafide hero called Mountain Dan."[697] New York-born Henry Winkler (of German-immigrant parents and Jewish descent)[699] directed. That same year, the TriStar release *No Mercy* (1986) starred Richard Gere and Kim Basinger in the story of "a Chicago detective who goes to New Orleans to investigate the murder of his partner and ends up

protecting a beautiful woman (Basinger) from the vicious kingpin who 'owns ' her."[700] California-born Richard Pearce directed for producer D. Constantine Conte.

On Valentine's Day (1986) was based on another of Horton Foote's plays. This one takes place in Harrison, Texas, where Horace and Elizabeth Robedaux are moving up in the world in 1917, and several other townspeople—including Elizabeth's wastrel brother and the town eccentric . . . are losing their social [footing].[701] Ken Harrison directed. Also, in 1986, *Resting Place* starred John Lithgow, Richard Bradford and Morgan Freeman in a "drama about a deceased black Vietnam War hero whose family is barred from burying his body in an all-white cemetery in the South."[702] Indiana-born John Korty directed.

That same year (1986), the DeLaurentiis release *Crimes of the Heart* portrayed three "attractive, eccentric Southern sisters (who) are reunited by their grandfather's failing health and a shooting incident involving the youngest."[703] Australian Bruce Bereford directed for producers Freddie Fields (born in New York) and Burt Sugarman. Also, in 1986, *Getting Even* (aka *Hostage: Dallas*) was about "an enterprising Texan who pinches a deadly chemical from the Commies in Afghanistan for Uncle Sam, only to have a rotten U.S. chemical king steal the poison gas for his own monetary purposes[704]." Dwight H. Little directed.

Also, in 1986, *As Summers Die* "plays like a seamy B movie about Southern decadence from the fifties" and deals with "a black woman's fight to hang onto her land."[706] Jean-Claude Tramont directed. The 1986 Warner's release *True Stories* starred David Byrne, Swoosie Kurtz and Spalding Gray, among others, in what Steven Scheuer calls a "condescending New Yorky view of small-town life in a Texas community."[707] Scottish-born David Byrne directed for producers Edward Pressman (originally from New York) and Gary Kurfirst.

The 1986 De Laurentiis release *Maximum Overdrive*, starred Emilio Estevez, Pat Hingle, Laura Harrington and Yeardley Smith in Stephen King's "brutal hodgepodge of attacks by killer machines and hysterical attempts by a group of rednecks to avoid being splattered on the grilles of eighteen-wheelers . . ."[708] in a corner of North

Carolina."[709] Stephen King (born in Maine) wrote and directed for producer Martha Schumacher.

Also, in 1986, *The Supernaturals* starred Maxwell Caulfield, Michelle Nichols and Talia Balsam in the story of a "modern-day bivouac (during which) . . . the ghosts of Confederate soldiers come back to avenge themselves on visiting Yankees in order to settle a century-old score[710]." Armand Mastroianni directed. The independently produced film *Belizaire, The Cajun* (1986) is described by Steven Scheuer as a "thick, atmospheric chunk of Cajun folklore," a movie about "a cagey Cajun who defends himself and the rights of his people against their Louisiana neighbors."[711] Glen Pitre directed.

The following year (1987), *Guilty of Innocence: The Lenell Geter Story* (1987) was about an "up-and-coming Texan (who is) railroaded on an armed robbery charge." The film is purportedly based "on the real-life 1982 Dallas case of an engineer wrongly accused and sentenced to life imprisonment."[712] Chicago-born Richard T. Heffron directed. Also, in 1987, Orion's *House of Games* included a scene in which a psychiatrist specializing in addictive behavior helps a gambler to "fleece a (stereotypical) high-roller Texan in a big-stakes poker game."[713] Chicago-born Jewish writer/director David Mamet[714] wrote and directed for producer Michael Hausman. That same year, *Roses Are for the Rich* (1987) portrayed an "Appalachian girl who vows to settle a score with . . . the man she accuses of killing her husband and destroying her family[715]." Michael Miller directed.

Tri-Star's 1987 release *Extreme Prejudice* featured Nick Nolte as a "Texas Ranger . . . (who) wears a mean . . . squint as he battles seedy drug trafficker (Powers Boothe)."[717] California-born Walter Hill directed for producer Buzz Feitshans. This film represents one of the more recent of a long line of Hollywood produced movies relating to the theme that there is a great deal of "extreme prejudice" in the South (specifically in Texas). However, the real "extreme prejudice" can be seen in the minds of the people who have created this long line of anti-Southern films.

Square Dance (1987) starred Jane Alexander, Jason Robards, Jr., Winona Ryder (Horowitz) and Rob Lowe in the story of "an ugly duckling (who) blossoms into woman-hood without the support of

her irresponsible mother and manages to retain her purity of spirit despite the tawdriness of her surroundings"[718] in rural Texas.[719] Canadian-born Daniel Petrie produced and directed. The 1987 Kings Road release *The Big Easy* included portrayals of three Southern males as a "dishonest cop . . . a defense attorney (who talks with) . . . a shrill Cajun shriek . . . (and) a slick . . . police captain" who cannot do the right thing.[720] New York-born Jim McBride directed for producer Stephen Friedman.

TriStar's *Angel Heart* (1987) was about "an ex-lounge singer" whose search for a missing debtor "takes him to Louisiana voodoo country where he discovers some unsettling truths about his client, his quarry, and ultimately himself."[721] The film was written and directed by British-born Alan Parker for producers Alan Marshall (born in London) and New York-born Elliott Kastner. Also, in 1987, *Hunter's Blood* was about some "urbanites (who) got to the woods (in Arkansas)[722] for rest and relaxation and instead encounter crazed hillbillies who don't cotton to outsiders[723]." Robert C. Hughes directed. *A Special Friendship* (1987) starred Tracy Pollan, Akousa Busia, LeVar Burton and Josepf Sommer in a "Civil War drama about a bond between a Virginia plantation owner's daughter . . . and her intellectual slave."[724] Georgia-born Fielder Cook directed.

In *A Gathering of Old Men* (1987) after "the shooting of a racist Cajun farmer, Richard Widmark's sheriff expects a lynch mob, but it doesn't turn out that way. Louis Gossett, Jr. leads a band of prideful old blacks in this adaptation of Ernest Gaines' novel[725]." German-born Volker Schlondorff directed. A film like this raises the question as to how many Cajun's were involved in the production. Also, is it likely today that a Louisiana Cajun filmmaker would be allowed to make a Hollywood film about a racist Jew? Such questions, point to the problem with the U.S. film industry today. Some people, like the Louisiana Cajuns, are the consistent targets of negative and stereotypical portrayals in Hollywood films, while others (specifically, the Jewish males of European heritage who control Hollywood) escape relatively unscathed. At least there are few, if any non-Jewish Hollywood outsiders, portraying Jews in U.S. films

in a negative manner. Such consistent prejudice and discrimination in movies may inevitably lead to bitter hatreds in real life.

In 1988, *Talk Radio* was inspired by "the murder of Alan Berg . . . a Denver talk radio host who was murdered on June 18, 1984 . . . [w]hen the members of a lunatic right-wing group gunned him down in the driveway of his home." In the movie the talk show host "works in a studio in a Texas high-rise."[726] Unfortunately, the New York-born Oliver Stone directed, and his choice of Texas for this movie (as opposed to all the other states that could have been chosen) suggests that the "lunatic (and murderous) right-wing group" were from that state; another example of the Hollywood choices that consistently portray people and places in the American South in a negative manner. Also, in 1988, *D.O.A.* starred Dennis Quaid as a University of Texas at Austin English professor who "learns he has been poisoned, and has twenty-four hours to live—twenty-four hours to find his killer." He is aided in his quest by the Meg Ryan character who is rather unbelievably portrayed as a college freshman. This very confusing movie offers bad acting and two killers with numerous and overlapping victims but very slight motivation on the part of each. The movie supposedly "plays sly variations on the theme of 'publish or perish.'" But, this movie asks its viewers to believer that college professors, even in the South, are under so much pressure to publish that they would actually kill three people just to steal a student's unpublished novel.[728] The film was directed by Rocky Morton and Annabel Jankel and produced by Ian Sander and Laura Ziskin.

The 1988 Warner Bros. release *Bird* included a portrayal of the time Charlie Parker's band "toured the South with a band including Red Rodney, a white sideman who was passed off as "Albino Red" because integrated bands were forbidden."[729] San Francisco-born Clint Eastwood produced and directed. I have no argument with the truth of this specific portrayal. I simply ask, where are the positive portrayals of the South in American movies? It appears that the U.S. motion industry is primarily populated with people who suffer from a case of severe regional prejudice. Also, in 1988, Orion's *Mississippi Burning* takes place in and around a "small Southern city

... (in) rural Mississippi" in 1964 and is allegedly "based on a true story," although a story involving the same basic facts can clearly be portrayed in a number of different ways.

As told in the film, the story involves "the disappearance of . . . three young civil rights workers who were part of a voter registration drive in Mississippi. When their murdered bodies were finally discovered, the corpses were irrefutable testimony against the officials who had complained that the whole case was a publicity stunt, dreamed up by Northern liberals and outside agitators." The movie is also about the efforts of two FBI men to lead an investigation into the disappearances." One of the keys to solving the case turns out to be a southern "woman who had been raised and trained and beaten into accepting her man as her master, and who finally rejects that role simply because with her own eyes she can see that it's wrong to treat black people the way her husband doesshe represents a generation that finally said, hey, what's going on here is simply not fair."730 In addition, to saying: "Hey, what's going on here is simply not fair" about prejudice and discrimination in the South, it is time the current generation said the same thing about the prejudice and discrimination ongoing in the U.S. film industry. *Mississippi Burning* was directed by London-born Alan Parker and produced by Frederick Zollo and Robert F. Colesberry.

The Cannon 1988 release, *Shy People* is about a "sophisticated Manhattan magazine writer, who convinces her bosses at Cosmopolitan to let her write about her family roots . . . Barbara Hershey plays (Jill) Clayburgh's long-lost distant cousin, who lives in isolation in a crumbling, mossy home in the heart of the (Louisiana) bayou. The movie is essentially about the differences between these women, about family blood ties (and) . . . suggests that family ties are the most important bonds in the world"731 another favored Hollywood theme. The film was directed by Russian-born Andrei Konchalovsky and produced by the Israeli cousins Menahem Golan and Yoram Globus.

The following year, the 1989 Warner/Touchstone release *Blaze* told the story of the relationship between a "boozy, wheeler-dealer governor of Louisiana . . . and . . . (a) hillbilly girl who became a

famous stripper." The governor is also presented as a pragmatist "who contributed to the progress" of a "segregated South . . . [by favoring] the votin' rights bill" for blacks[732]. The film was directed by California-born Ron Shelton for producers Gil Friesen and Dale Pollock. Also, in 1989, the Columbia/TriStar release *Steel Magnolias* "takes place down in Louisiana during . . . the 1980s and involves a tightly knit group of women" who gossip. "These six women are the steel magnolias of the title." They are portrayed as "dippy . . . Southern Belles."[733] The film was directed by New York-born Herbert Ross for producer Ray Stark.

In 1989, *Miss Firecracker* starred Holly Hunter, Mary Steenburgen and Tim Robbins suggesting that one of the most important events in the lives of two Mississippi cousins is their participation in the Yazoo City, Mississippi Fourth of July beauty pageant. Ms. Hunter's character "works as a fish-gutter at the local catfish packing plant." The film ultimately suggests that "all beauty contests are about the need to be loved, and . . . how silly a beauty contest can seem if somebody really loves you[734]." Thomas Schlamme directed for producer Fred Berner. That same year, Columbia/TriStar's *Glory* (1989) told the story of "the 54th Regiment of the Massachusetts Volunteer Infantry, made up of black soldiers" which fought in the U.S. Civil War against the Confederates[735]. Edward Zwick (originally from Illinois) directed for New York-born producer Freddie Fields.

The 1989 Warner release, *Driving Miss Daisy* told the story of a quarter-century relationship between "a proud old Southern lady" (Jessica Tandy) and her black chauffeur (Morgan Freeman). Although Miss Daisy "prides herself on being a Southern Jewish liberal, she is not always very quick to see the connection between such things as an attack on her local synagogue and the Klan's attacks on black churches." At one point in the movie Daisy says: "Things have changed," referring to race relations in the South, and Morgan Freeman replies that "they have not changed all that much."[736] Here again we have another Hollywood portrayal of race relations in the South, drawing similarities between the black and Jewish struggles against racist whites. It would actually be more realistic to produce

and release a major studio motion picture showing how the Hollywood insiders, (a small group of Jewish males of a European heritage, who are politically liberal and not very religious) have arbitrarily denied blacks, Latinos, women and all other non-Hollywood insiders from making a fair living in the film industry for nearly 100 years? That's discrimination and it is just as prevalent in contemporary Hollywood as it ever was in the American South.

Daisy was "directed by Bruce Beresford, an Australian whose sensibilities (according to Ebert) seem curiously in tune with the American South."[737] It would be more accurate to say that Beresford's sensibilities about the American South are more in tune with the stereotypical views of the Hollywood insiders who decide which movies are going to be produced and released to national audiences. The film was produced by Richard and Lili Fini Zanuck.

Also, in 1989, the film *Sex, Lies, and Videotape* was set "in Baton Rouge, Louisiana, and it tells the story of four people in their early thirties whose sex lives are seriously confused."[738] The film was written and directed by Steve Soderbergh (born in Atlanta and raised in Louisiana) for producers Robert Newmeyer and John Hardy. That same year, the Universal release *Fletch Lives* (1989) starred Chevy Chase as "a wisecracking (investigative) newspaper reporter" from Los Angeles, and portrays a "crumbling Southern mansion, a genial small-town lawyer, a TV evangelist, a jailhouse bully, a smart black FBI man who pretends to be stupid, a sexy young real estate woman, an evil industrial polluter . . . a cynical newspaper editor . . . a seductive Southern belle and a dozen Ku Klux Klansmen."[739] all set in the South. Wisconsin-born Michael Ritchie directed for the producer group identified as Douglas/Griesman.

National Lampoon's Christmas Vacation (Warner—1989) includes a portrayal by Randy Quaid of "a hillbilly cousin (with a strong Southern accent) who seems to have traveled in his camper directly from Dogpatch[740]." Jeremiah S. Chechik directed for producers John Hughes (born in Michigan) and Tom Jacobson. That same year, (1989), the Island Pictures release *Crusoe* took place "in the slave-trading days of the 19th century, when a Southern aristocrat in need of money (Aidan Quinn) sets off on a risky venture to bring back

slaves from Africa[742]." The question raised here is why is the Crusoe of this film portrayed as a "Southern aristocrat." Isn't it true that many slave traders of the day were other than men from the South, or does this film again simply reflect a prejudice held by many in the Hollywood film community? Philadelphia-born Caleb Deschanel (French father and Quaker mother)[743] directed for producer Andrew Braunsberg.

As the '90's decade opened, *Dances With Wolves* (1990) contained a brief scene in which a fat, ugly white Anglo-Saxon Southern male was portrayed as the single most arrogant, obnoxious jerk in the picture. Again, such portrayals are not so offensive standing alone. But, when considered as part of the larger body of Hollywood films, and the consistency of Hollywood's negative and stereotypical portrayals of people from the South is revealed, it is obvious that such characterizations are not incidental. California-born Kevin Costner directed and co-produced with Jim Wilson. Also in 1990, *Mystery Train* was another film that painted a rather depressing view of the South, this time Memphis, Tennessee. The story revolves around two teen-age Japanese tourists (an Elvis fan and a Carl Perkins fan) and the various odd-ball characters they meet in their tour of rock 'n' roll shrines and the fleabag hotel in which they stay[744]. Ohio-born Jim Jarmusch wrote and directed for producer Jim Stark.

The lead role in Henry: *Portrait of a Serial Killer* (1990) was played by Michael Rooker an actor from Jasper, Alabama[745]. John McNaughton directed and co-produced with Lisa Dedmond and Steven A. Jones. Also, in 1990, *Texasville* starred Jeff Bridges, Cybill Shepherd and Annie Potts in a film set in the same small, dusty, dreary Texas town which served as the location for *The Last Picture Show*, the "small Texas town where everybody knows everybody, and they all seem to be having affairs, and everybody knows all about it." The people in this town all seem to suffer from a "general aimlessness . . . (and) they have given up having any dreams or expectations . . . now under these wide Texas skies people lower their eyes to smaller concerns and lives without vision."[746] New York-born Peter Bogdanovich wrote and directed and co-produced with Barry Spikings.

The following year, (1991) *The Five Heartbeats* provided a scene "showing racial prejudice against the group (they're touring the South when they're stopped by racist state troopers), and (according to Roger Ebert) "it seems a little tacked on, as if the only purpose of the Southern trip was to justify the scene."⁷⁴⁷ Which is precisely one of the points being made in this section of the book, (i.e., many scenes are put into movies to communicate similar negative portrayals or positive portrayals of the filmmaker's choosing). Chicago-born Robert Townsend directed for producer Loretha C. Jones. Also, in 1991, *The Butcher's Wife* (1991) portrays Demi Moore as "a simple, soft-spoken women with a Southern accent."⁷⁴⁸ (Why can't Southern women be portrayed as sophisticated?) In any case, the film was directed by Terry Hughes and produced by Wallis Nicita and Lauren Lloyd (screenplay by Ezra Litwak and Marjorie Schwartz). The 1991 film *Mississippi Masala* portrays the "saga of an Indian family expelled by Uganda's Idi Amin, whose members discover in America's South that racial bias has no boundaries." ⁷⁴⁹Mira Nair (born in India) directed the film. She co-produced with Michael Nozik.

As noted earlier *Slacker* (1991) in addition to being a rare exception to the homogeneous film (after all, it is an independent production) also provides another negative portrayal of the people in a Southern city, Austin, Texas. The film contains scenes involving a hit-and-run driver who kills his mother, a thief, "a man who 'knows' that one of the moon astronauts saw an alien spacecraft . . . a woman who owns a vial containing the results of an intimate medical procedure carried out on Madonna; and various folk singers, strollers, diners, sleepers, paranoids, do-gooders, quarreling couples, friends, lovers, children, and conspiracy theorists." Again, it is not offensive that some or all of these characters are set in a Southern city, only that this negative portrayal joins a long list of similar negative portrayals creating a clear pattern of bias in the movies either produced or released by the Hollywood film community. It is not relevant that there may in fact be real people like the ones portrayed. There are also real people in the South that would constitute a more positive portrayal. The problem is that the moviegoing audience rarely

gets to see those and such constant brain-washing about the nature of the people who live in a particular region of the country, cannot help but influence the attitudes of people in other parts of the country and the world toward those same people. This film was written and directed by Richard Linklater.

Also in 1991, the evil character played by Robert De Niro in the new version of *Cape Fear* talked with a heavy Southern accent. The film was directed by British-born J. Lee-Thompson for producer Sy Bartlett (born Sacha Baraniev in Russia). And, *The Ballad of the Sad Café* (procured by Merchant Ivory, released by Angelika Films—1991) provides a depressing portrayal of a retired café owner who sells moonshine to the "local backwoods folk" and engages in the healing arts.[750] The film offers a "Venessa Redgrave . . . impersonation of a love-starved rural moonshiner." The story is set "in the Depression, the action unwinds in a desperately poor and isolated Southern hamlet, where the men have been beaten into silent passivity by their poor-paying, numbing mill jobs and where the women are flummoxed by boredom. Stimulation is so rare that a riverside revival meeting is interrupted so all involved can watch a train pass by."[751] Simon Callow directed for producer Ismail Merchant (born in India).

Thelma & Louise (MGM-Pathe Entertainment/1991) is about "two pistol-packing, formerly respectable Arkansas women on the lam from husbands, lovers, and the law-men in general."[755] British-born Ridley Scott directed and co-produced with Mimi Polk. Also, in 1991, *Wild Hearts Can't Be Broken* (Walt Disney Pictures) was "a Depression-era story of a poor, Southern lass . . . the stubborn orphaned ward of her dirt-poor Georgia aunt . . . (who) runs away after her aunt threatens her with the state orphanage . . . (and she) achieves fame and fortune riding the diving horse at New Jersey's Atlantic City Steel Pier, despite being blinded in a diving accident."[756]

Doc Hollywood (1991) starred Michael J. Fox as "a recent medical school graduate on his way from Washington to Los Angeles . . . (when) . . . his car plows through the fence of the local judge" in a make-believe town, Grady, South Carolina, portrayed as the

"Squash Capitol of the South." The movie does not go as far as most Hollywood movies in providing negative portrayals of Southerners but still presents a rather stereotypical picture of a small town in the South.[758] As pointed out in *The Hollywood Reporter*, "Doc Hollywood" is about "a city slicker M.D. getting the lowdown and his comeuppance from a collection of colorful country folk . . . a bunch of small-town eccentrics." The Southern town is portrayed "with drooping Southern flora and weathered store fronts."[758] Scottish-born Michael Caton-Jones directed for producers Susan Solt and Deborah D. Johnson.

Necessary Roughness (1991) was about a Texas college football team (the Texas state Armadillos) that was "last year's national college football champions before an investigation uncovered widespread corruption in the school's athletic program."[760] New York-born Stan Dragoti directed for producers Mace Neufeld (also, originally from New York) and Robert Rehme. In the 1991 release *Rambling Rose* (starring Robert Duvall, Diane Ladd, Laura Dern and Lukas Haas) "[c]omfortably eccentric Southerners learn from life and each other in this familiar-sounding, moral-friendly Depression Era tale of a middle class family and their sexually irrepressible housekeeper[760]." It appears that Hollywood cannot provide a movie about people in the South without portraying some of them as eccentric, depressing, poor, crude or dim-witted or all of the above. Connecticut-born Martha Coolidge directed this film for producer Renny Harlin (born in Finland).

The Long Walk Home (1991) starred Sissy Spacek and Whoopi Goldberg in a movie about "a critical turning point in American history," the time in Montgomery, Alabama in 1955 that "a black woman named Rosa Parks "refused to stand up in the back of the segregated bus when there was an empty seat in the front." Movie critic Roger Ebert says that in "a way, this movie takes up where 'Driving Miss Daisy' leaves off. Both are about affluent white southern women who pride themselves on their humanitarian impulses, but who are brought to a greater understanding of racial discrimination—gently, tactfully, and firmly—by their black employees."[762] Of course, the filmmakers are hoping that the movie will bring the

audience to a "greater understanding of racial discrimination—gently, tactfully, and firmly." This movie appears to be part of a broader pattern of choices regarding what movies are made and where they are set with respect to depicting racial discrimination against blacks in the U.S. It is quite fair to point out that the South is not the only place where racial discrimination has and continues to be directed against African-Americans. For example, racial discrimination against African-Americans and others has been occurring for nearly 100 years and continues to occur in the Hollywood-based U.S. film industry. Thus, such films turn out to be one cultural group lecturing another when neither is perfect. California-born Richard Pearce directed *The Long Walk Home* for producers Howard W. Koch, Jr., and David Bell.

Finally, in 1991, the Columbia Pictures release *Prince of Tides* at least balances its portrayal of another dysfunctional Southern family with the story of one son (played by Nick Nolte) who survives, grows and adjusts (with the help of a Jewish psychiatrist played by Barbra Streisand). The father of the family from South Carolina was "a violent alcoholic who abused" the mother and the children. The mother eventually traded "up to a local rich man whose cruelty was more refined."[762] There was even a hint, early in the movie, that the mother may be anti-Semitic based on the tone of her voice when she tells the Nolte character that his sister is being treated by a "psychiatrist, some Jewish woman from New York." The movie also makes numerous references to an overly broad generalization about the South, called "the Southern Way", a supposed regional behavior pattern suggesting that people from the South are taught to avoid conflict in conversation by either changing the topic or making a joke. New York-born Jewish actress/director Barbra Streisand directed and co-produced with Andrew Karsch.

In 1992, film critic Roger Ebert proclaims that although *My Cousin Vinny* (starring Joe Pesci and Marisa Tomei) is "set in the South (Alabama) and has an early shot of a sign that says 'Free Horse Manure,' this is not another one of your Dixie-bashing movies. The judge . . . and prosecutor . . . are civilized men who aren't trying to railroad anybody."[762]

Apparently, "Dixie-bashing" in Hollywood movies is so obvious that when a film set in the South is not blatantly anti-Southern even a Chicago movie critic like Roger Ebert can recognize it. Although, it does not appear that Roger has otherwise complained in his reviews of all of the other movies that were clearly "Dixie-bashing" films. The truth is that *My Cousin Vinny* did provide another negative and stereotypical portrayal of a poor, small Southern town, along with some prejudiced inhabitants. The film was directed by Jonathan Lynn for producers Dale Launer and Paul Schiff.

Also, in 1992, portions of the movie *Fried Green Tomatoes* took place "in the town of Whistle Stop, Georgia . . . (as Roger Ebert says) one of those Southern towns were decent folks get along fine with the Negroes, but the racist rednecks are forever driving up in their pickups and waving shotguns around and causing trouble." The movie shows an incident during which the "local Klansmen get riled . . . (over a black man being served at the café), although the movie "is really about nonconformity in an intolerant society. It's pretty clear that Idgie (Mary Stuart Masterson) is a lesbian, and fairly clear that she and Ruth (Mary-Louise Parker) are a couple, although (again according to Ebert) given the mores of the South at the time a lot goes unspoken, and we are never quite sure how clear things are to Ruth. It is also clear that they consider Sipsey and George better company than most of the white folks in town, and that, by deciding for themselves who they are and how they will lead their lives, Idgie and Ruth are a threat to the hidebound localsv[763] New York-born Jon Avnet directed and co-produced the film with Jordan Kerner.

The Tri-Star release *City of Joy* (1992) is one of just a few Hollywood films that provides any portrayal of a contemporary Southern urban environment and it happens to be somewhat negative, after all, the film stars Patrick Swayze as a Houston surgeon "[f]leeing from the rigors of life" there. Swayze's character (positively portrayed) then becomes "involved with some of India's "most deprived citizens . . . " in the "dense, mysterious" city of Calcutta[764]. London-born Roland Joffe directed and co-produced with Jake Eberts. That same year (1992), *Daughters of the Dust* told the story of

a family of African-Americans who have lived for many years on a Southern offshore island, and of how they come together one day in 1902 to celebrate their ancestors before some of them leave for the North."[766] Watching Hollywood movies over the years, might convince any reasonable person that few if any positive things have occurred in the American South throughout its history. *Daughters of the Dust* was directed by Julie Dash, who co-produced with Arthur Jafa.

Also, in 1992, *Storyville* provides another "lurid example of the genre of Southern gothic excess, a story of feckless youths and crooked politicians and dangerously seductive women and secrets that creep down through the generations with their tails between their legs[767]." Mark Frost directed for producers David Roe and New York-born Edward R. Pressman. *Straight Talk* (1992) starred Dolly Parton as "a Southern woman with a bumpy marital record . . . (who) gets into her car and heads north to the big city of Chicago . . . (where) . . . she (applies for a job at a radio station and) is mistaken for the newly hired advice personality, put on the air, and is an instant hit[767]." This film is another example of the rather prejudicial Hollywood filmmaker notion that people from the South can't find success and happiness unless they leave. Barnet Kellman directed for producers Robert Chartoff (New York-born) and Fred Berner.

One False Move (1992) was about "three criminals on the run from Los Angeles to Arkansas." One of the criminals is portrayed as a "violent, insecure redneck type." The group is headed for "the small Arkansas town where (he) . . . was born and raised." The local lawman is portrayed as a "naive greenhorn" whose aspirations "to make the big time in L.A . . . someday" are joked about by the Los Angeles detectives in the movie.[768] Carl Franklin directed for producers Jesse Beaton and Ben Myron. Also, in 1992, *Pure Country* (Warner Bros.) provided Hollywood with another opportunity to portray a "Texas ranch gal" (Isabel Glasser) and "Texas locations"[769] the way such people and places are perceived and commonly portrayed by Hollywood filmmakers, that is as cowgirls and cowboys in cow country, while films portraying the more urban environments

of three of the nation's ten largest cities (Houston, Dallas and San Antonio) are seldom portrayed positively in a contemporary story.

In 1993, the independently produced *Passion Fish* focuses on a woman (May-Alice, played by Mary McDonnell) whose "life was essentially going nowhere before her accident. She's in a dead-end career, her marriage has ended, and she's filled with deep discontent. Then she is paralyzed in an accident, and goes back home to (the rural) Louisiana (bayou country) to recover, filled with resentment . . . She has enough money to hire a full-time companion" and ultimately hires "Chantell, a black woman played by Alfre Woodard." The balance of the movie is about the struggle for power in the relationship between these two main characters, plus "comic portraits of May-Alice's many visitors."[772] New York-born John Sayles wrote and directed for producers Sarah Green and Maggie Renzi.

In another Hollywood portrayal of Texas and Texans (Paramount's 1993 release *Flesh and Bone*) Arlis, played by Dennis Quaid, is a solitary guy who lives in a motel room and traverses the endless highways (across the flat Texas prairie) tending to vending machines. Before long, Kay (Meg Ryan) . . . stumbles into his life." Then "the evil father, Roy (James Caan), pops up" and his "presence eventually proves fatally disruptive." As *Variety*'s Todd McCarthy states, Meg Ryan's character comes off as a "boisterous little Texas tart."[773] More negative and stereotypical portrayals of Texas and Texans, appear in the 1993 Warner Bros. release *A Perfect World*. The film tells the story of "Butch Hayes (played by Kevin Costner), a lifelong loser toughened up by many years in the pen . . . Butch and his nasty partner Terry (Keith Szarabajka) break out of the joint on Halloween night 1963, commandeer a car and, after briefly terrorizing a family, make off with 7-year-old Phillip Perry (T.J. Lowther) as a hostage. Quickly taking up the chase . . . across the vast, sunbaked Texas landscape . . . is Texas Ranger Red Garnett (San Francisco-born Clint Eastwood, who also directed)." In the meantime, "little Phillip begins admiring his abductor for his cool . . . take-charge ways and his friendly, liberating words of encouragement, things he never hears from his severe, Jehovah's Witnesses mom."[774]

The 1993 Columbia release *Geronimo–An American Legend* "relates the final stages of the U.S. government's subjugation of the West's native population."[775] The great Indian warrior is portrayed as "a complex figure who surrenders himself to the white man, only to rise up in anger after soldiers murder an Indian ghost dancer in the middle of a ritual. The original script, written by John Milius "indicated that the main reason Geronimo left the reservation was that he hated being a farmer."[776] Hollywood thus, appears to have recently made a start in utilizing more balanced portrayals of Indians, but in effect, has merely substituted, the continued negative and stereotypical portrayal of another group, the white Anglo Saxon male and more specifically, Texans and others from the American South. The worst of the worst bad guys in this movie are portrayed as Texans. Robert Duvall, for example, gratuitously refers to Texans at one point as "the lowest form of human life." If a line of dialogue in a movie said African-Americans, Latinos, women, Jews, gays or lesbians were the "lowest form of human life", such a comment would create justifiable outrage among the offended populations. This comment went beyond what is acceptable for any identifiable group and it was clearly not important in telling the movie's story. Maybe it was an insider's joke since Duvall has often played Texans in the past. Under any circumstances, it was totally uncalled for. Incredibly, one reviewer of the film "Geronimo" even went so far as to describe it as "politically correct."[777] Politically correct, in this instance, means that it is permissible to protect the images of some people (e.g., the American Indians) while simultaneously seeking to defame other people (e.g., Texans) as this movie does with its vicious-anti-Texan defamation. Chicago-born Walter Hill produced and directed the screenplay by Milius and Larry Gross. In addition to Duvall, the other stars include Jason Patric, Gene Hackman, Wes Studi, Matt Damon, Rodney A. Grant and Kevin Tighe.

In the Warner Bros. release, *Sommersby* (1993), a post-Civil War story is set in the South and portrays an entire town full of Southern bigots one of whom refuses to live near African-Americans (although that is not the word she used) and others who bitterly complain because the film's leading character (played by Richard

Gere) offers to allow blacks to own property. The film also includes a Ku Klux Klan cross-burning, racial hatreds based on Christian religious beliefs and a white racist on the witness stand in a court-room overseen by a black judge (James Earl Jones). The townspeople are also portrayed as being so stupid as to allow a man who some believe to be an imposter to talk them into giving him all of their remaining valuable treasures so he can ride off into the sunset (supposedly to buy tobacco seeds). Fortunately, for them he does return. British-born Jon Amiel directed for producers Arnon Milchan (born in Israel) and Steven Reuther.

The 1993 film *Love Field* is about "a Dallas housewife who worships Jacqueline Kennedy, and is stuck in a drab marriage (according to Hollywood there is no other kind in the South) with a husband whose idea of communication is to ask her to get him another beer out of the icebox."[778] The "chattery Southern belle . . . acts out her devotion to the late President by hopping a Greyhound . . . and heading for his funeral. Her journey is presented as an act of proto-feminist defiance against her domineering, white-trash (Texan) husband.[778] The film was directed by Paris-born Jonathan Kaplan for producers Sarah Pillsbury (from New York) and Midge Sanford.

Also, in 1993, *Passenger 57* starred Wesley Snipes in an action/thriller movie in which he fights "both terrorists and pigheaded bureaucrats." In addition, the film includes a portrayal of "a dim Southern sheriff named Biggs (as in bigot)."[780] This Warner Bros. release was directed by Kevin Hooks for producers Lee Rich, Dan Paulson and Dylan Sellers.

Rich in Love (1993) is another movie containing regional stereotypes. Movie critic Roger Ebert uses this film to illustrate his belief that "one of the reasons we go to the movies (is) . . . to see people who are crazier than we." Ebert says "these characters live to a different rhythm than people in the North." They are "colorful and irreverent and eccentric and romantic, and they gab a lot about life and fate." The central family in the movie "lives in an elegant (and stereotypical) old Southern mansion."[781] Australian Bruce Beresford again directed for producers Richard and Lili Fini Zanuck of Los Angeles. Also, in 1993, *The Firm* portrays a Memphis, Tennessee law

firm, most of whose clients "are thieves, scoundrels, and money-launderers." In addition, the firm's partners act "as bagmen shipping the money to offshore banks."[782] Sydney Pollack (who, as noted earlier, was born in Indiana, the "son of first-generation Russian-Jewish Americans")[783] directed for producers Scott Rudin (born in New York) and John Davis.

Also, in 1993, Stephen Sommers version of *The Adventures of Huck Finn* portrays an escaping slave ("Jim") in the South who "guides Huck out of the thickets of prejudice and sets him on the road to tolerance and decency." In the movie "Jim . . . explains . . . to (Huck and the audience) . . . that black people have the same feelings as everyone else, and are deserving of his respect[784]." Along the way, the film, once again, portrays a whole slew of Southerners as ignorant, racist, hicks (including Huck's alcoholic and abusive father). Sommers wrote and directed for producer Laurence Mark. That same year, (1993), the Universal release *Hard Target*, (starring Jean-Claude Van Damme), told the story of "a sadistic band of hunters, headed by amoral chief Fouchon . . . and his deputy . . . who operate a profitable 'safari game' in which the prey are homeless combat veterans (in urban New Orleans)[785]." The film was directed by John Woo of Hong Kong for producers James Jacks and Sean Daniel.

In 1994, director Tim Burton's film *Ed Wood* (Touchstone Pictures) included a brief negative and stereotypical portrayal of a Southern man and his son. The man owns a meat packing plant and becomes a financial backer for one of Ed Wood's film. As noted earlier, director Burton was born in California. That same year, Paramount finally gave the American South a true hero, but he turns out to be somewhat dim-witted and quite unbelievable. *Forrest Gump* offered a wonderful story about a fairly common Hollywood theme (i.e., the struggles of a person who is "different"). The film is enhanced by beautiful cinematography as it tells the story of how a white Anglo-Saxon male from Alabama with an I.Q. of 75 deals with the Vietnam war, hippies, drugs, Watergate, integration and Elvis. The picture otherwise portrays various characters from the South as ignorant jerks, racists, child molesters, exploiters of college athletes and red neck bullies, with a small bit about the Ku

Klux Klan thrown in for good measure. Chicago-born Robert Zemeckis directed.

The 1994 Universal release *Reality Bites* tells the story of "four recent Texas college grads" who are aimless. Danny DeVito and Michael Shamberg produced. Ben Stiller director. The screenplay was written by Hellen Childress. The film stared Winona Ryder (Horowitz), Ethan Hawke, Ben Stiller, Janeane Garofalo, Steven Zahn and Swoosie Kurtz.[786]

The 1994 summer offering of *Maverick* starring Mel Gibson, James Garner and Jodie Foster offered another slight of the South. The movie shows the Foster character saying she is from Mobile, Alabama, but when pressed to name people there she knows, she claims she's tried so hard to forget them all. New York-born Richard Donner directed. Also, the 1994 Sylvester Stallone/Sharon Stone film *The Specialist* provides another routine portrayal of the southern city of Miami as a major center for the illegal trafficking of drugs. The Hollywood Pictures 1994 release *Tombstone* starring Kurt Russell, Val Kilmer and Sam Elliott not only provides "over 100 exiled Texas outlaws (who supposedly) banded together (following the Civil War) to form a "ruthless gang" referred to by film narrator Robert Mitchum as "the earliest example of organized crime in America" as the bad guys, the film also provides a cartoon-like caricature of a Southern gentleman in Kilmer's portrayal of the sickly Doc Holiday. Finally, Hollywood Pictures' 1994 release *Quiz Show* (directed by California native Robert Redford) provided another stereotypical and negative portrayal of a U.S. Congressman from the South.[9]

The 1994 Universal release *The War* presented another poor family from the South, this one from "Mississippi during the summer of 1970." The actual "story focuses on a poor family whose patri-

9 Most of the biographical information for this section came from the Katz Film Encyclopedia. Thus, when the place of birth and other biographical information are not disclosed in this presentation, it is generally because the named persons were not even listed in Katz. In fact, it was somewhat surprising to see how many producers of the above discussed films were not listed in Katz, raising the question as to who these people are (or on the other hand, whether they actually exist).

arch (Kevin Costner) has returned from Vietnam bearing emotional scars that make it difficult for him to hold a job." New York-born Jon Avnet directed and produced with Jordan Kerner. Kathy Mc-Worter wrote the screenplay. Other stars included Elijah Wood, Mare Winingham, Lexi Randall, Christine Baranski and Raynor Scheine.[787]

The 1994 20th Century-Fox release *Nell* is the story of a young woman (played by Jodie Foster) who was "left alone in a remote lakeside cabin (in the North Carolina backwoods) when her mother dies." The girl "speaks in a unique way due to her mother's stroke-induced speech impediments." The "medical authorities at Charlotte University want to hospitalize this prize specimen for extended observation and treatment" but "an independent mind-ed doctor Jerome Lovell (Neeson) manages to win a stay of three months." British-born Michael Apted directed for producers Renee Missel and Jodie Foster. The screenplay was written by William Nicholson and Mark Handley. Other stars included Natasha Rich-ardson, Richard Libertini, Nick Searcy, Robin Mullins, Jeremy Da-vis and O'Neal Compton.[788]

As can be seen from the above fairly comprehensive overview of Hollywood movies about the American South, the Hollywood movie Southern stereotype typically involves "tyrannical" fathers and uncles, "eccentric" mothers, "demented" hillbillies, moonshin-ers, corrupt sheriffs and racist rednecks. Specific Texas stereotypes involve cowboys, millionaires and oil field roughnecks.

Research Project: Determine whether Hollywood has ever made a movie touching on people, places or things from the South that did not portray some of the film's Southern characters in a negative or stereotypical manner. If so, in which movies?

It would appear from the above review of motion pictures that the Hollywood-based U.S. industry has for the past nearly 100 years systematically engaged in the malicious defamation of an entire re-gion of our country, the American South. Much as Michael Medved argues that the film industry is losing potential revenues from a major segment of an overlooked potential moviegoing audience by

focusing on vulgar, crude, bizarre, sexually explicit, violent movies, a similar argument can be made that motion picture revenues in the South, including Texas are less than they would be if there was more balance in the movie industry portrayals of people and places in the South. It is safe to say that a lot of people in the South simply do not go to see modern Hollywood movies because they consider them silly and quite often insulting or offensive.

A total of 251 movies are included in this survey. As it turns out, only 29 of them (12%) were directed by directors from the South. Fifty-five (55) of these movies (22%) were directed by directors from the state of New York alone. Sixty-five (65) others (26%) were directed by directors from other Northern states besides New York. Sixty-nine (69 or 27%) were directed by foreign directors and another 33 (13%) were directed by directors from the American West. In all, 88% of these films about people, places and things of the American South, were directed by non-Southerners. This may help explain why so many of them present negative and/or stereotypical portrayals of these subjects.

Consider the multiple levels of arrogance involved in a filmmaking community, controlled by Jewish males of a European heritage, who are politically liberal and not very religious, that consistently turns out films portraying the people, places and things in the South in a negative or stereotypical manner. There is an initial level of arrogance and supposed "superiority" involved in the moralistic judgment made in deciding that it is ok for one cultural group to consistently be critical of another. There is a second level of arrogance in assuming that other regions of the country cannot provide an approximate equal number of the settings for some of these negative portrayals. There is a third level of arrogance in controlling the film industry to the exclusion of other cultural groups, thus preventing the other cultural groups (including people from the South) from providing a more accurate or alternative depiction of themselves on the screen. And there is a fourth level of arrogance involved in the proposition that the people of the South are so stupid that they will continue to pay money to see such films, money which in turn al-

lows the Hollywood filmmakers to continue to spread this kind of negative propaganda.

It appears quite clear from the record set forth above that the people who control the U.S. film industry are very much into including messages that promote tolerance, whenever tolerance might affect them, but promoting "hate" whenever their movies have anything to do with people, places and things from the South. Based on such an observation, it would be fair to label the people who control Hollywood as "hatemongers" and "bigots".

The fact that some of these films providing negative or stereotypical portrayals of people, places and things of the American South are based on the works of Southern writers is also irrelevant. The relevant consideration here is who has the power to determine what movies are made and the content of those movies and how has that power been exercised for the nearly 100 year history of the U.S. film industry. If, for example, there are 100 writers from the Southern region of the country writing about the South and fifty of them provide negative and stereotypical portrayals of people, places and things in the South, but the Hollywood moviemakers choose almost all of their movies from this group of fifty negative writers, as opposed to the group that provides more positive portrayals, what difference does it make, that the literary works on which the movies are based were written by someone from the South? This logical argument relating to the contributors to such film projects also applies to all of the other patterns of bias exhibited by Hollywood movies.

In response to the possible criticism that not all of the movies discussed in this book were viewed by the author, it only need be pointed out that it is not necessary to actually see all of the movies, if the reviews themselves reveal enough information to determine that such movies provide negative or stereotypical portrayals of people, places or things in the South. Besides, my experience suggests that a systematic viewing of all of the movies produced or released by U.S. film companies throughout the history of the film industry or some other more limited period, would only disclose more of such patterns of bias, not less. In other words, in those instances

where these movies have actually been viewed, such viewings have resulted in additional examples of anti-Southern negativity or stereotypical portrayals in films for which such bias was not revealed in the reviews. Thus, it may be fairly predicted that any more careful review of a representative sampling of Hollywood movies will turn up an even larger number of examples of anti-Southern bias, not a smaller number.

Another aspect of the problem with the American film industry is that it seems to make a lot of movies about racism generally (as opposed to other equally important issues), and racism in the South, specifically, the cumulative effect of which is to falsely suggest that most of the racism directed toward blacks in this country is geographically centered in the southern United States. At the same time, prejudice, racism and discrimination directed toward blacks and others pervades the very industry that produces and releases these accusatory movies. The situation is so bad that the U.S. film industry may be one of the most racist industries in America, and of course, what makes the situation even worse, is that the film industry produces a product that is effected by the beliefs of those filmmakers.

Confirmation of this blatant prejudice may be revealed simply by asking the question: How many Hollywood films during the last ten years have portrayed white males in the cities of Miami, Atlanta, New Orleans, Houston, Dallas or San Antonio, or any of the other vibrant cities in the South as anything other than redneck assholes? Obviously, not very many, because (1) most Hollywood films about the South are set in the rural South and (2) because most of the white people portrayed are presented as ignorant, prejudice local yokels. Another variation on that question, the answer to which tends to corroborate the premise that the U.S. film industry consistently produces and distributes movies exhibiting such a regional prejudice, is: What and how many major studio/distributor releases in the past ten years have featured a positive portrayal of an urban, contemporary, white Anglo-Saxon Southern male? The answer is, very few indeed, if any.

Here is an example of the potential harm from regional prejudice. In 1986, some eleven years after the so-called Malibu Mafia launched the Energy Action Committee, the lobbying organization Hollywood liberals used "to battle big oil in the legislative wars over energy policy . . . "[789] the OPEC oil countries arbitrarily decided to flood the world oil markets with cheap oil, at prices so low, domestic oil producers could not compete. The U.S. Congress then had an opportunity to step in and protect our domestic oil industry, from the anti-competitive and predatory actions of this foreign cartel with tariff supports. It basically came to a vote of the non-oil producing states against the oil-producing states (essentially a regional industry primarily based in the South). It is my contention that the kind of regional prejudice fostered by the movie industry's pattern of bias (i.e., its consistent negative or stereotypical portrayals of people, places and things of the American South), and the well-financed lobbying activities of the Malibu Mafia, may have contributed to the 1986 Congressional decision not to provide support for the domestic oil industry when threatened by the economic attack of the OPEC oil cartel. As a result of that crucial Congressional decision (very possibly based on the same kind of regional prejudice regularly spewed forth through Hollywood movies), hundreds of oil industry related companies in the South went out of business, thousands of people working in affected jobs were out of work, homes were lost, real estate values suffered significantly, savings and loans and banks suffered losses, etc. There may, of course, be no way of knowing for certain whether regional prejudice played a part in that decision, but in the Congressional debates themselves, which were carried live on cable television, you could easily see that the regional interests of the country were being debated, not the national interest. At the very least, such an incident highlights the critical importance for Congress not to allow an important communications medium like the U.S. film industry to be controlled by people who consistently provide negative portrayals of any segment of our population. After all, in addition to the potential for psychological damages, such consistent negative portrayals may ultimately affect the economic interests of the region being

victimized. And, as can be seen from the above example, adversely affecting the economic interests of a region destroys jobs, careers, fortunes and lives. Further, of course, if a region of the country can be victimized by this sort of Hollywood propaganda, what is to stop such propaganda from being turned on other segments of our diverse population?

As Paul Johnson wrote in his 1987 book *A History of the Jews*,[790] "Germany could not be judged by Nazi anti-Semitism, any more than France by its Terror, Protestantism by the Ku-Klux-Klan or, for that matter, 'the Jews by their parvenus[10]." In addition, the American South cannot fairly be judged by the racist attitudes of just some of the people who live there, cannot be fairly judged by the many negative movie portrayals of Southern country-folk and cannot be fairly judged by the Hollywood movie portrayals of "tyrannical" fathers and uncles, "eccentric" mothers, "demented" hillbillies, moonshiners, corrupt sheriffs, racist rednecks, cowboys, millionaires or oil field roughnecks. There is much more to the American South than what Hollywood wants the world to see. Thus, this book is an argument for extending the common Hollywood movie theme of tolerance to the real world, including Hollywood itself.

If the roles were reversed (i.e., a small group of white males from the South had been able to gain control of the U.S.-based film industry through the use of anti-competitive business practices, historical accident or otherwise, and had established its headquarters in Atlanta, instead of Los Angeles, then proceeded to produce and distribute movies that portrayed American Jews in a consistently negative or stereotypical manner for more than 100 years), the country would be rightfully outraged. The country should also be equally outraged by what has actually been offered by the Holly-

10 Parvenus are "persons who have suddenly risen to a higher social and economic class and have not yet gained social acceptance by others in that class. In other words, parvenus are "new rich". In that same sense, we should add that our attitudes toward Jews generally, should not be determined by our judgments relating to that small group of Jewish males of European heritage, who are politically liberal and not very religious, and that also happens to control Hollywood.]

wood-based U.S. film industry, certainly with respect to its consis-
tent defamation of the American South.

CHAPTER 7

Other Negative Portrayals in Hollywood Films

The above listing and discussion is not intended to be exhaustive nor does it include all groups that have complained about being consistently negatively or stereotypically portrayed by the American film industry (or about the related lack of equal employment opportunity at all levels of the film industry). Other identifiable populations voicing complaints from time to time with regard to their portrayals in Hollywood movies include Muslims, Italian-Americans, German-Americans, Irish-Americans, Gypsies, the deaf and hard of hearing and the elderly. Also, we rarely see any Mormons working in the Hollywood-based U.S. film industry, nor many films about Mormons. Practitioners of the Voodoo religion are also consistently portrayed as villains in Hollywood movies, along with most forms of religions that are considered by the Hollywood community to be cults.

In addition to serving as a brief history of those groups that have recently complained about biased movies and their negative or stereotypical portrayals in American movies, this review also tells us which groups of people view themselves as "outsiders" or the

"disenfranchised" in relation to the Hollywood power structure. Thus, relating back to issues discussed in this book's companion volume *Who Really Controls Hollywood*, this listing tells us quite clearly, who does not control Hollywood. For surely, if any of these groups controlled Hollywood, they would choose to portray themselves in a more positive light in motion pictures from time to time and provide more equal employment opportunities for members of their respective groups. Further, we see again that creative control in Hollywood cannot be separated from economic control, after all, the top studio executives ultimately make the decision as to which movies are produced and released for viewing by most moviegoers, and these same executives exercise considerable contractual control over the producer, director, screenwriter, script, actors, actresses, budget, running time and MPAA rating, all of which affect the creative result.

Many of the business practices (primarily distributor business practices) discussed in this book's companion volumes *Hollywood Wars* and *The Feature Film Distribution Deal* contribute to the major studio/distributors' control and dominance of the motion picture industry. That control in turn gives the major studio/distributors the power to make whatever movies they want and to communicate through such movies whatever ideas they choose. In addition, the control of the major studio/distributors excludes large segments of our multi-cultural society from meaningful participation in the movie-making process and results in the consistent portrayal of many of these same "outsider" interest groups in a negative or stereotypical manner.

Movie critic Roger Ebert comments on the problem of movie villains saying that "[m]ovies like *The Fourth War* (1990) are a reminder that Hollywood is running low on dependable villains. The Nazis were always reliable, but World War II ended forty-five years ago. Now the cold War is winding down, and just when *Lethal Weapon 2* introduced South African diplomats as the bad buys, de Klerk came along to make that approach unpredictable. Drug dealers are wearing out their welcome. Bad cops are a cliche'. Suggestions?"[792]

Yes, the portrayals of movie bad guys should be distributed more evenly among all populations within our society. It may be unreasonable, however, to expect the presently configured power structure in Hollywood to engage in such a re-distribution of portrayals. Thus, it may be necessary to take further steps to alter that power structure. Another planned companion volume to this book *Motion Picture Industry Reform* contains numerous suggestions along those lines. Included are detailed discussions of the following possibilities, among others: (1) the creation of a national coalition to monitor and publicize on an annual basis, the patterns of bias contained in Hollywood films; (2) the creation of a national political action group designed to tell the truth about what is really going on in Hollywood to the general public, the press and our representatives in Congress (particularly with respect to employment discrimination and anti-competitive business practices), so as to bring about reasonable reforms to permit all interest groups a fair opportunity to tell their important cultural stories through this significant medium for the communication of ideas; (3) the bringing of a class-action lawsuit by all net and gross profit participants against the major studio/distributors for cheating them out of their fair share of the upside economic potential of their own films, with the related result that the creative control of such participants is severely weakened; and (4) the organization of a national boycott (including participants from all groups that are consistently portrayed in Hollywood movies in a negative or stereotypical manner) of all feature length motion pictures distributed by the major studio/distributors, until more diversity is brought about in the top level studio executive positions and throughout the industry, as well as more diversity in the portrayals in Hollywood films. Hollywood is too powerful for a limited boycott of one or two offensive films by a single interest group to be effective. Finally, on the novel side for possible remedies, it would only seem fair that a regional organization such as a Chamber of Commerce of the South might be able to bring a class action lawsuit against the major studio/distributors for defamation of the entire region.

Of course, it is also important to keep in mind that offensive negative portrayals or stereotypical movie portrayals do not always rise to the level of a movie villain (i.e., a person, place or thing can be portrayed in a movie in a negative manner without that person, place or thing having to serve as the movie's villain) or even as a lead character. It would also be quite natural to ask: "If all of these groups have been consistently portrayed in a negative or stereotypical manner all of these years, what group or groups in our diverse society have benefited from positive Hollywood film portrayals?" Unfortunately, that question goes beyond the scope of this specific work. However, it is treated separately in the companion volume *Movies and Propaganda*.

Conclusion—As we have seen, in recent years, numerous interest groups in the U.S. have vigorously complained about being consistently portrayed in a negative manner but such complaints have been effectively ignored by the MPAA companies. Quite often, as in this case, where power is concentrated in the hands of a few, such power breeds arrogance. Such outsider groups include women, the elderly, African-Americans, Hispanics, Arabs and Arab-Americans, Asians and Asian-Americans, Italian-Americans, German-Americans, Southerners, gay/lesbians, Christians and others. Unfortunately, it is very likely that the consistent portrayal of negative stereotypes in U.S.-made movies contributes to prejudice. Prejudice in turn contributes to discrimination and discrimination often leads to conflict. Thus, in all probability, the U.S. motion picture industry has, over the years, become a contributing factor and potential cause of unnecessary conflict within our society.

SELECTED BIBLIOGRAPHY

Articles, Films, Media Reports and Papers:

Abode, P.J., "Pick-Ups, Pre-Sales and Co-Ventures", *Montage* (IFP/West publication), Winter 1991/1992.

Achbar, Mark and Wintonick, Peter, *Manufacturing Consent: Noam Chomsky and the Media*, (a documentary film), 1992.

Auf der Maur, Rolf, *Enforcement of Antitrust Law and the Motion Picture Industry*, student paper presented to UCLA Extension class "The Feature Film Distribution Deal" (instructor—John W. Cones), 1991.

Barsky, Hertz, Ros, and Vinnick, *Legal Aspects of Film Financing*, April, 1990.

Berry, Jennifer, *Female Studio Executives*, (a research paper for "Film Finance and Distribution", UCLA Producer's Program, Fall, 1994.]

Bertz, Michael A., "Pattern of Racketeering Activity-A Jury Issue", *Beverly Hills Bar Journal*, Vo. 26, No. 1, Winter, 1992.

Bertz, Michael A., "Pursuing a Business Fraud RICO Claim", *California Western Law Review*, Vol. 21, No. 2, 1985.

Bibicoff, Hillary, "Net Profit Participations in the Motion Picture Industry", *Loyola Entertainment Law Journal*, Vol. 11, 1991.

Bowser, Kathryn, "Opportunities Knock (Co-Production Possibilities with Japan and Britain)", *The Independent*, November, 1991.

Brett, Barry J., and Friedman, Michael D., "A Fresh Look At The Paramount Decrees", *The Entertainment and Sports Lawyer*, Volume 9, Number 3, Fall 1991, 1.

Brooks, David, "A Fantasy at the Speed of Sound", *Insight*, May 26, 1986.

Cash William, "Too Many Hoorays for Hollywood", *The Spectator*, October, 1992.

Chrystie, Stephen, Gould, David and Spoto, Lou, "Insolvency and the Production and Distribution of Entertainment Products", *The Entertainment and Sports Lawyer*, Vol. 6, No. 4, Spring 1988.

Cohen, Roger, "Steve Ross Defends His Paychecks", *The New York Times Magazine*, March 22, 1992.

Cohodas, Nadine, "Reagan Seeks Relaxation of Antitrust Laws", *Congressional Quarterly*, February 1, 1986, 190.

Colton, Edward E., "How to Negotiate Contracts, Deals in the Movie Industry", Edward E. Colton, *New York Law Journal*, September 23, 1988.

Colton, Edward E., "What to Include in Pacts Between Author & Film Co.", *New York Law Journal*, October 7, 1988.

Colton, Edward E., "Defining Net Profits, Shares for a Motion Picture Deal", *New York Law Journal*, September 30, 1988.

Cones, John W., "Feature Film Limited Partnerships: A Practical Guide Focusing on Securities and Marketing for Independent Producers and Their Attorneys", *Loyola of Los Angeles Entertainment Law Journal*, 1992.

Cones, John W., "Three Hundred Thirty-Seven Reported Business Practices of the Major Studio/Distributors", (self-published compilation, 1991).

Cones, John W., "Maximizing Producers' Negative Pick-Up Profits", *Entertainment Law & Finance*, Vol. VIII, No. 3, June, 1992.

Continuing Education of the Bar, California, *Tax Literacy for the Business Lawyer*, (seminar handout, September 1991).

Corliss, Richard, "The Magistrate of Morals", Richard Corliss, *Time*, October 12, 1992.

Fleming, Karl, "Who Is Ted Ashley?" *New York*, June 24, 1974.

The Hollywood Reporter, "Antitrust Suit By Theater to Proceed", January 14, 1992, 6.

"JFK and Costello", *New York Times*, July 27, 1973.

Custolito, Karen and Parisi, Paula, "Power Surge—Women in Entertainment", *The Hollywood Reporter*, December 6, 1994.

Dekom, Peter J., "The Net Effect: Making Net Profit Mean Something", *American Premiere*, May-June, 1992.

Dellaverson, John J., "The Director's Right of Final Cut—How Final Is Final?", *The Entertainment and Sports Lawyer*, Vo. 7, No. 1, Summer/Fall 1988.

Denby, David, "Can the Movies be Saved?", *New York*, July 21, 1986.

Disner, Eliot G., "Is There Antitrust After 'Syufy'?—Recent Ninth Court Cases Create Barriers to Enforcement", *California Lawyer*, March 1991, 63.

Eshman, Jill Mazirow, "Bank Financing of a Motion Picture Production", *Loyola of Los Angeles Entertainment Law Journal*, 1992.

Farrell, L.M., "Financial Guidelines for Investing in Motion Picture Limited Partnerships", *Loyola of Los Angeles Entertainment Law Journal*, 1992.

Faulkner, Robert R. and Anderson, Andy B., "Short-Term Projects and Emergent Careers: Evidence from Hollywood", *American Journal of Sociology*, Volume 92, Number 4, January 1987.

Feller, Richard L., "Unreported Decisions and Other Developments (RICO and Entertainment Litigation)", *The Entertainment and Sports Lawyer*, Vol. 3, No. 2, Fall 1984.

Freshman, Elena R., "Commissions to Non-Broker/Dealers Under California Law", *Beverly Hills Bar Journal*, Volume 22, Number 2.

Gaydos, Steven, "Piercing Indictment, Steven Gaydos", *Los Angeles Reader*, December, 1992.

Glasser, Theodore L., "Competition and Diversity Among Radio Formats: Legal and Structural Issues", *Journal of Broadcasting*, Vol. 28:2, Spring 1984.

Goldman Sachs, "Movie Industry Update—1991", (*Investment Research Report*), 1991.

Gomery, Douglas, Failed Opportunities: "The Integration of the U.S. Motion Picture and Television Industries", *Quarterly Review of Film Studies*, Volume 9, Number 3, Summer 1984.

Goodell, Jeffrey, "Hollywood's Hard Times", *Premiere*, January, 1992.

Granger, Rod and Toumarkine, Doris, "The Un-Stoppables", *Spy*, November, 1988.

Greenspan, David, "Miramax Films Corp. V. Motion Picture Ass'n of Amer., Inc. The Ratings Systems Survives, for Now", *The Entertainment and Sports Lawyer*, Vol. 9, No. 2, Summer 1991.

Greenwald, John, "The Man With the Iron Grasp", *Time*, September 27, 1993.

Gregory, Keith M., "Blind Bidding: A Need For Change", *Beverly Hills Bar Journal*, Winter 1982-1983.

Hammond, Robert A. and Melamed, Douglas A., "Antitrust in the Entertainment Industry: Reviewing the Classic Texts in The Image Factory", *Gannet Center Journal*, Summer 1989.

Hanson, Wes, "Restraint, Responsibility & the Entertainment Media", Wes Hanson, *Ethics Magazine*, Josephson Institute, 1993.

Harris, Kathryn, "Movie Companies, TV Networks and Publishers Have Been Forced to Audition the Same Act: Cost Cutting", *Forbes*, January 6, 1992.

Honeycutt, Kirk, "Film Producer Mark Rosenberg Dies at Age 44", *The Hollywood Reporter*, November 9, 1992.

Independent Feature Project/West, "Feature Development: From Concept to Production", (seminar), November, 1991.

Jacobson, Marc, "Film Directors Agreements", *The Entertainment & Sports Lawyer*, Vol. 8, No. 1, Spring 1990.

Jacobson, Marc, "Structuring Film Development Deals", *Entertainment Law & Finance*, September, 1990.

Kagan, Paul, and Associates, *Motion Picture Investor* (newsletter), June and December issues, 1990.

Kagan, Paul, and Associates, *Motion Picture Finance*, (seminar), November, 1991.

Kasindorf, Martin, "Cant' Pay? Won't Pay!", *Empire*, June 1990.

Kopelson, Arnold, "One Producer's Inside View of Foreign and Domestic Pre-Sales in the Independent Financing of Motion Pictures", *Loyola of Los Angeles Entertainment Law Journal*, 1992.

Layne, Barry and Tourmarkine, Doris, "Court Vacates Consent Decree Against Loews", *The Hollywood Reporter*, February 20, 1992, 3.

Lazarus, Paul N, III, "Ensuring a Fair Cut of a Hit Film's Profits", *Entertainment Law & Finance*, Leader Publications, November, 1989.

Leedy, David J., "Projecting Profits from a Motion Picture" (excerpts from an unpublished work), presented Fall 1991, for UCLA Extension class: "Contractual Aspects of Producing, Financing and Distributing Film".

Levine, Michael and Zitzerman, David B., "Foreign Productions and Foreign Financing—The Canadian Perspective", *The Entertainment and Sports Lawyer*, Vol. 5, No. 4, Spring 1987.

Litwak, Mark, "Lessons In Self Defense—Distribution Contracts and Arbitration Clauses", Mark Litwak, *The Independent*, 1993.

Litwak, Mark, Successful Producing in the Entertainment Industry (seminar), UCLA Extension, 1990.

Logan, Michael, "He'll Never Eat Lunch In This Town Again!", *Los Angeles Magazine*, September 1992.

Los Angeles Times, "Film Studios Threaten Retaliation Against States Banning Blind Bids", June 1, 1981.

Marcus, Adam J., "Buchwald v. Paramount Pictures Corp. and the Future of Net Profit", *Cardozo Arts & Entertainment Law Journal*, Vol. 9, 1991.

Mathews, Jack, "Rules of the Game", *American Film*, March, 1990.

McCoy, Charles W. "Tim", Jr., "The Paramount Cases: Golden Anniversary in a Rapidly Changing Marketplace", *Antitrust*, Summer 1988, 32.

McDougal, Dennis, "A Blockbuster Deficit", Dennis McDougal, *Los Angeles Times*, March 21, 1991.

Medved, Michael, "Researching the Truth About Hollywood's Impact—Consensus and Denial", *Ethics Magazine*, Josephson Institute, 1993.

Moore, Schuyler M., "Entertainment Financing for the '90s: Super Pre-Sales", *Stroock & Stroock & Lavan Corporate Entertainment Newsletter*, Vol. 1, Q1 1992.

Morris, Chris, "Roger Corman: The Schlemiel as Outlaw", in Todd McCarthy and Charles Flynn, eds., *King of the Bs*, New York: Dutton, 1975.

Nochimson, David and Brachman, Leon, "Contingent Compensation for Theatrical Motion Pictures", *The Entertainment and Sports Lawyer*, Vol. 5, No. 1, Summer 1986.

O'Donnell, Pierce, "Killing the Golden Goose: Hollywood's Death Wish", *Beverly Hills Bar Journal*, Summer, 1992.

Olswang, Simon M., "The Last Emperor and Co-Producing in China: The Impossible Made Easy, and the Easy Made Impossible", *The Entertainment and Sports Lawyer*, Vol. 6, No. 2, Fall 1987.

Phillips, Mark, C., "Role of Completion Bonding Companies in Independent Productions", *Loyola of Los Angeles Entertainment Law Journal*, 1992.

Phillips, Gerald F., "Block Booking—Perhaps Forgotten, Perhaps Misunderstood, But Still Illegal", *The Entertainment and Sports Lawyer*, Vo. 6, No. 1, Summer 1987.

Phillips, Gerald F., "The Recent Acquisition of Theatre Circuits by Major Distributors", *The Entertainment and Sports Lawyer*, Vol. 5, No. 3, Winter 1987, 1.

Powers, Stephen P., Rothman, David J., and Rothman, Stanley, "Hollywood Movies, Society, and Political Criticism", *The World & I*, April 1991.

Pristin, Terry, "Hollywood's Family Ways", *Los Angeles Times* Calendar Section, January 31, 1993.

Richardson, John H., "Hollywood's Actress-Hookers—When Glamour Turns Grim", John H. Richardson, *Premiere*, 1992.

Robb, David, "Police Net is Arrested by Boxoffice Drop", *The Hollywood Reporter*, September 8, 1992.

Robb, David, "Net Profits: One Man's View from Both Sides", *The Hollywood Reporter*, August, 31, 1992.

Robb, David, "Net Profits, No Myth, But Hard to Get Hands On", *The Hollywood Reporter*, August 17, 1992.

Robb, David, "Net Profits: Breaking Even is Hard to Do", *The Hollywood Reporter*, September, 14, 1992.

Robb, David, "Net Profits, 'Endangered' by Big Budgets", *The Hollywood Reporter*, August 24, 1992.

Rodman, Howard, "Unequal Access, Unequal Pay: Hollywood's Gentleman's Agreement", *Montage*, October 1989.

Royal, David, "Making Millions and Going Broke, How Production Companies Make Fortunes and Bankrupt Themselves", *American Premiere*, November/December 1991.

Sarna, Jonathan, D., "The Jewish Way of Crime", *Commentary*, August, 1984.

Schiff, Gunther, H., "The Profit Participation Conundrum: A Glossary of Common Terms and Suggestions for Negotiation", Gunther H. Schiff, *Beverly Hills Bar Journal*, Summer, 1992.

Screen, "Vertical Integration, Horizontal Regulation—The Growth of Rupert Murdoch's Media Empire", Volume 28, Number 4 (May-August, 1986).

Sills, Steven D., and Axelrod, Ivan L., "Profit Participation In The Motion Picture Industry", *Los Angeles Lawyer*, April, 1989.

Simensky, Melvin, "Determining Damages for Breach of Entertainment Agreements", *The Entertainment and Sports Lawyer*, Vol. 8, No. 1, Spring 1990.

Simon, John, Film—"Charlatans Rampant", *National Review*, February 1, 1993.

Sinclair, Nigel, "U.S./Foreign Film Funding (Co-Production Tips)", *Entertainment Law & Finance*, March, 1991.

Sinclair, Nigel, "Long-Term Contracts for Independent Producers", *Entertainment Law & Finance*, November, 1986.

Sinclair, Nigel, "How to Draft Multi-Picture Deals", *Entertainment Law & Finance*, January, 1987.

Sinclair and Gerse, "Representing Independent Motion Picture Producers", *Los Angeles Lawyer*, May, 1988.

Sobel, Lionel, S., "Protecting Your Ideas in Hollywood", *Writer's Friendly Legal Guide*, Writer's Digest Books, 1989.

Sobel, Lionel S., "Financing the Production of Theatrical Motion Pictures", *Entertainment Law Reporter*, May, 1984.

Sperry, Paul, "Do Politics Drive Hollywood? Or do Markets Determine What Studios Make?", Paul Sperry, *Investor's Business Daily*, March 19, 1993

Stauth, Cameron, "Masters of the Deal", *American Film*, May, 1991.

Tagliabue, Paul J., "Anti-Trust Developments in Sports and Entertainment Law", *Anti-Trust Law Journal*, 1987.

UCLA Entertainment Law Symposium, Never Enough: The "A" Deal, Business, Legal and Ethical Realities, (Sixteenth Annual), February, 1992.

Whitney, Simon N., "Antitrust Policies and the Motion Picture Industry" (article appearing in Gorham Kindem's book: *The American Movie Industry—The Business of Motion Pictures*, Southern Illinois University Press, 1982.

Wilson, Kurt E., "How Contracts Escalate into Torts", *California Lawyer*, January, 1992.

Wolf, Brian J., "The Prohibitions Against Studio Ownership of Theaters: Are They An Anachronism?", *Loyola of Los Angeles Entertainment Law Journal*, Vol. 13, 413.

Zitzerman, David B. and Levine, Michael A., "Producing a Film in Canada—The Legal and Regulatory Framework", *The Entertainment and Sports Lawyer*, Vol. 8, No. 4, Winter 1991.

Books

Andersen, Arthur & Co., *Tax Shelters—The Basics*, Harper & Row, Publishers, 1983.

Anger, Kenneth, *Hollywood Babylon*, Dell Publishing, 1981.

Anger, Kenneth, *Hollywood Babylon II*, Penguin Books, 1984.

Armour, Robert A., *Fritz Lang*, Twayne Publishers, 1977.

Bach, Steven, *Final Cut—Dreams and Disaster in the Making of Heaven's Gate*, William Morrow & Co., 1985.

Ballio, T. ed., *The American Film Industry*, 2nd rev. ed. Madison: University of Wisconsin Press, 1985.

Bart, Peter, *Fade Out—The Calamitous Final Days of MGM*, Anchor Books, 1991.

Baumgarten, Paul A., Farber, Donald C. and Fleischer, Mark, *Producing, Financing and Distributing Film—A Comprehensive Legal and Business Guide*, 2nd edition, Limelight Editions, 1992.

Bayer, William, *Breaking Through, Selling Out, Dropping Dead and Other Notes on Filmmaking*, First Limelight Edition, 1989.

Behrman, S.N., *People In A Diary—A Memoir*, Little, Brown & Co., 1972.

Biederman, Berry, Pierson, Silfen and Glasser, *Law and Business of the Entertainment Industries*, Auburn House, 1987.

Billboard Publications, Inc., *Producer's Masterguide*, 1989, 1990 & 1991.

Billboard Publications, *Hollywood Reporter Blu-Book*, 1990.

Blum, Richard A., *Television Writing (From Concept to Contract)*, Focal Press, 1984.

Brady, Frank, *Citizen Welles—A Biography of Orson Welles*, Anchor Books, 1989.

Brownstein, Ronald, *The Power and the Glitter—The Hollywood-Washington Connection*, Vintage Books, 1992.

Cameron-Wilson, James & Speed, F. Maurice, *Film Review 1994*, St. Martin's Press, 1993.

Cohen, Sarah Blacher, *From Hester Street to Hollywood*, Indiana University Press, 1983.

Collier, Peter & Horowitz, David, *The Kennedys—An American Drama*, Warner Books, 1984.

Commerce Clearing House, Inc., *Blue Sky Law Reporter*, 1984.

Cones, John W., *The Feature Film Distribution Deal*, (self-published), 1995.

Cones, John W., *Film Finance and Distribution—A Dictionary of Terms*, Silman-James Press, 1992.

Cones, John W., *Film Industry Contracts*, (self-published) 1993.

Cones, John W., *Forty-Three Ways to Finance Your Feature Film*, Southern Illinois University Press, 1995.

Cones, John W., *How the Movie Wars Were Won*, (self-published), 1995.

Considine, Shawn, *The Life and Work of Paddy Chayefsky*, Random House, 1994.

Corman, Roger & Jerome, Jim, *How I Made a Hundred Movies in Hollywood and Never Lost a Dime*, Dell Publishing, 1990.

Curran, Trisha, *Financing Your Film*, Praeger Publishers, 1985.

Custen, George F., *Bio/Pics—How Hollywood Constructed Public History*, Rutgers University Press, 1992.

Delson, Donn and Jacob, Stuart, *Delson's Dictionary of Motion Picture Marketing Terms*, Bradson Press, Inc., 1980.

Dinnerstein, Leonard, *Anti-Semitism In America*, Oxford University Press, 1994.

Downes, John and Goodman Jordan Elliot, *Dictionary of Finance and Investment Terms—2nd Ed*, Barron's Educational Series, Inc., 1987.

Duncliffe, William J., *The Life and Times of Joseph P. Kennedy*, New York, 1965.

Ebert, Roger, *Roger Ebert's Video Companion*, 1994 Edition, Andrews and McMeel, 1993.

Eberts, Jake and Lott, Terry, *My Indecision Is Final*, Atlantic Monthly Press, 1990.

Eisenberg, Dennis et al., *Meyer Lansky: Mogul of the Mob*, New York, 1979.

Ephron, Henry, *We Thought We Could Do Anything*, W.W. Norton & Co., 1977.

Erens, Patricia, *The Jew in American Cinema*, Indiana University Press, 1984.

Evans, Robert, *The Kid Stays in the Picture*, Hyperion, 1994.

Farber, Stephen and Green, Marc, *Hollywood Dynasties*, Putnam Publishing, 1984.

Farber, Stephen and Green, Marc, *Outrageous Conduct*, Morrow, 1988.

Farber, Donald C., *Entertainment Industry Contracts; Negotiating and Drafting Guide*, Matthew Bender, 1990.

Field, Syd, Screenplay—*The Foundations of Screenwriting*, Dell Publishing Co., Inc., 1985.

Fox, Stuart, *Jewish Films in the United States*, G.K. Hall & Co., 1976.

Fraser, George MacDonald, *The Hollywood History of the World*, Viking Penguin, Inc., 1989.

Frederickson, Jim & Stewart, Steve, *Film Annual—1992*, Companion Publications, 1992.

Fried, Albert, *The Rise and Fall of the Jewish Gangster in America*, Revised Edition, Columbia University Press, 1993.

Friedman, Lester, *The Jewish Image in American Film*, Citadel Press, 1987.

Gabler, Neal, *An Empire of Their Own—How the Jews Invented Hollywood*, Anchor Books, 1988.

Gilroy, Frank, D., *I Wake Up Screening—Everything You Need to Know About Making Independent Films Including a Thousand Reasons Not To*, Southern Illinois University Press, 1993.

Goldberg, Fred, *Motion Picture Marketing and Distribution—Getting Movies into a Theatre Near You*, Focal Press, 1991, 158.

Goldman, William, *Adventures in the Screen Trade*, Warner Books, 1983.

Gomery, Douglas, *Movie History: A Survey*, Wadsworth Publishing Company, 1991.

Gomery, Douglas, *The Hollywood Studio System*, MacMillan, 1986; New York: St. Martin's Press, 1986.

Goodell, Gregory, *Independent Feature Film Production*, St. Martin's Press, 1982.

Goodman, Ezra, *The Fifty Year Decline and Fall of Hollywood*, Simon & Schuster, 1961.

Gribetz, Judah, Greenstein, Edward L. and Stein, Rigina, *The Timetables of Jewish History*, Simon & Schuster, 1993.

Hearst, William Randolph, Jr.. & Casserly, Jack, *The Hearsts—Father and Son*, Roberts Rinehart Publishers, 1991.

Herrman, Dorothy, *S.J. Perelman, A Life*, Simon & Schuster, 1986.

Higham, Charles, *Howard Hughes—The Secret Life*, Berkley Books, 1993.

Hill, Geoffrey, *Illuminating Shadows: The Mythic Power of Film*, Shambhala, 1992

Holsinger, Ralph L., *Media Law*, McGraw-Hill, Inc., (2nd edition), 1991.

Houghton, Buck, *What a Producer Does—The Art of Moviemaking (Not the Business)*, Silman-James Press, 1991.

Houseman, John, *John Houseman—Run Through*, Simon and Schuster, 1972.

Hurst, Walter E., Minus, Johnny and Hale, William Storm, *Film-TV Law—3rd Ed*, Seven Arts Press, Inc., 1976.

Johnson, Paul, *A History of the Jews*, Harper & Row, 1987.

Katz, Ephraim, *The Film Encyclopedia*, Harper Collins, 1994.

Kennedy, Joseph P., ed. *The Story of the Films*, W. W. Shaw Company, 1927; reprint, Jerome S. Ozer, 1971.

Kent, Nicolas, *Naked Hollywood—Money and Power in The Movies Today*, St. Martin's Press, 1991.

Kim, Erwin, *Franklin J. Schaffner*, Scarecrow Press, 1985.

Kindem, Gorham, *The American Movie Industry—The Business of Motion Pictures*, Southern Illinois University Press, 1982.

King, Morgan D., *California Corporate Practice Guide—2nd Ed*, Lawpress Corporation, 1989.

Kipps, Charles, *Out of Focus*, Century Hutchinson, 1989.

Koppes, Clayton R. and Black, Gregory D., *Hollywood Goes to War—How Politics, Profits and Propaganda Shaped World War II Movies*, University of California Press, 1987.

Kosberg, Robert, *How to Sell Your Idea to Hollywood*, HarperCollins, 1991.

Kotkin, Joel, *Tribes—How Race, Religion and Identity Determine Success in the New Global Economy*, Random House, 1993.

Lasky, Betty, *RKO—The Biggest Little Major of Them All*, Rountable Publishing, 1989.

Lasky, Jesse, Jr., *Whatever Happened to Hollywood?*, Funk & Wagnalls, 1975.

LeRoy, Mervyn and Kelmer, Dick, *Mervyn LeRoy: Take One*, Hawthorn Books, 1974.

Levy, Emanuel, *George Cukor—Master of Elegance*, William Morris, 1994.

Linson, Art, *A Pound of Flesh—Perilous Tales of How to Produce Movies in Hollywood*, Grove Press, 1993.

Litwak, Mark, *Dealmaking in the Film & Television Industry—From Negotiations to Final Contracts*, Silman-James Press, 1994.

Litwak, Mark, *Reel Power—The Struggle for Influence and Success in the New Hollywood*, William Morrow and Company, Inc., 1986.

Lucaire, Ed, *The Celebrity Almanac*, Prentice Hall, 1991.

Lyman, Darryl, *Great Jews on Stage and Screen*, Jonathan David Publishers, 1987.

Maltin, Leonard, *Leonard Maltin's Movie Encyclopedia*, Penguin Group, 1994.

Martin, Mick and Porter, Marsha, *Video Movie Guide—1989*, First Ballantine Books, 1988.

McClintick, David, *Indecent Exposure*, Dell Publishing, Company, 1983.

Medved, Michael, *Hollywood vs. America—Popular Culture and the War on Traditional Values*, Harper Collins, 1992.

Medved, Harry & Medved, Michael, *The Hollywood Hall of Shame—The Most Expensive Flops in Movie History*, Angus & Robertson Publishers, 1984.

Moldea, Dan E., *Dark Victory (Ronald Reagan, MCA, and the Mob)*, Penguin Books, 1987.

Monder, Eric, *George Sidney: A Bio-Bibliography*, Greenwood Press, 1994.

Murphy, Art, *Art Murphy's Box Office Register*, 1990.

National Association of Securities Dealers, *NASD Manuel*, September 1990.

National Association of Theatre Owners, *Encyclopedia of Exhibition*, 1990.

Navasky, Victor S., *Naming Names*, Penguin Books, 1980.

O'Donnell, Pierce and McDougal, Dennis, *Fatal Subtraction—How Hollywood Really Does Business*, Doubleday, 1992.

Palmer, James & Riley, Michael, *The Films of Joseph Losey*, Cambridge University Press, 1993.

Parrish, James Robert, *The Hollywood Celebrity Death Book*, Pioneer Books, 1993.

Penney, Edmund, *Dictionary of Media Terms*, G.P. Putnam's Sons, 1984.

Phillips, Julia, *You'll Never Eat Lunch in this Town Again*, Julia Phillips, Penguin Books, 1991.

Powdermaker, Hortense., *Hollywood: the Dream Factory; an Anthropologist Looks at the Movie-Makers*, Reprint of 1950 ed. New York: Ayer, 1979.

Pratley, Gerald, *The Cinema of John Frankenheimer*, A.S. Barnes & Co., 1969.

Prifti, William M., *Securities: Public and Private Offerings*—(Rev Ed), Callaghan & Company, 1980.

Prindle, David F., *Risky Business—The Political Economy of Hollywood*, Westview Press, 1993.

Rappleye, Charles and Becker, Ed, *All American Mafioso—The Johnny Rosselli Story*, Doubleday, 1991.

Ratner, David L., *Securities Regulation*—3rd Ed, West Publishing Company, 1989.

Rawlence, Christopher, *The Missing Reel*, Atheneum, 1990.

Research Institute of America, Inc., *Federal Tax Coordinator 2d*, 1990.

Reynolds, Christopher, *Hollywood Power Stats—1994*, Cineview Publishing, November, 1993.

Rollyson, Carl, *Lillian Hellman—Her Legend and Her Legacy*, St. Martin's Press, 1988.

Rosen, David and Hamilton, Peter, *Off-Hollywood: The Making & Marketing of American Specialty Films*, The Sundance Institute and the Independent Feature Project, 1986.

Rosenberg, David, *The Movie That Changed My Life*, Viking Penguin, 1991.

Rosenfield, Paul, *The Club Rules—Power, Money, Sex, and Fear—How It Works in Hollywood*, Warner Books, 1992.

Russo, Vito, *The Celluloid Closet: Homosexuality in the Movies*, rev. ed., Harper & Row, 1987.

Sachar, Howard M., *A History of the Jews in America*, Vintage Books, 1993.

Scheuer, Steven H., *Movies on TV and Videocassette*, Bantam, 1987.

Schwartz, Nancy Lynn, *The Hollywood Writers' Wars*, McGraw-Hill, 1982.

Shapiro, Michael, *The Jewish 100—A Ranking of the Most Influential Jews of All Time*, Citadel Press, 1994.

Sherman, Allan, *A Gift of Laughter—The Autobiography of Allan Sherman*, Atheneum Publishers, 1965.

Siegel, Eric S., Schultz, Loren A., Ford, Brian R. and Carney, David C., *Ernst & Young Business Plan Guide*, John Wiley & Sons, 1987.

Silfen, Martin E. (chairman), Counseling Clients in the Entertainment Industry (seminar book), Practicing Law Institute, 1989.

Simensky, Melvin and Selz, Thomas, *Entertainment Law*, 1984.

Sinclair, Andrew, *Spiegel—The Man Behind the Pictures*, Little, Brown & Co., 1987.

Sinetar, Marsha, *Reel Power: Spiritual Growth Though Film*, Triumph Books, 1993

Singleton, Ralph S., *Filmmaker's Dictionary*, Lone Eagle Publishing Co., 1990.

Sklar, Robert. *Movie-Made America: A Cultural History of American Movies*, Random House, 1975.

Sperling, Cass Warner and Millner, Cork, *Hollywood Be Thy Name—The Warner Brothers Story*, Prima Publishing, 1994.

Squire, Jason E., *The Movie Business Book*, (2nd edition), Simon & Schuster, 1992.

Stanger, Robert A., *Tax Shelters—The Bottom Line*, Robert A. Stanger & Company, Publisher, 1982.

Steel, Dawn, *They Can Kill You...But They Can't Eat You—Lessons From the Front*, Pocket Books, 1993.

Tartikoff, Brandon and Leerhsen, Charles, *The Last Great Ride*, Random House, 1992.

Trager, James, *The People's Chronology*, Henry Holt & Co., 1992.

Ursini, James, *The Fabulous Life & Times of Preston Sturges*, Curtis Books, 1973.

Van Doren, Charles, *Webster's American Biographies*, Merriam-Webster, 1984.

Vidal, Gore, *Who Makes the Movies?*, (a collection of essays), "Pink Triangle and Yellow Star", published by William Heinemann, Ltd., London, 1982.

Vogel, Harold L., *Entertainment Industry Economics—A Guide for Financial Analysis*, Cambridge University Press, 1986 & 1990.

Von Sternberg, Josef, *Fun in a Chinese Laundry*, Mercury House, 1965.

Wakeman, John, *World Film Directors* (Volumes One & Two, 1890-1985), 1987.

Walker, John, *Halliwell's Film Guide*, Harper Collins, 1991 & 1994.

Wallis, Hal and Higham, Charles, *Starmaker, The Autobiography of Hal Wallis*, MacMillan, 1980.

Warshawski, Morrie, *Distributing Independent Films & Video*, The Media Project (Portland, Oregon) and Foundation for Independent Video and Filmmakers (New York), 1989.

Waxman, Virginia Wright & Bisplinghoff, Gunther, *Robert Altman—A Guide to Reference & Reason*, G.K. Hall & Co., 1984.

Wigoder, Dr. Geoffrey, *The New Standard Jewish Encyclopedia*, 7th Edition, Facts on File, 1992.

Writers Guild of America Theatrical and Television Basic Agreement, 1988.

Yule, Andrew, Picture Shows—*The Life and Films of Peter Bogdanovich*, Limelight Editions, 1992.

About The Author

John W. Cones is a securities and entertainment attorney who was based in Los Angeles, for 23 years. Throughout that period, he maintained a private solo practice advising independent feature film, video, television and theatrical producer clients with respect to their compliance obligations when seeking to raise financing from investors. Although continuing to practice law, he is currently traveling throughout the U.S. providing film finance lectures to groups of independent filmmakers. His lectures on "Investor Financing of Entertainment Projects" have been presented in Los Angeles, Las Vegas, Dallas, Houston, Boise, Sacramento, Portland, New Orleans, Austin, San Francisco, Charleston and Washington, D.C. and have been sponsored by the American Film Institute, IFP/West, state film commissions, independent producer organizations and American University. He has also lectured for the USC Cinema-TV School, the UCLA (graduate level) Producer's Program, UCLA Extension and the UCLA Anderson Graduate School of Management. His previous publications include *Film Finance and Distribution—A Dictionary of Terms*, *Film Industry Contracts* (a collection of 100 sample film industry agreements, available in hard-copy form or on computer diskettes) , *43 Ways to Finance Your Feature Film*, *The*

Feature Film Distribution Deal—A Critical Analysis of the Single Most Important Film Industry Agreement, *Business Plans for Filmmakers* and numerous magazine and journal articles on related topics.

OTHER BOOKS BY THE SAME AUTHOR

Film Finance & Distribution—A Dictionary of Terms—Definitions of some 3,600 terms used in the film industry in the finance and distribution of feature films. In addition, to the definitions, examples of usage and commentary are provided for some terms.

Film Industry Contracts—A collection of 100 sample film industry agreements relating to acquisition, development, packaging, employment, lender financing, investor financing, production, distribution, exhibition, merchandising and licensing.

43 Ways to Finance Your Feature Film—A comprehensive overview of film finance with a discussion of advantages and disadvantages of forty-three different ways to finance feature films and other entertainment projects.

The Feature Film Distribution Deal—A provision by provision critical analysis of the single most important film industry agreement. The book also provides samples of five different film distribution agreements in its appendix.

Who Really Controls Hollywood—A re-examination of the question raised earlier by Neal Gabler, Michael Medved, Joel Kotkin and others with respect to who really controls the Hollywood-based U.S. film industry and is therefore primarily responsible for the decisions made with respect to which movies are produced and released, who gets to work on those movies and the actual content of such films.

Hollywood Wars – How Insiders Gained and Maintain Illegitimate Control Over the Film Industry—A comprehensive analysis and dis-

cussion of hundreds of the specific business practices used during the nearly 100-year span of control of the Hollywood-based U.S. film industry by the so-called Hollywood control group (or traditional Hollywood management).

Motion Picture Industry Reform—A discussion of various techniques, strategies and methods that may be useful in bringing about the long-term reform of the U.S. motion picture industry, which is considered by the author to be one of the most significant media for the communication of ideas yet devised by human beings.

ENDNOTES

Chapter 1

1. Custen, George F., *Bio/Pics—How Hollywood Constructed Public History*, Rutgers University Press, 1992, 149.
2. Powdermaker, Hortense, *Hollywood: The Dream Factory; An Anthropologist Looks at the Movie-Makers*, Reprint of 1950 ed. New York: Ayer, 1979, 77.
3. Powdermaker, 116.
4. Powdermaker, 124.
5. Powdermaker, 100.
6. Powdermaker, 86.
7. Powdermaker, 87.
8. Pristin, Terry, "Hollywood's Family Ways", *Los Angeles Times* Calendar Section, January 31, 1993, 7.
9. Kent, Nicholas, *Naked Hollywood—Money and Power in the Movies Today*, St. Martin's Press, 1991, 28.
10. Prindle, David F., *Risky Business—The Political Economy of Hollywood*, Westview Press, 1993, 123.
11. Scheuer, Steven H. *Movies on TV and Videocassette*, Bantam, 1987.
12. Walker, John, *Halliwell's Film Guide*, Harper Collins, 1991 & 1994.
13. Ebert, Roger, *Roger Ebert's Video Companion*, 1994 Edition, Andrews and McMeel, 1993.

Chapter 2

14. Frook, John Evan, "'Aladdin' Lyrics Altered", *Variety*, July 12, 1993, 1.

15. Holiday Movie Reviews, *Entertainment Weekly*, November 20, 1992, 39.

16. Scheuer, 707.

17. Anger, Kenneth, *Hollywood Babylon*, Dell Publishing, 1981, 14.

18. Walker, 1091.

19. Scheuer, 798.

20. Katz, Ephraim, *The Film Encyclopedia*, Harper Collins, 1994, 662.

21. Scheuer, 734.

22. Anger, *Kenneth, Babylon II*, Penguin Books, 1984, 221.

23. Scheuer, 539.

24. Scheuer, 474.

25. Scheuer, 539.

26. Scheuer, 539.

27. Scheuer, 33.

28. Koppes, Clayton R. and Black, Gregory D., *Hollywood Goes to War—How Politics, Profits and Propaganda Shaped World War II Movies*, University of California Press, 1987, 131.

29. Scheuer, 427 & 428.

30. Scheuer, 539.

31. Scheuer, 717.

32. Walker, 993.

33. Scheuer, 123.

34. Scheuer, 46.

35. Scheuer, 202.

36. Scheuer, 475.

37. Scheuer, 629.

38. Scheuer, 304.

39. Walker, 483.

40. Scheuer, 41.

41. Scheuer, 269.

42. Scheuer, 733.

43. Scheuer, 677.

44. Scheuer, 680.

45. Scheuer, 852.

46. Scheuer, 6 & 7.

47. Scheuer, 850.

48. Scheuer, 733.

49. Scheuer, 439.

50. Scheuer, 632.

51. Scheuer, 612.

52. Scheuer, 677.

53. Scheuer, 539.

54. Scheuer, 892.

55. Scheuer, 587.

56. Scheuer, 242.

57. Scheuer, 441.

58. Scheuer, 719.

59. Scheuer, 80.

60. Scheuer, 530.

61. Scheuer, 409.

62. Walker, 583.

63. Walker, 1062.

64. Scheuer, 342.

65. Katz, 1238.

66. Scheuer, 124.

67. Scheuer, 539.

68. Scheuer, 417.

69. Scheuer, 672.

70. Walker, 936.

71. Katz, 1098.

72. Scheuer, 836.

73. Scheuer, 854.

74. Scheuer, 557.

75. Walker, 782.

76. Katz, 1200.

77. Scheuer, 75.

78. Evans, 284.

79. Walker, 123.

80. Katz, 486.

81. Scheuer, 503.

82. Scheuer, 717.

83. Scheuer, 33.

84. Scheuer, 178.

85. Scheuer, 739.

86. Katz, 1051.

87. Friedman, Lester, *The Jewish Image in American Film*, Citidel Press, 1987, 240.

88. Scheuer, 461.

89. Walker, 650.

90. Scheuer, 116.

91. Scheuer, 375.

92. Katz, 384.

93. Scheuer, 408.

94. Ebert, 340.
95. Ebert, 171.
96. Ebert, 280.
97. Walker, 474.
98. Scheuer, 775.
99. Scheuer, 819.
100. Scheuer, 582.
101. Scheuer, 149.
102. Walker, 222.
103. Scheuer, 622.
104. Scheuer, 195.
105. Walker, 280.
106. Scheuer, 398.
107. Ebert, 331.
108. Katz, 918.
109. Fraser, George MacDonald, *The Hollywood History of the World*, Viking Penguin, Inc., 1989, 14.
110. Ebert, 476.
111. Robertson, 106.
112. Ebert, 10.
113. *Entertainment Weekly*, December 4, 1992, 70.
114. *Entertainment Weekly*, May 28, 1993, 47.
115. Lowry, Brian, "Film Review—The Pelican Brief", *Daily Variety*, December 13, 1993, 4 & 8.
116. Rooney, David, "Film Reviews—Little Odessa", *Variety*, September 12-18, 1994, 44.
117. Koppes, 60 & 61.
118. Sperling, Cass Warner and Millner, Cork, *Hollywood Be Thy Name—The Warner Brothers Story*, Prima Publishing, 1994, 246.
119. Ebert, 68.
120. Ebert, 69.
121. Ebert, 487.
122. "Protests Rising over 'Sun'", *Daily Variety*, July 28, 1993, 3.
123. *Entertainment Weekly*, May 28, 1993, 32 & 33.
124. Appelo, Tim. "'Down' Beat", *Entertainment Weekly*, March 12, 1993, 9.
125. Ebert, 211.
126. Simon, John, "Film—A Hole in the Soul", *National Review*, May 10, 1993, 52.
127. Burr, Ty. "Viva la Diferencia!, *Entertainment Weekly*, September 4, 1992, 75.
128. Burr, 75.
129. Scheuer, 663.
130. Scheuer, 812.
131. Scheuer, 32.

132. Scheuer, 633.

133. Scheuer, 44.

134. Scheuer, 858.

135. Scheuer, 884.

136. Scheuer, 116.

137. Scheuer, 96.

138. Scheuer, 861.

139. Scheuer, 760.

140. Ebert, 194.

141. Ebert, 624.

142. Burr, 75.

143. Burr, 75.

144. Broderick, Peter, "A Film for a Song—Robert Rodriguez's Garage Movie", *Filmmaker*, Winter, 1992, 32.

145. Chambers, Veronica. "Rushes", *Premiere*, January 1993, 31.

146. Reviews, *Variety*, January 25, 1993, 133.

147. Ebert, 83.

148. *Entertainment Weekly*, May 28, 1991, 50.

149. O'Donnell, Pierce and McDougal, Dennis, *Fatal Subtraction—How Hollywood Really Does Business*, Doubleday, 1992, 35 & 36.

150. Koppes, 179.

151. Koppes, 179.

152. Koppes, 184.

153. Brownstein, 168.

154. Ayer, Douglas, Roy E. Bates, Peter J. Herman, "Self-Censorship in the Movie Industry: A Historical Perspective on Law and Social Change", article appearing in *The American Movie Industry—The Business of Motion Pictures* (edited by Gorham Kindem), Southern Illinois University Press, 1982, 233.

155. Scheuer, 367.

156. Scheuer, 777.

157. Film Review, *The Hollywood Reporter*, July 12, 1991, 10 & 15.

158. Shah, Diane K., "Steven Spielberg, Seriously—Hollywood's Perennial Wunderkind Confronts History, Sentiment and the Fine Arts of Growing Up", *Los Angeles Times Magazine*, December 19, 1993, 24.

159. Ebert, 185.

160. Film Review, *The Hollywood Reporter*, April 29, 1991, 6.

161. Film Review, *The Hollywood Reporter*, May 15, 1991, 12.

162. "Blurred Images", *The Hollywood Reporter*, May 22, 1991, 3.

163. Ptacek, Greg. "Coalition of Black Groups Plans 'Fever,' "Boyz' Boycott", *The Hollywood Reporter*, July 2, 1991, 3.

164. "Holiday Movie Preview", *Entertainment Weekly*, November 20, 1992, 48.

165. O'Donnell and McDougal, 191.

166. Summer Movie Preview, *Entertainment Weekly*, May 22, 1992, 29.

167. Hanson, Wes, "Restraint, Responsibility & The Entertainment Media", Josephson Institute–*Ethics*, April 1993, 48.

168. Hanson, 42.

169. "Parent's Guide", *Weekly Entertainment*, March 12, 1993.

170. Ebert, 26.

171. Reviews, *Variety*, February 22, 1993, 64.

172. Brownstein, Ronald, *The Power and the Glitter—The Hollywood-Washington Connection*, Vintage Books, 1992, 229.

173. Ranier, Peter, New Video Releases, *American Film*, September/October 1991, 53.

174. "Acting Against Racism", October 23, 1992, *Entertainment Weekly*, 34.

175. Fraser, 190.

Chapter 3

176. Rosenberg, David, *The Movie That Changed My Life*, Viking Penguin, 1991, 29.

177. Rosenberg, 32.

178. Anger, *Babylon II*, 165.

179. Rosenberg, 243 -252.

180. Ebert, 248.

181. Ebert, 36.

182. Scheuer, 646.

183. Ebert, 611.

184. Rosenberg, 6.

185. Ebert, 748.

186. Ebert, 365.

187. Diggs, Terry Kay, "No Way to Treat a Lawyer", *California Lawyer*, December 1992, 48.

188. Reviews, *Variety*, March 22, 1993, 50.

189. *Entertainment Weekly*, July 30, 1993, 62.

190. Kennedy, Dana, "Women Who Run With the Wolves", *Entertainment Weekly*, February 11, 1994, 19.

191. Joyce, Elisabeth. "Giving Women the Boot: Violent Women in Total Recall", paper presented at 47th Annual Conference of the University Film & Video Association, Temple University, August 1993, 8.

192. McCarthy, Todd, "Film Reviews", *Variety*, Dec. 5-11, 1994, 73.

193. Reported on Los Angeles television (Channel 4—Morning News), Saturday, December 10, 1994.

194. Scheuer, 92.

195. Scheuer, 847.

196. Scheuer, 323.

197. Scheuer, 210.

198. Katz, 514.

199. Scheuer, 176.

200. Scheuer, 610.

201. Ebert, 643.

202. Ebert, 652.

203. Scheuer, 369.

204. Russo, Vito, *The Celluloid Closet: Homosexuality in the Movies*, rev. ed., Harper & Row, 1987, 133 and 226.

205. Russo, 139 and 162.

206. Ebert, 693.

207. Film Review, *The Hollywood Reporter*, May 20, 1991, 9 & 16.

208. "Gay Groups Outline Plan for Oscar Demonstration", *The Hollywood Reporter*, March 13, 1992, 6.

209. "Gay Protest Fails", *The Hollywood Reporter*, April 26, 1991, 3.

210. Cusolito, Karen. "Gay Groups Form 'Instinct' Protest", *The Hollywood Reporter*, March 12, 1992, 4.

211. Cusolito, 4.

212. "Gay Groups Outline Plan for Oscar Demonstration", *The Hollywood Reporter*, March 13, 1992, 6.

213. Ebert, 655.

214. Erens, 213.

215. Loud, Lance and Slifkin, Irving. "Philadelphia Storyboard (News & Notes)", *Entertainment Weekly*, December 11, 1992, 12.

216. Loud and Slifkin, 12.

217. Fleming, Michael. "Sneeze Factor", *Variety*, March 30, 1992, 100.

218. Stosine, William. "Reader Response/Letters", *Premiere*, August 1992, 8.

219. "Where Hollywood Fears to Tread—The Success of 'Angels in America' Challenges the Way Movies Deal With Gays", *Entertainment Weekly*, May 21, 1993, 29.

220. Ebert, Roger, *Roger Ebert's Video Companion*, 1994 Edition, Andrews and McMeel, 1993, 683.

221. Fleming, Michael, "'Philadelphia' Draws Fire From Gay Kid in the Hall", *Variety*, Jan. 24 - 30, 1994, 2.

222. Levy, Emanuel, "Film Reviews", *Variety*, Oct. 3-9, 1994, 63.

Chapter 4

223. Medved, 52.

224. Medved, 52.

225. Scheuer, 882.

226. Scheuer, 672.
227. Scheuer, 458.
228. Scheuer, 504.
229. Ebert, 689.
230. Ebert, 107.
231. Ebert, 107.
232. Scheuer, 52.
233. Katz, 665.
234. Scheuer, 890.
235. Scheuer, 340.
236. Katz, 1213.
237. Scheuer, 676.
238. Scheuer, 420.
239. Friedman, 92.
240. Ebert, 702.
241. Scheuer, 626.
242. Scheuer, 20.
243. Katz, 615.
244. Scheuer, 276.
245. Scheuer, 390.
246. Scheuer, 172.
247. Scheuer, 424 & 425.
248. Scheuer, 348.
249. Scheuer, 693.
250. Ebert, 757.
251. Scheuer, 305.
252. Scheuer, 10.
253. Ebert, 461.
254. Scheuer, 551.
255. Scheuer, 305.
256. Scheuer, 524.
257. Scheuer, 680.
258. Ebert, 188.
259. Ebert, 673.
260. Scheuer, 57.
261. Scheuer, 542.
262. Scheuer, 347.
263. Prindle, 151.
264. Ebert, 373.
265. Ebert, 736.
266. Medved, 54.
267. Ebert, 340.

268. Ebert, 561.

269. Ebert, 38.

270. Ebert, 69.

271. Ebert, 548.

272. Film Reviews, *The Hollywood Reporter*, October 1, 1991, 5 & 56.

273. Ebert, 228.

274. Ebert, 105.

275. Ebert, 86.

276. Reviews, *Variety*, November 9, 1992, 62.

277. "Now Playing", *Entertainment Weekly*, June 5, 1992, 41.

278. Reviews, *Variety*, October 12, 1992, 185.

279. Ebert, 375.

280. Ebert, 792.

281. McCarthy, Todd, "Film Reviews", *Variety*, Oct. 3-9, 1994, 62.

282. McCarthy, Todd, "Film Reviews", *Variety*, April 25 - May 1, 1994, 30.

283. Medved, 76.

284. Hanson, 41.

285. Medved, 61.

286. Hanson, 38.

287. Scheuer, 774.

288. Katz, 1089.

289. Scheuer, 322.

290. Scheuer, 110.

Chapter 5

291. Ebert, 169.

292. McCarthy, Todd, "Film Reviews", *Variety*, Oct. 3-9, 1994, 62.

293. Klady, Leonard, "Film Reviews", *Variety*, Dec. 19, 1994 - Jan. 1, 1995, 72.

294. Scheuer, 513.

295. Scheuer, 419.

296. Scheuer, 615.

297. Erens, 170.

298. Scheuer, 190.

299. Scheuer, 27.

300. *Entertainment Weekly*, October 16, 1992, 17.

301. Scheuer, 892.

302. Scheuer, 859.

303. Scheuer, 404.

304. Scheuer, 245.

305. Scheuer, 315.

306. Scheuer, 95.

307. Ebert, 327.
308. Scheuer, 640.
309. Scheuer, 808.
310. Ebert, 449.
311. Scheuer, 40.
312. Scheuer, 844.
313. Scheuer, 721.
314. Ebert, 465.
315. Ebert, 249.
316. Scheuer, 679.
317. Scheuer, 200.
318. Ebert, 577.
319. Ebert, 526.
320. Scheuer, 458.
321. Scheuer, 770.
322. Rosenfield, 225.
323. "Film Review", *The Hollywood Reporter*, June 7, 1991, 12.
324. Ebert, 520.
325. Ebert, 335.
326. Rosenberg, 186.
327. Ebert, 620.
328. Ebert, 473.

Chapter 6

329. Scheuer, 749.
330. Scheuer, 818.
331. Walker, 1117.
332. Scheuer, 374.
333. Scheuer, 110.
334. Katz, 314.
335. Sperling, 186.
336. Lyman, 163.
337. Katz, 818.
338. Scheuer, 377.
339. Scheuer, 461.
340. Scheuer, 465.
341. Scheuer, 524.
342. Scheuer, 729.
343. Scheuer, 712.
344. Scheuer, 48.
345. Katz, 305.

346. Scheuer, 34.
347. Scheuer, 419.
348. Scheuer, 408.
349. Scheuer, 314.
350. Katz, 1228.
351. Johnson, 317.
352. Rosenberg, 104.
353. Scheuer, 88.
354. Scheuer, 27.
355. Scheuer, 856.
356. Walker, 1163.
357. Scheuer, 856.
358. Scheuer, 462.
359. Scheuer, 436.
360. Scheuer, 817.
361. Scheuer, 475.
362. Scheuer, 21.
363. Walker, 34.
364. Scheuer, 414.
365. Scheuer, 177.
366. Walker, 256.
367. Scheuer, 299.
368. Walker, 430.
369. Scheuer, 186.
370. Scheuer, 683.
371. Katz, 1474.
372. Katz, 1142.
373. Scheuer, 553.
374. Scheuer, 152.
375. Scheuer, 670.
376. Scheuer, 259.
377. Katz, 1244.
378. Scheuer, 838.
379. Scheuer, 30.
380. Scheuer, 292.
381. Scheuer, 672.
382. Scheuer, 16.
383. Katz, 1179.
384. Scheuer, 615.
385. Scheuer, 760.
386. Scheuer, 599.
387. Katz, 1052.

388. Scheuer, 307.
389. Katz, 1006.
390. Scheuer, 753.
391. Scheuer, 436.
392. Walker, 1046.
393. Scheuer, 760.
394. Scheuer, 382.
395. Scheuer, 44.
396. Scheuer, 846.
397. Scheuer, 259.
398. Scheuer, 361.
399. Katz, 920.
400. Scheuer, 524.
401. Scheuer, 460.
402. Scheuer, 682.
403. Scheuer, 779.
404. Scheuer, 810.
405. Scheuer, 22.
406. Scheuer, 643.
407. Scheuer, 900.
408. Scheuer, 483.
409. Scheuer, 638.
410. Katz, 1422.
411. Scheuer, 612.
412. Katz, 723.
413. Katz, 723.
414. Scheuer, 854.
415. Walker, 1161.
416. Scheuer, 268.
417. Katz, 292.
418. Scheuer, 372.
419. Scheuer, 266.
420. Scheuer, 62.
421. Scheuer, 322.
422. Walker, 228.
423. Scheuer, 154.
424. Scheuer, 987.
425. Scheuer, 897.
426. Scheuer, 419.
427. Scheuer, 300.
428. Scheuer, 757.
429. Katz, 507.

430. Scheuer, 47.
431. Scheuer, 903.
432. Scheuer, 644.
433. Katz, 373.
434. Scheuer, 579.
435. Scheuer, 288.
436. Scheuer, 789.
437. Scheuer, 369.
438. Katz, 893.
439. Scheuer, 569.
440. Katz, 818.
441. Scheuer, 470.
442. Brady, 494.
443. Scheuer, 47.
444. Katz, 1153.
445. Scheuer, 125.
446. Scheuer, 810.
447. Scheuer, 424.
448. Katz, 314.
449. Scheuer, 310.
450. Scheuer, 895.
451. Scheuer, 895.
452. Scheuer, 726.
453. Katz, 1153.
454. Katz, 1422.
455. Scheuer, 459.
456. Scheuer, 363.
457. Scheuer, 203.
458. Scheuer, 904.
459. Scheuer, 391.
460. Walker, 556.
461. Scheuer, 706.
462. Katz, 292.
463. Walker, 562.
464. Corman and Jerome, 98 & 181.
465. Scheuer, 681.
466. Scheuer, 464.
467. Walker, 1050.
468. Scheuer, 764.
469. Scheuer, 904.
470. Scheuer, 861.
471. Katz, 373.

472. Scheuer, 274.
473. Scheuer, 816.
474. Walker, 1115.
475. Scheuer, 816.
476. Katz, 1051.
477. Scheuer, 622.
478. Scheuer, 366.
479. Scheuer, 28.
480. Scheuer, 154.
481. Scheuer, 314.
482. Scheuer, 826.
483. Scheuer, 402.
484. Scheuer, 429.
485. Walker, 612.
486. Scheuer, 840.
487. Scheuer, 572.
488. Scheuer, 793.
489. Scheuer, 439.
490. Scheuer, 134.
491. Katz, 1068.
492. Walker, 1097.
493. Katz, 1089.
494. Scheuer, 9.
495. Scheuer, 369.
496. Scheuer, 388.
497. Scheuer, 652.
498. Scheuer, 470.
499. Katz, 723.
500. Scheuer, 256.
501. Martin, Mick and Porter, Marsha, *Video Movie Guide*, Ballantine Books, 1989, 38.
502. Scheuer, 162.
503. Katz, 1006.
504. Walker, 237.
505. Scheuer, 376.
506. Lyman, 24.
507. Scheuer, 345.
508. Scheuer, 412.
509. Scheuer, 679 & 680.
510. Scheuer, 723.
511. Walker, 728.
512. Katz, 1210.

513. Walker, 150.
514. Scheuer, 548.
515. Scheuer, 443.
516. Scheuer, 898.
517. Scheuer, 571.
518. Scheuer, 811.
519. Scheuer, 380.
520. Katz, 486.
521. Scheuer, 531.
522. Walker, 751.
523. Robertson, 143.
524. Scheuer, 56.
525. Walker 93.
526. Ebert, 371.
527. Scheuer, 444.
528. Scheuer, 102.
529. Scheuer, 91.
530. Scheuer, 736.
531. Ebert, 621.
532. Katz, 1153.
533. Strager, James, *The People's Chronology*, Henry Holt, 1992, 498.
534. Scheuer, 441.
535. Scheuer, 104.
536. Scheuer, 605.
537. Scheuer, 200.
538. Scheuer, 194.
539. Scheuer, 457.
540. Scheuer, 441.
541. Scheuer, 862.
542. Katz, 723.
543. Scheuer, 862.
544. Scheuer, 879.
545. Ebert, 52.
546. Walker, 78.
547. Scheuer, 467.
548. Katz, 1200.
549. Scheuer, 339.
550. Scheuer, 857.
551. Scheuer, 877.
552. Scheuer, 124.
553. Ebert, 675.
554. Scheuer, 791.

555. Ebert, 664.
556. Scheuer, 108.
557. Scheuer, 803.
558. Corman and Jerome, 201.
559. Scheuer, 764.
560. Katz, 1283.
561. Johnson, 464 & 465.
562. Lyman, 105.
563. Scheuer, 486.
564. Scheuer, 309.
565. Katz, 73.
566. Scheuer, 481.
567. Katz, 853.
568. Scheuer, 160.
569. Katz, 1153.
570. Scheuer, 40.
571. Scheuer, 429.
572. Katz, 1487.
573. Scheuer, 194.
574. Scheuer, 658.
575. Scheuer, 342.
576. Scheuer, 650.
577. Scheuer, 531.
578. Scheuer, 339.
579. Scheuer, 542.
580. Scheuer, 501.
581. Scheuer, 552.
582. Ebert, 461.
583. Scheuer, 686.
584. Walker, 322.
585. Scheuer, 565.
586. Scheuer, 344.
587. Scheuer, 170.
588. Scheuer, 535.
589. Scheuer, 485.
590. Scheuer, 414.
591. Scheuer, 576.
592. Scheuer, 847.
593. Scheuer, 226.
594. Ebert, 492.
595. Ebert, 633.
596. Katz, 1115.

597. Scheuer, 825.
598. Scheuer, 521.
599. Scheuer, 460.
600. Scheuer, 504.
601. Scheuer, 540.
602. Scheuer, 810.
603. Scheuer, 320.
604. Scheuer, 262.
605. Scheuer, 726.
606. Scheuer, 726.
607. Scheuer, 725.
608. Scheuer, 418.
609. Scheuer, 190.
610. Ebert, 161.
611. Katz, 886.
612. Ebert, 734.
613. Scheuer, 161.
614. Martin and Porter, 38.
615. Scheuer, 161.
616. Scheuer, 267.
617. Scheuer, 520.
618. Scheuer, 765.
619. Katz, 665.
620. Scheuer, 320.
621. Scheuer, 19.
622. Scheuer, 541.
623. Scheuer, 571.
624. Bart, 70.
625. Ebert, 474.
626. Katz, 1153.
627. Scheuer, 481.
628. Scheuer, 848.
629. Evans, 13.
630. Lyman, Daniel, *Great Jews on Stage and Screen*, Jonathan David Publishers, 1987, 229.
631. Scheuer, 619.
632. Scheuer, 150.
633. Walker, 223.
634. Scheuer, 365.
635. Katz, 1089.
636. Scheuer, 298.
637. Katz, 977.

638. Scheuer, 504.
639. Scheuer, 541.
640. Scheuer, 350.
641. Scheuer, 113.
642. Scheuer, 656.
643. Scheuer, 167.
644. Ebert, 540.
645. Scheuer, 44.
646. Katz, 1153.
647. Scheuer, 423.
648. Katz, 1428.
649. Ebert, 622.
650. Walker, 1019.
651. Ebert, 622.
652. Scheuer, 173.
653. Scheuer, 563.
654. Martin and Porter, 139.
655. Scheuer, 674.
656. Ebert, 691.
657. Katz, 1089.
658. Scheuer, 60.
659. Katz, 625.
660. Ebert, 131.
661. Katz, 878.
662. Katz, 1051.
663. Ebert, 305.
664. Scheuer, 862.
665. Ebert, 235.
666. Ebert, 666.
667. Ebert, 664.
668. Scheuer, 761.
669. Scheuer, 47.
670. Ebert, 392.
671. Ebert, 390.
672. Scheuer, 466.
673. Scheuer, 442.
674. Scheuer, 419.
675. Scheuer, 541.
676. Scheuer, 318.
677. Scheuer, 665.
678. Ebert, 83.
679. Scheuer, 617.

680. Walker, 865.
681. Katz, 114.
682. Scheuer, 617.
683. Scheuer, 270.
684. Scheuer, 729 & 730.
685. Ebert, 499.
686. Scheuer, 602.
687. Walker, 843.
688. Scheuer, 86.
689. Ebert, 685.
690. Ebert, 698.
691. Scheuer, 831.
692. Walker, 1131.
693. Scheuer, 12.
694. Ebert, 232.
695. Walker, 227.
696. Scheuer, 153.
697. Katz, 1283.
698. Scheuer, 557.
699. Scheuer, 606.
700. Martin, 98.
701. Scheuer, 451.
702. Katz, 1075.
703. Katz, 568.
704. Ebert, 283.
705. Ebert, 187.
706. Katz, 695.
707. Scheuer, 727.
708. Lyman, 231.
709. Scheuer, 568.
710. Scheuer, 582.
711. Scheuer, 655.
712. Scheuer, 172.
713. Scheuer, 299.
714. Scheuer, 36.
715. Scheuer, 833.
716. Scheuer, 504.
717. Walker, 717.
718. Scheuer, 769.
719. Scheuer, 57.
720. Scheuer, 329.
721. Ebert, 309.

722. Gribetz, 666.

723. Scheuer, 672.

724. Scheuer, 247.

725. Scheuer, 743.

726. Walker, 1026.

727. Ebert, 64.

728. Scheuer, 27.

729. Martin, 569.

730. Scheuer, 376.

731. Scheuer, 739.

732. Scheuer, 295.

733. Ebert, 659.

734. Ebert, 180.

735. Ebert, 67.

736. Ebert, 434 & 435.

737. Ebert, 602.

738. Ebert, 71.

739. Ebert, 634.

740. Ebert, 433.

741. Ebert, 256.

742. Ebert, 192.

743. Ebert, 192.

744. Ebert, 592.

745. Ebert, 231.

746. Ebert, 463.

747. Ebert, 146.

748. Katz, 358.

749. Ebert, 457.

750. Katz, 1171.

751. Ebert, 670.

752. Ebert, 228.

753. Ebert, 99.

754. Katz, 993.

755. Ebert, 51.

756. Film Review, *The Hollywood Reporter*, May 8, 1991, 5.

757. Film Reviews, *The Hollywood Reporter*, May 6, 1991, 5.

758. "Reviews in Review", *The Hollywood Reporter*, May 28, 1991, 16.

759. Ebert, 181.

760. Film Reviews, *The Hollywood Reporter*, July 29, 1991, 8 & 22.

761. Ebert, 464.

762. Film Reviews, *The Hollywood Reporter*, August 23, 1991, 10.

763. Ebert, 394.

764. Ebert, 528.

765. Ebert, 452.

766. Ebert, 243.

767. Reviews, *Variety*, April 13, 1992, 64.

768. Ebert, 158.

769. Ebert, 639.

770. Ebert, 640.

771. Ebert, 484.

772. Reviews, *Variety*, October 26, 1992, 67.

773. Ebert, 501.

774. McCarthy, Todd, "Film Reviews", *Daily Variety*, Nov. 1, 1993., 4 & 18.

775. McCarthy, Todd, "Film Review—A Perfect World", *Daily Variety*, November 19, 1993, 2 & 23.

776. McCarthy, Todd, "Film Reviews", *Variety*, Dec. 13, 1993, 36.

777. Bart, Peter, "'Tis the PC Season", *Variety*, December 13, 1993.

778. "Review", *Variety*, January 3-9, 1994, 53, column 2.

779. Ebert, 398.

780. *Entertainment Weekly*, February 12, 1993, 38.

781. *Entertainment Weekly*, April 16, 1993, 57.

782. Ebert, 557.

783. Ebert, 224.

784. Katz, 1089.

785. Ebert, 7.

786. Film Review, *Daily Variety*, August 16, 1993, 4.

787. Klady, Leonard, "Film Reviews", *Variety*, Jan. 31 - Feb. 6. 1994, 68.

788. Levy, Emanuel, "Film Reviews", *Variety*, Oct. 31 - Nov. 6, 194, 88.

789. McCarthy, Todd, "Film Reviews", *Variety*, Dec. 5-11, 1994, 73.

790. Brownstein, 206.

791. Johnson, 469.

Chapter 7

792. Ebert, 238.

INDEX